COMPLETE SUMI-E TECHNIQUES

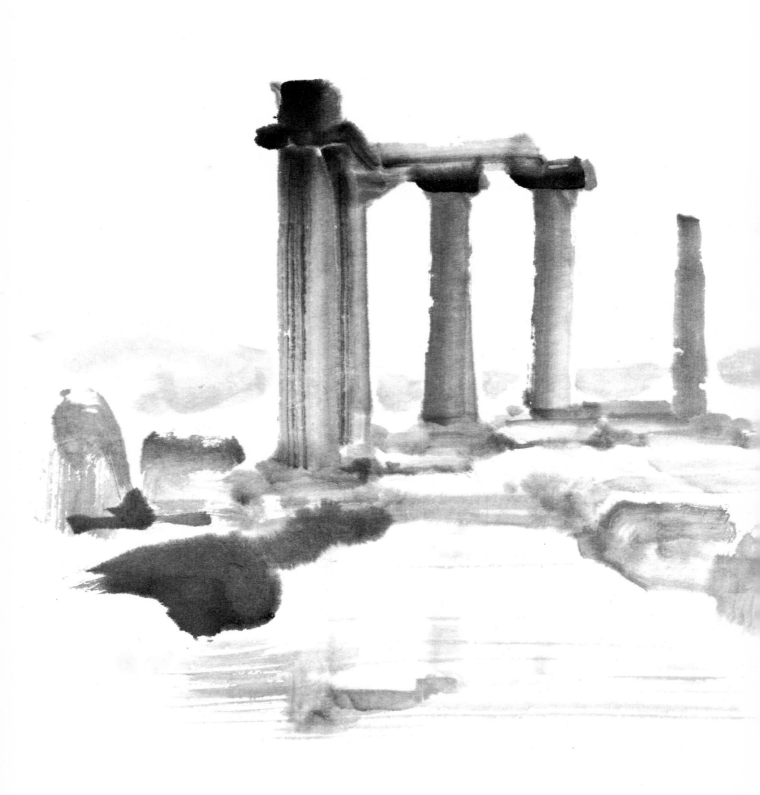

Complete Sumi-e Techniques

By SADAMI YAMADA

Professor of Art at Tamagawa University

Complete Instructions for Painting
Over 200 Subjects including
Flowers, Trees, Animals, Fish,
and Landscapes

JAPAN PUBLICATIONS TRADING COMPANY
Elmsford, N.Y. San Francisco Tokyo

This work is a compilation of
all four volumes of our sumi-e series,
Sumi-e in Three Weeks,
Floral Sumi-e in Three Weeks,
Animal Sumi-e in Three Weeks, *and*
Landscape Sumi-e in Three Weeks.

Published by
JAPAN PUBLICATIONS TRADING COMPANY
of Elmsford, N.Y., San Francisco, Calif., and Tokyo
with editorial offices at
1-2-1, Sarugaku-cho, Chiyoda-ku, Tokyo 101, Japan

©1966 by Sadami Yamada
Translation by Transearch, under the direction of Charles Pomeroy
Library of Congress Catalog Card Number 66-24010
ISBN-0-87040-361-3
First printing: June 1966
Third printing: August 1975
Printed in Japan by Dai Nippon Printing Co., Ltd.

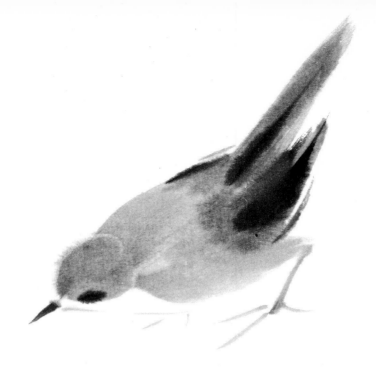

Foreword

THE type of painting known as *sumi-e* forms one of the great traditions of Far Eastern Art. Its primary colors are black and white. *Sumi*, the ink from which this painting takes its name (*sumi*, "Chinese" or "Indian" ink; *e*, picture), is considered in Far Eastern aesthetics to have five color values, and the ink painting that developed from this approach to ink is distinguished by simplicity, lucidity and elegance of style.

Sumi-e are painted on white paper as pure and clean as fresh-fallen snow, and the tonal variations of the monochrome ink with which the subjects are given form represent a direct expression of the emotions.

Expression in *sumi-e* is simple beauty. The desired expression cannot be achieved through the use of delicate lines throughout, for they have a tendency to be merely descriptive, in ink painting. The essential nature of a thing however can be condensed in a few abbreviated strokes, and the spontaneous feeling of the individual can be expressed through the subtle tonal variations produced by the brush.

Neither light and shade nor backgrounds are painted in *sumi-e*. The white untouched areas of the paper serve as background, but these areas must not be thought of as merely paper without any significance. The white areas have a profound meaning, for they give the painting a sense of spatial depth, they produce a sense of elegance and refinement, they perfect the idealistic concept, and they introduce vitality into the painting. *Sumi-e* may, in fact, be called "the art of white blankness."

<div align="right">S. Y.</div>

Contents

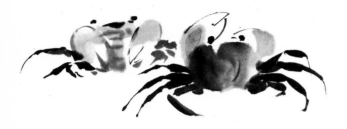

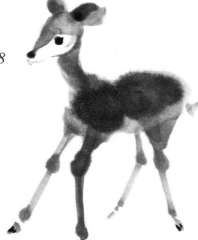

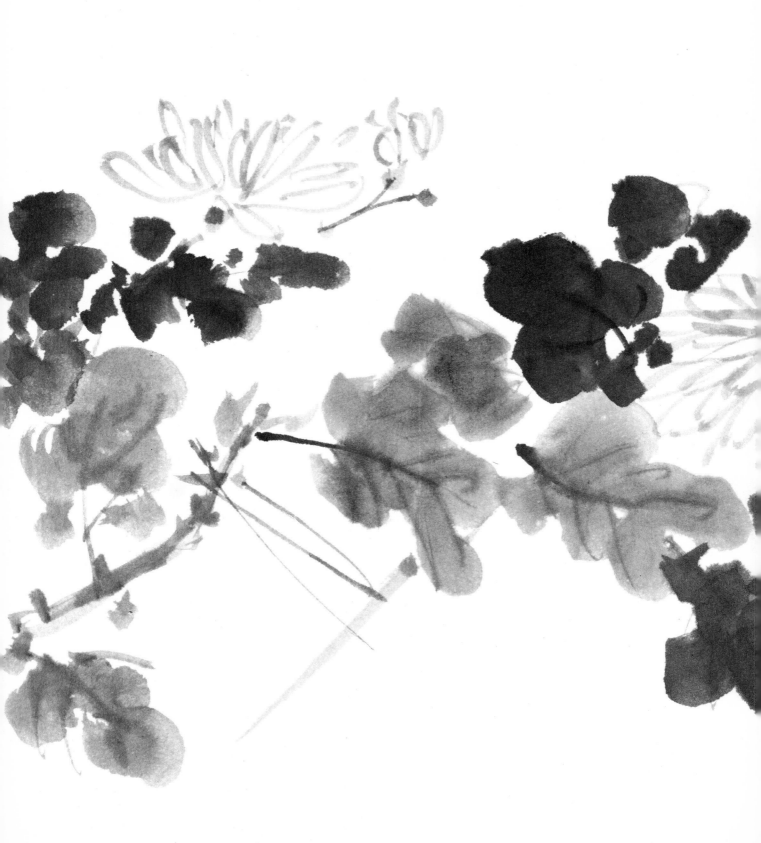

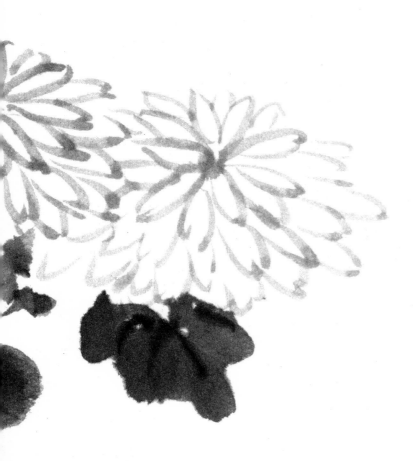

BASICS

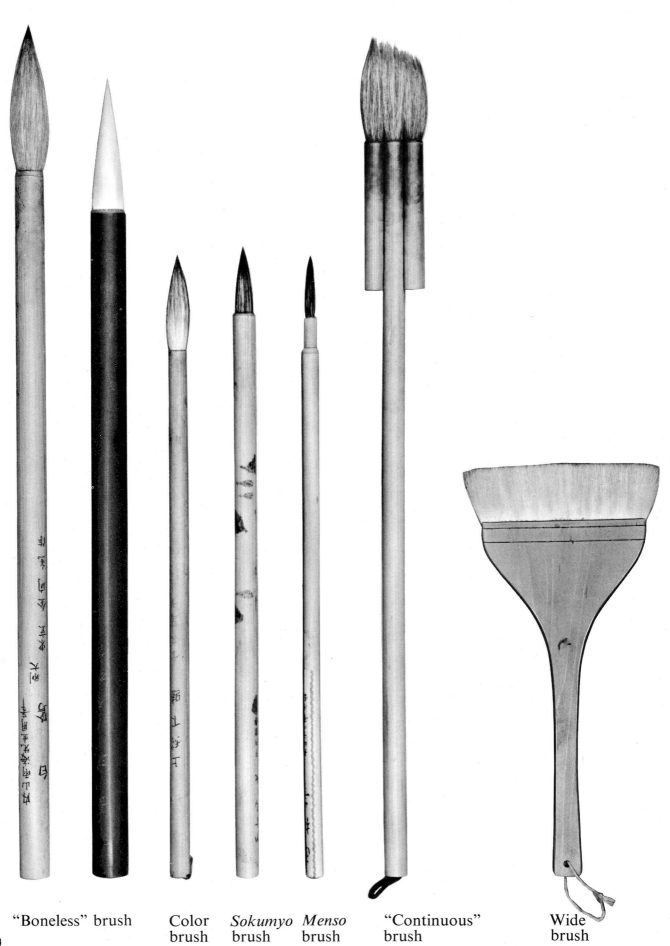

"Boneless" brush Color brush *Sokumyo* brush *Menso* brush "Continuous" brush Wide brush

Materials and Implements

Brushes (*Fude*)

Wide lines, narrow lines, strong lines, weak lines, hard lines and soft lines can all be produced with a Japanese brush. The construction of the brush also permits wide surfaces and shading to be effected with single strokes.

A wide variety of brushes are used in Japanese painting, but not so many are ordinarily required for *sumi-e*.

BRUSH FOR PAINTING AREAS WITHOUT OUTLINES (*Mokkotsu*)

This brush should have long bristles that are evenly arranged and elastic, and none of the bristles should be split. Some brushes will have stiff bristles and some soft bristles, and they will come in three sizes, large, medium, and small. The best bristles are taken from the summer coats of deer.

Brushes of this type are used for *mokkotsu* or "boneless" painting, in which ink is applied in broad strokes without the use of outlines.

OUTLINE BRUSH

This brush is used for painting lines. The type known as *sakuyo* can be freely used for lines of varying qualities, such as narrow or wide, heavy or thin, and so on. There are other brushes, like the *menso* or "feature" brush, which has long bristles and is used for fine lines, and the *sokumyo* brush, which is used for elegant lines.

menso brush—for painting very fine lines.

sokumyo brush—for painting soft lines; the bristles are softer than those of the *menso* brushes.

COLOR BRUSH

This brush has soft, white bristles and is used for applying color. The bristles will hold a large quantity of water. When used in painting *sumi-e*, soft tones can be obtained.

"CONTINUOUS" BRUSH

This brush is made up of a combination of two or three brushes of the type used for "boneless" or color painting. The wide part of the brush can be used to produce light and dark tones with one stroke, or it can be used to produce gradations on a broad surface. It is used mainly by professionals.

WIDE BRUSH

This brush is used for painting broad surfaces or for making gradations. By using this brush to apply water to the paper, ink can be applied without leaving brush marks and tonal effects can be easily achieved. It is used mainly by professionals.

HANDLING AND CARE OF BRUSHES

The tip of the brush should be immersed in water until the bristles are completely soaked, then the bristles should be gently squeezed and washed. Next the water is shaken out of the bristles and the tip arranged in a point.

Immediately after use, the brush should be washed clean of ink, then the bristles dried with a cloth and shaped in a point. It is also important to store the brush in such a way that it will be protected from insects and dust.

Inkstones (*Suzuri*)

Inkstones of both the Japanese and the Chinese types vary in size and shape, including square, oblong, round, egg-shaped, or even natural-shaped stones. High-quality stones are best, because they produce the most even textured ink.

Among the more famous Japanese inkstones are the Amahata stone from Yamanashi Prefecture, the Akama stone from Yamaguchi Prefecture and the Takashima stone from Shiga Prefecture. The best Chinese inkstone is the Tankei from Kwantung Province.

Sumi

There are both Japanese and Chinese *sumi* inks, as well as Japanese and Chinese inkstones. Carbon from burnt pine or from lampblack is first mixed with a binding agent and is then formed into ink sticks. Since the ink made from burnt-pine carbon has a blueish tinge, it is known as *aozumi* or "blue ink," while the ink made from lampblack has a brown tinge and is consequently called *chazumi* or "brown ink." This "brown ink" has been much favored in modern times; however, any reasonably good ordinary ink may be used.

Brush-washing Receptacles

Either a metal or a ceramic container filled with clean water may be used for washing brushes. Undecorated bowls or pans are suitable.

Wiping Cloths

Cloths should be dipped in water and lightly wrung out, then placed in a dish for use. They are used to reduce the water of ink content in the bristles of the brush.

Dishes

Dishes are used to test the degree of blackness of the ink, for dissolving dry pigments, and for regulating the charge of ink in the brush. The dishes should be white and about 6 inches in diameter.

Paper

Paper should be used for *sumi-e*. The paper should be capable of absorbing and showing off the ink well, and of producing the proper chiaroscuro effect.

Although paper for Japanese painting may be sized with a mixture of alum and glue, unsized paper is better for *sumi-e*. Types of Japanese paper used for *sumi-e* include *ma-shi*, *gasen-shi*, *tosato-shi* and *mino-shi*. Newspapers may be used for practice.

The *gasen* paper takes a brush stroke and shows off the ink color well, but blots easily and tears when wet. Chinese paper is not as absorbent as *gasen*, but its surface is easy to paint on; there are both yellowish and whitish varieties. The *ma* paper is suitable absorbent and shows off the ink well. It is possible to paint over the ink when this paper is used, and it is in popular use.

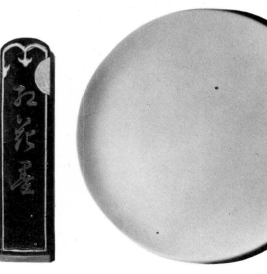

12 Inkstone (*Suzuri*) Ink stick (*Sumi*) Dish

Preparing the Ink

First place clean water in the well at the end of the inkstone and then wet the grinding surface. Holding the ink stick perpendicularly so that its flat end is flush against the grinding surface, move the stick in large circular motions. Draw fresh liquid from the well during the grinding process and continue until the liquid is of a rich, even texture.

It is important to always grind fresh ink before painting. Never use old ink. The inkstone is washed thoroughly and wiped after use. Old ink will spoil the color effect and sediment will ruin the texture as well as result in possible damage to the grinding surface. The glue in the ink will cause it to stick to the stone when it dries, making it extremely difficult to remove.

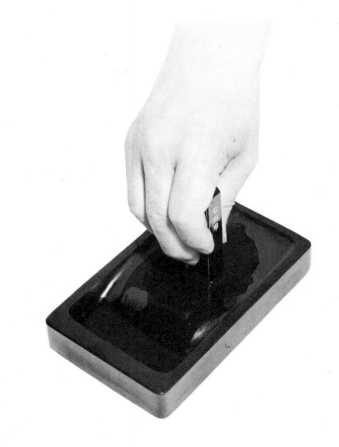

Holding the Brush

There are two ways of holding a brush. In one, the *tankou* method, the brush is held with the forefinger and thumb and allowed to rest against the middle finger. In the other, the *sokou* method, the brush is held with the forefinger, the middle finger, and the thumb and allowed to rest against the ring finger. In either case, the brush is held at a point slightly above center. The *sokou* method is preferred for ink painting. When making strokes, the arm and elbow are raised and the arm moved in large, deliberate motions.

Before using the brush, the tip should be immersed in water to the base of the hairs, using the brush-washing receptacle, and carefully washed. The water is then gently squeezed from the tip with the forefinger and thumb and the hairs arranged into a symmetrical point.

After the brush has been used it should be washed well and dried with a cloth before being put away.

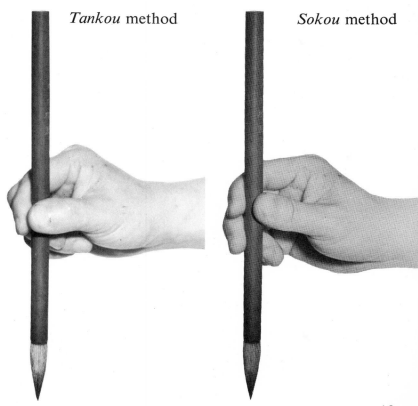

Tankou method *Sokou* method

Sumi-e Techniques

The *Mokkotsu* ("Boneless") Technique

This technique is called *mokkotsu* or "boneless" because the strokes are made without depending on outlines, which are usually the bones of a painting. In preparing the brush for making these strokes, it is first washed as described above and then wiped with a damp cloth. The tip of the hairs is then wet with a small amount of water and the brush charged with dark ink from the inkstone. Next work the brush tip against the white dish, thus mixing the water and ink absorbed by the hairs and producing a lighter intensity of color. Again charge the tip of the hairs with dark ink. As a result of these operations, the brush should contain a charge of three gradations of "color": dark at the tip, light at the middle, and almost colorless at the top.

This way of charging a brush, known as the "three-ink" method, is fundamental in ink painting. When the brush is held at an angle and a stroke made, the effect produced will be one of fine gradation.

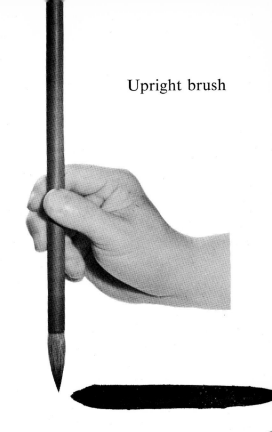

Upright brush

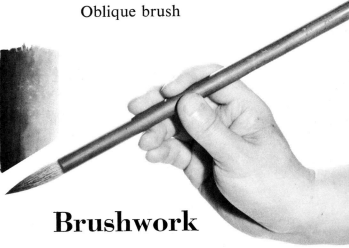

Oblique brush

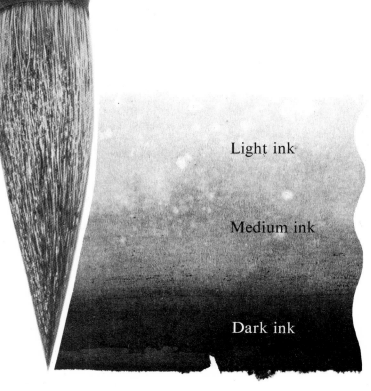

Light ink

Medium ink

Dark ink

Brushwork

1 Upright Brush

The upright brush stroke is made by holding the brush at a perpendicular angle to the paper. This allows the very tip of the brush to travel along the center of the line when making a stroke, resulting in a powerful effect. The upright stroke is best suited for expressing strength of will.

2 Oblique Brush

The oblique brush stroke is made by holding the brush at an angle to the paper. When making a stroke with the brush held in this position, the tip will pass along one edge of the line and the middle part of the brush tip will pass along the other edge. This allows a free, flexible mode of expression because the width of the stroke can be controlled by pressure on the brush tip. The oblique stroke is best used for expressing emotion.

When the upright and oblique brush strokes are used in combination, an intermingled and impressive effect can be achieved. The beginning student would do well to practice these brush movements and to study the different gradations that can be produced with the strokes.

The Eight Oblique Strokes

There are eight positions in which the brush may be held in making oblique strokes. These are called *happitsu*.

1. Downward from the top of the paper with the brush held slanted to the right.

2. Downward from the top of the paper with the brush held slanted to the left.

3. From left to right with the brush held slanted away from the painter.

4. From left to right with the brush held slanted toward the painter.

5. Diagonally from the upper right to the lower left with the brush held slanted to the right.

6. Diagonally from the upper left to the lower right with the brush held slanted to the left.

7. Diagonally from the upper left to the lower right with the brush held slanted to the right.

8. Diagonally from the upper right to the lower left with the brush held slanted to the left.

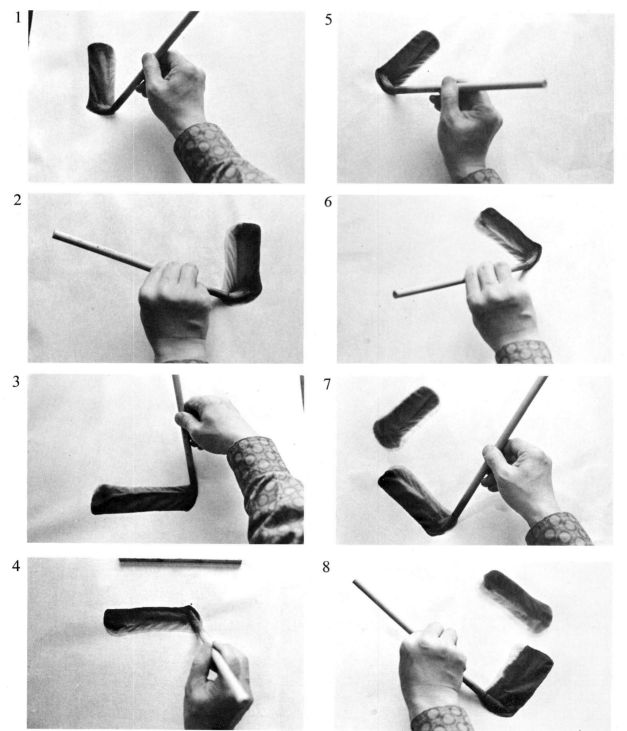

Types of *Sumi-e*

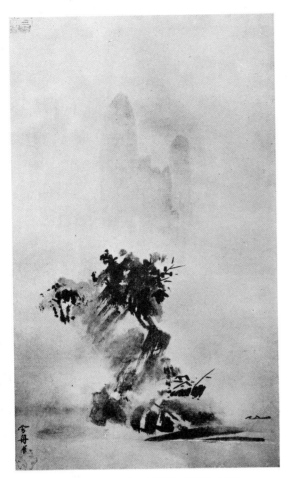

LANDSCAPE *by Sesshu (1420–1506). "Bone-less" painting* (Hatsubokuga).

Although *sumi-e* are painted in monochrome black on white paper, various types or styles have developed from different ways of expression.

OUTLINE PAINTING

This method consists of using only linear strokes. It is known as "white painting," as "bone painting" and as linear painting.

In Japanese painting, not only is the form of the subject drawn, but various meanings, feelings and emotions are also expressed. A sense of movement in the subject and the feeling of the artist are expressed through the speed, the relative weight, the direction, the modulations and variations of the brush strokes.

A linear stroke is made with a concentration of spirit throughout; the breath is held and a single stroke executed.

"BONELESS" PAINTING

Painting of this type, which is known as *mokkotsu* or *tsuketate-gaki* in Japanese, is done without making outlines. The brush is charged with ink of varying degrees of intensity, then applied to the paper.

The "boneless" painting technique expresses rich emotional expression rather than ideas of will. With this technique it is possible to express in one stroke a feeling of freshness and vitality.

In addition to the "boneless" strokes, the "spilled" or "sling" ink (*hatsuboku*) technique and the "broken" ink (*haboku*) technique are also used. These strokes are characteristically

PICTURE SCROLL OF ANIMALS, BIRDS AND HUMAN BEINGS IN CARICATURE (*Detail. Heian Period 794–1185). Outline painting* (Hakubyoga).

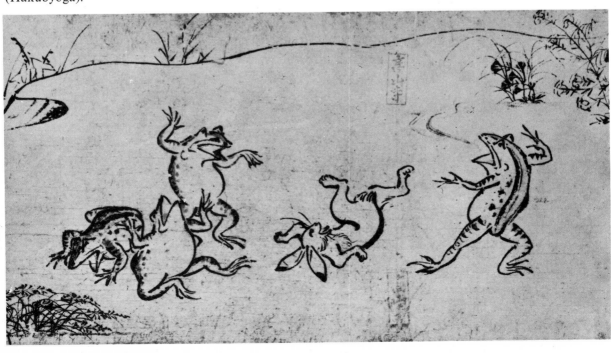

used in the "Southern" (*Nanga*) style or the "Literary" (*Bunjinga*) style of painting.

The "broken" ink technique consists of first applying thin ink to the paper, then retouching it with medium or heavy ink before it dries. The darker ink spreads out naturally through the thin ink and produces a subtle and beautiful effect. This technique is generally used in the "Southern" style.

The word *hatsu* means to pour, and the *hatsuboku* stroke is made with a heavily charged brush that produces a poured or "spilled" effect. This ink effect is one of a flat plane rather than of a line, and it becomes the simple expression of subjective mood rather than of form.

THE NORTHERN STYLE

In this style, linear outlines are made in heavy ink and shading executed over the form. The resulting painting is a combination of line and shaded surface.

Great attention is given to every line and dot in painting the outline, in which the upright brush technique is used. When shading is added to the dark outline, a painting of strong feeling results.

Paintings in the "Southern" style, made by literary men and amateurs, are intimate, calm, light and easy in feeling, while paintings in the "Northern" style are more the work of professionals.

China—Li T'ang, Ma Yuan, Hisa Kuei
Japan—Josetsu, Shubun, Sesshu, Dassoku

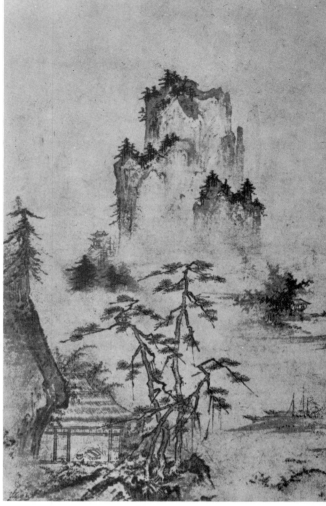

LANDSCAPE. *Attrib. to Shubun (14th–15th cent.). The Northern Style.*

EVENING GLOW OVER THE FISHING VILLAGE *by Mu-ch'i (1181–1239). "Boneless" painting* (Habokuga).

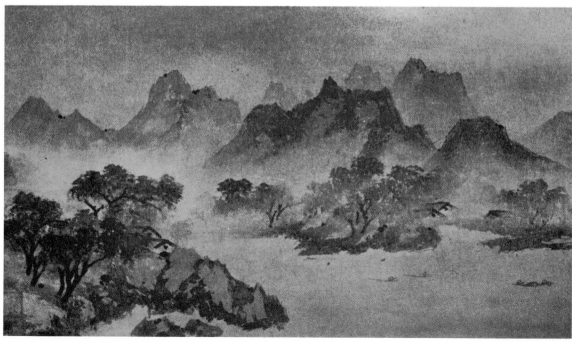

Brush Practice

Painting a Circle Using the Upright Brush Technique

Shape the bristles into a point and charge the brush with three shades of ink.

Holding the brush in the upright position, place the tip down at the point indicated by A in the diagram and gently direct the brush around to point B. Pull the brush around a little faster to point C and then while applying more pressure pull it around to point D in a downward motion, twisting the brush between the thumb and forefinger. Release the pressure on the brush tip when bringing the stroke around to point E, then increase the speed and complete the stroke at point A.

Since the brush is held in an upright position, the tip of the bristles should travel around in the center of the line. A heavy line is thus created, and the effect is not that of a circle but of a solid sphere.

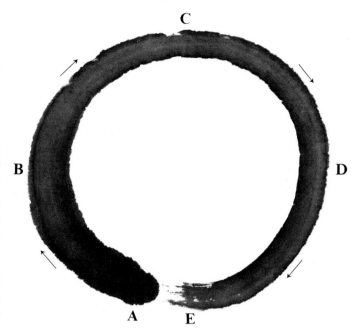

Painting a Circle

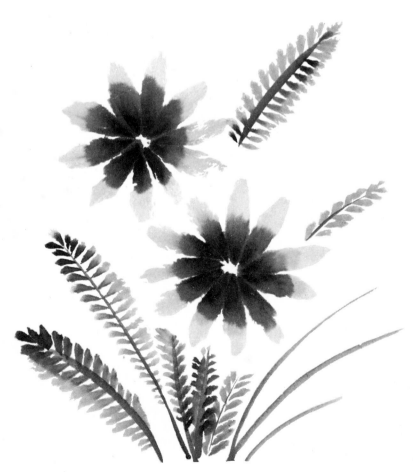

Painting a Flower Using the "Three ink method."

Painting a Flower Using the "Three Ink Method"

Wash the brush well, dip it in dark ink and work it gently in a dish. This produces a light ink. Complete charging the brush with three shades of ink by dipping the brush into ink of medium intensity and then into dark ink. The light ink should be at the top of the bristles, the medium ink in the middle, and the dark ink at the tip.

Place the tip of the brush in the center of the area where the flower is to be painted, and while pressing down for each petal, move the brush around in the order you want the petals to appear. With practice, a flower like that shown in the illustration can be easily made. To make the leaves, first paint the stem and then press the brush on the paper to form small leaves in the desired positions.

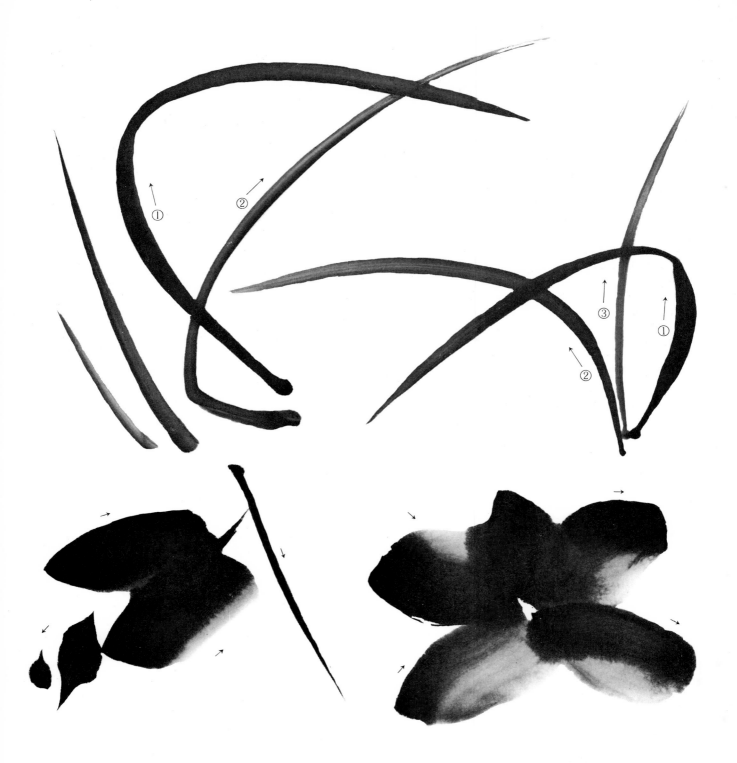

Brush Practice with
Grass and Leaves as Themes

1. Thoroughly wash the bristles of a *mok-kotsu* brush and charge the brush with clean water.

2. Press the bristles against a cloth to remove the water, then charge the brush again with a suitable amount of water.

3. Dip the tip of the brush into dark ink and work the bristles in a dish to combine the water and ink. Test for proper shading, then dip the tip of the brush into dark ink.

4. Once you have acquired the technique for charging the brush with three shades of ink, try making the strokes shown in the accompanying diagram, being careful to follow the numbers and to move the brush in the directions indicated by the arrow.

Practice the strokes many times, using the upright brush position and the oblique brush position. Also practice applying and releasing pressure on the brush tip. Any absorbent paper, such as newspaper, may be used for practice.

Practice for Brush Strokes

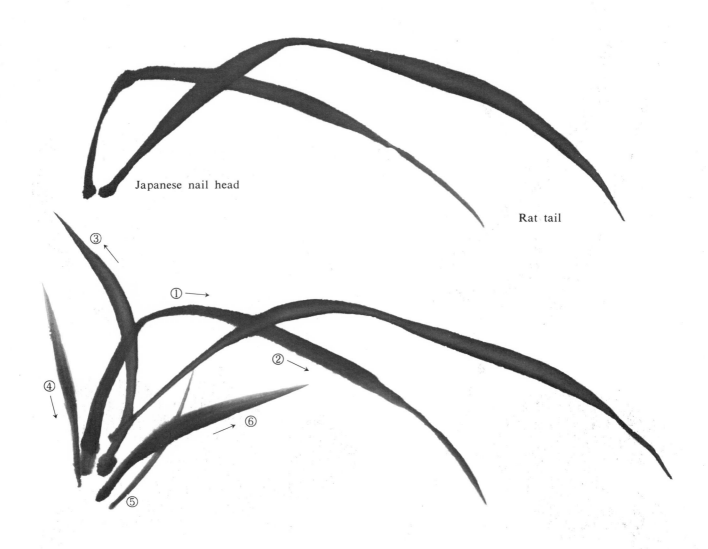

Japanese nail head

Rat tail

Grass Strokes

Orchids have long been favored flowers in Far Eastern painting. Here, we will practice "grass strokes" taking orchid leaves as our theme.

TECHNIQUE

Charge a *mokkotsu* brush with three shades of *sumi* ink. Starting with central and longest leaf, begin the first stroke at the lower left and move it toward the upper right to form the leaf. The stroke is made by first allowing the tip of the brush to touch the paper with enough pressure to form a mark that resembles the head of a Japanese nail, then make a vigorous stroke, finishing the stroke by pulling the brush away from the paper in such a way that a "rat tail" is formed.

Practice making the strong and weak pressure movements needed to produce the shading and modulation for a single leaf.

The second longest leaf, like the first, is made by starting the stroke at the lower left.

The third leaf is made by starting the stroke at the bottom.

The fourth and fifth leaves are made by starting each stroke at the top.

The brush is charged only once for painting all the leaves. All the strokes are made by keeping the brush upright and moving the arm.

When the practice in which the brush is moved from left to right is finished, practice making similar leaves by moving the brush from right to left.

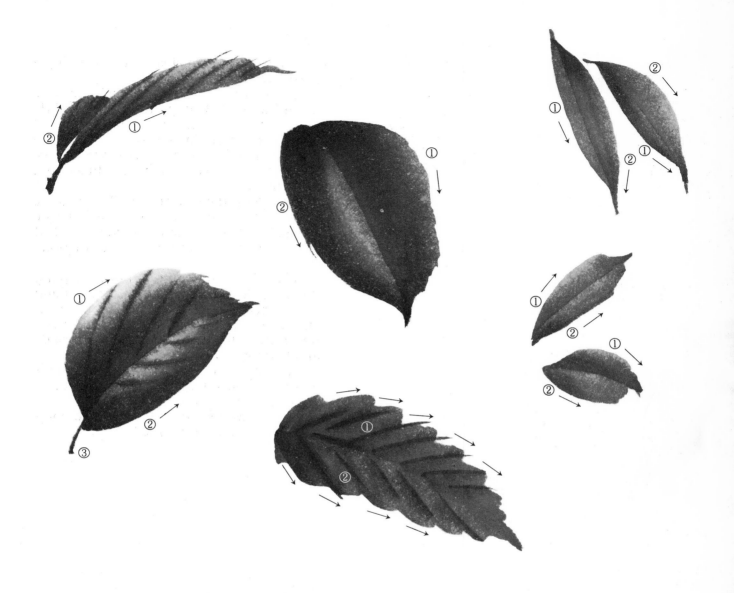

Painting Tree Leaves

1. SIDES OF LEAVES. Charge a *mokkotsu* brush with light, medium, and dark shades of *sumi* ink. To form the leaf shown in the lower right of the diagram, hold the brush with the tip pointed in toward the body (as shown in #3 in the diagram for the eight oblique strokes, p. 15) and make the stroke from left to right, then use the same technique to paint the upper left side of the leaf. Paint in the stem and the leaf veins.

2. UPPER SURFACE OF LEAVES. To paint the upper surface of a thin leaf with pronounced veins, charge the brush with three shades of *sumi* ink and form the leaf using two strokes, with the brush held in the underhand oblique position. Paint in the veins with dark ink.

To paint the upper surface of a dark leaf with light veins, charge a *mokkotsu* brush with three shades of *sumi* ink, tilt the handle to the right, and paint the right side of the leaf with an oblique stroke. Holding the brush in the same way, paint the left side of the leaf. The pointed tip of the leaf will be formed by the tip of the brush when it is touched and released from the paper. To use the tip of the brush this way requires a good deal of practice, but once the technique has been mastered, well-formed leaves can be easily made.

To paint leaves with serrated or cleft edges, make the brush strokes as indicated by the arrows in the diagram.

Painting Practice 1

A　　　　　**B**

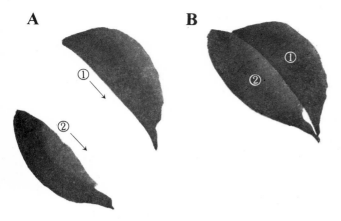

Painting leaves

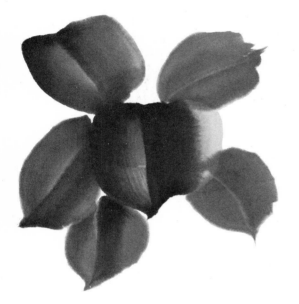

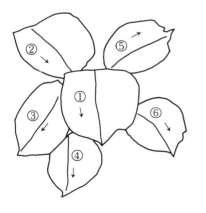

camellia

LEAVES. Each camellia leaf is painted with two strokes.

Wash a *mokkotsu* brush clean and wipe it with a cloth. Charge the brush slightly with water, dip the tip in dark ink and work the brush in a dish to make the charge of uniform intensity, then charge the brush to give it light, medium, and dark shades.

First paint the central leaf. This is done using oblique strokes, with the left side painted first, then the right side. The leaf will be easy to form after plenty of practice.

After the central line is finished, paint the upper left leaf, the middle left leaf and the lower left leaf, then paint the upper and lower right leaves in that order. Each leaf must be formed with two strokes made in left-right sequence.

Next, paint the flowers, stems and buds following the numbers. Finally, paint in the leaf veins with dark ink.

The leaves near the center of the composition should be painted darkest.

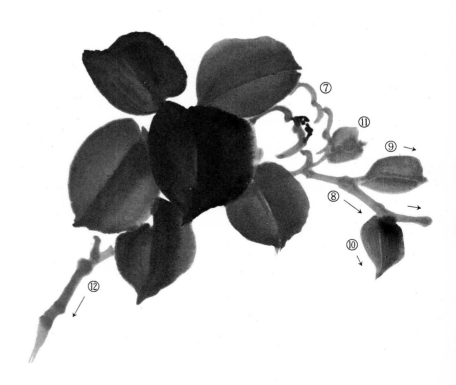

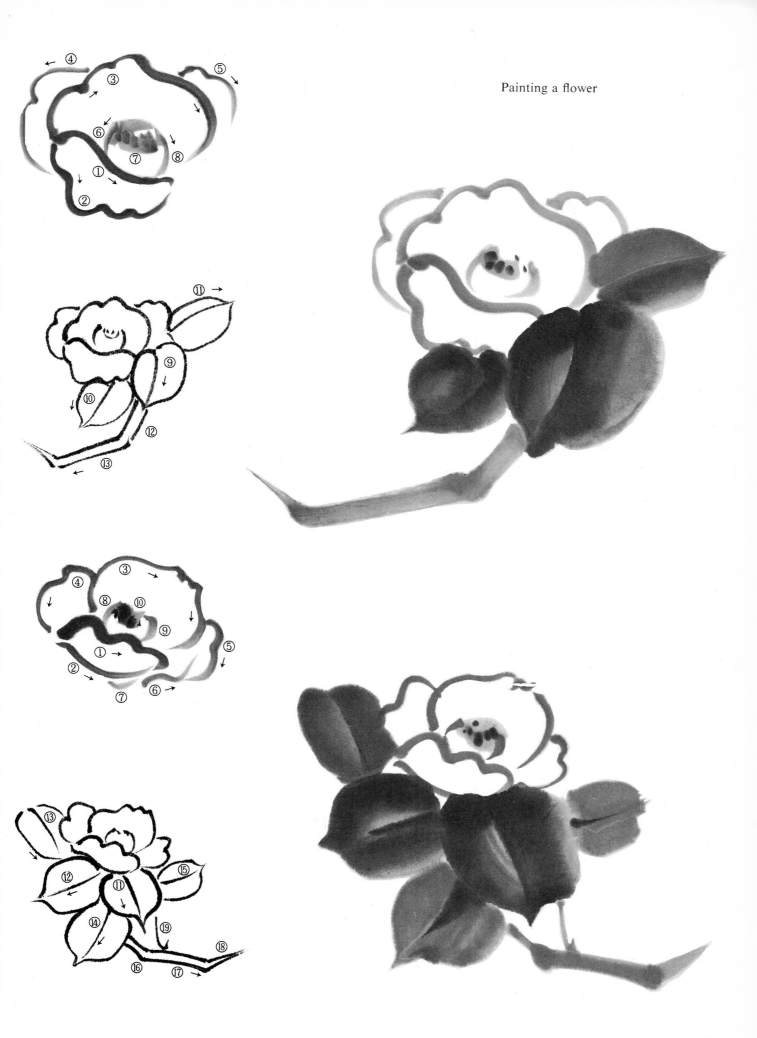

Painting a flower

23

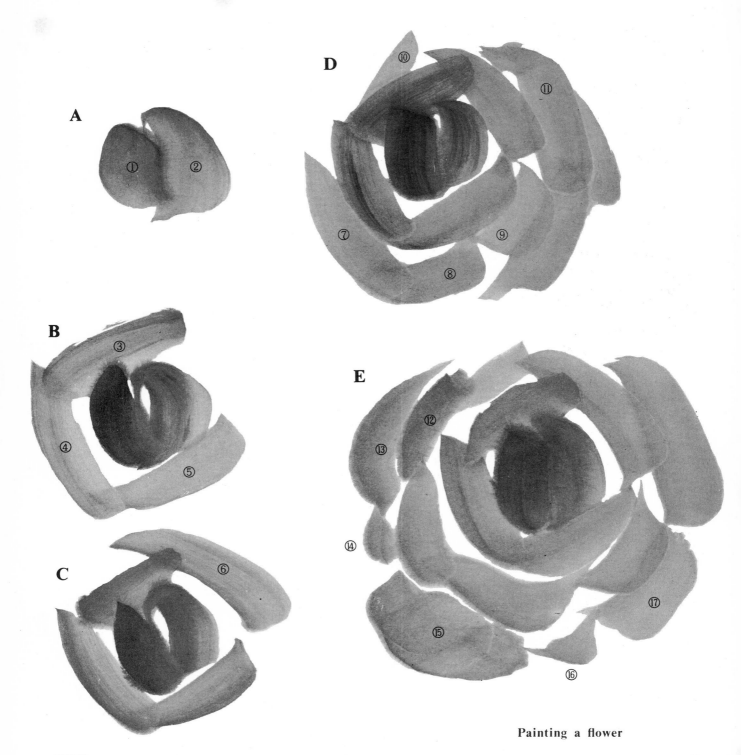

Painting a flower

rose

THE FLOWER. The center petals are painted first, then, in sequence, the outer petals. The form may be lightly drawn with charcoal before starting to paint.

Charge a *mokkotsu* brush with medium intensity ink, then dip the tip slightly in dark ink. Using oblique strokes, paint the center petals, forming each with two strokes, as shown in #1 and #2 in Figure A, then paint the surrounding petals, #3, #4 and #5. Make all strokes in the directions indicated by the arrows and follow the numbered sequence to complete forming the petals.

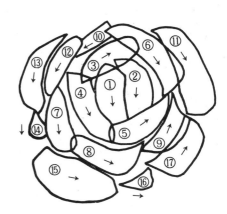

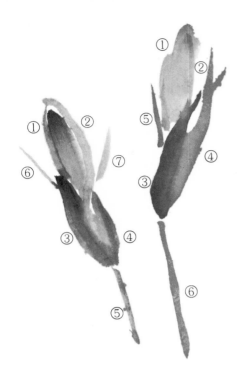

Painting flower buds

THE LEAVES. Rose leaves are painted in medium intensity ink in order to produce a soft feeling. Using two strokes, first paint the center leaf, then the leaf to the left. Next, paint the stem and leaf #4, then follow the numbered sequence in painting the remaining leaves.

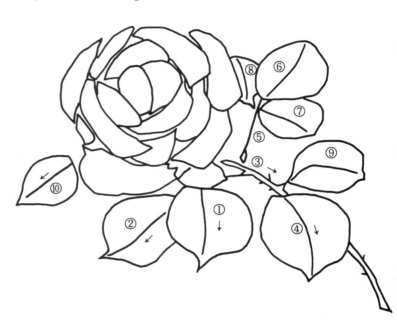

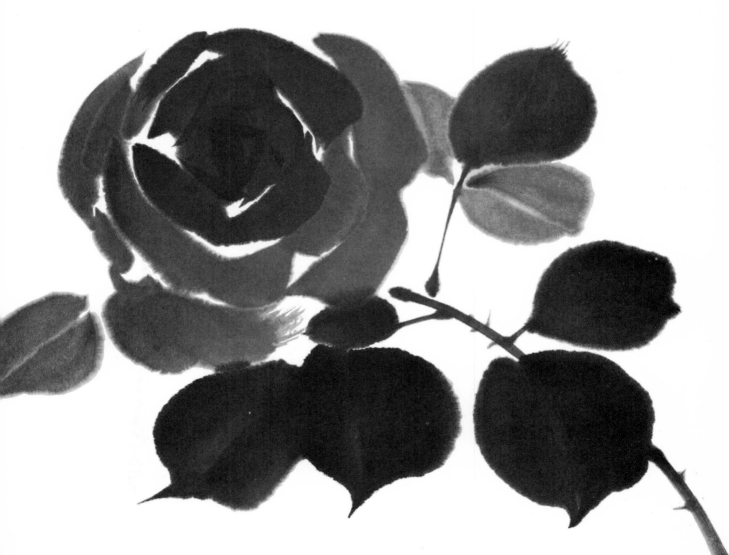

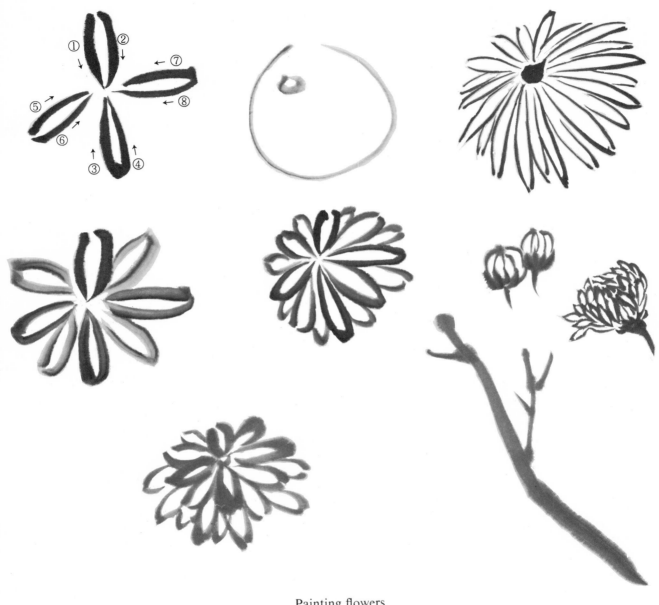

Painting flowers

chrysanthemum

THE FLOWER. Charge the brush with light intensity ink and, using two strokes for each, paint the first four petals as indicated by the arrows. Paint the next four petals as shown, making each one the appropriate length and size, to complete the eight basic petals, then paint in the remaining petals.

THE LEAVES. Medium-dark ink is used to paint the leaves. First paint the stem, then paint the five lobes of the leaf, starting with the largest and working down to the smallest. Paint in the veins with dark ink.

Leaves are painted in four ways, surface, underside, curled and rolled. Leaf surfaces are painted in heavy ink, and leaf undersides are painted in light ink.

When painting many flowers, it is important to take into consideration the direction in which each flower is facing.

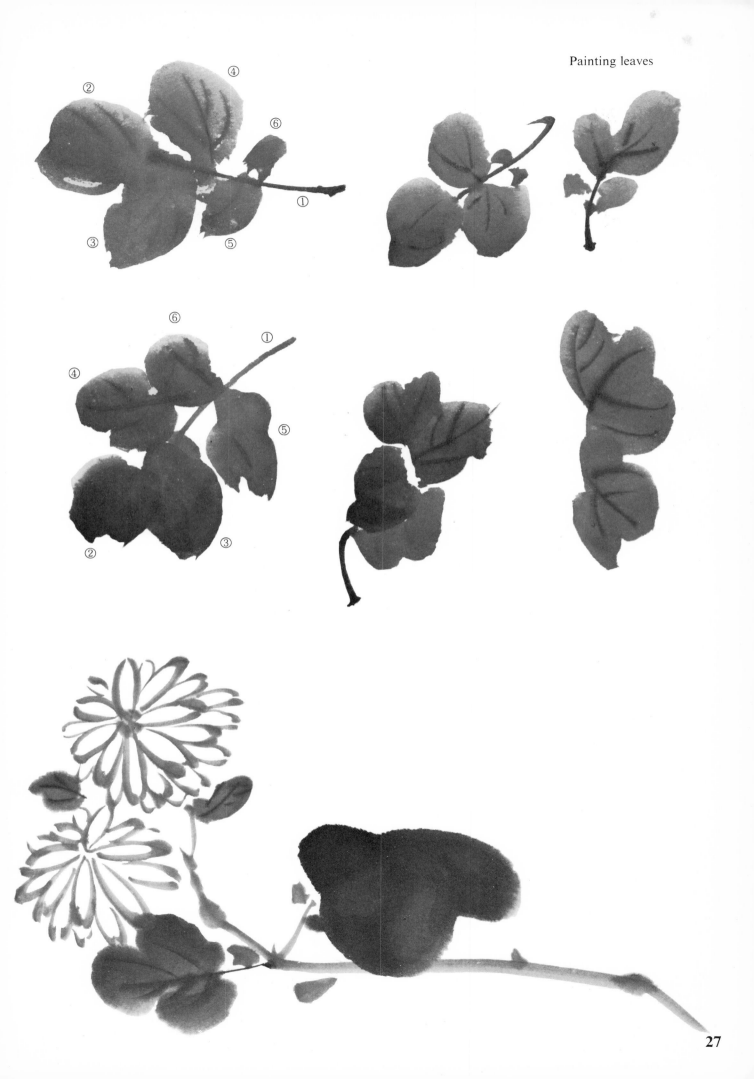

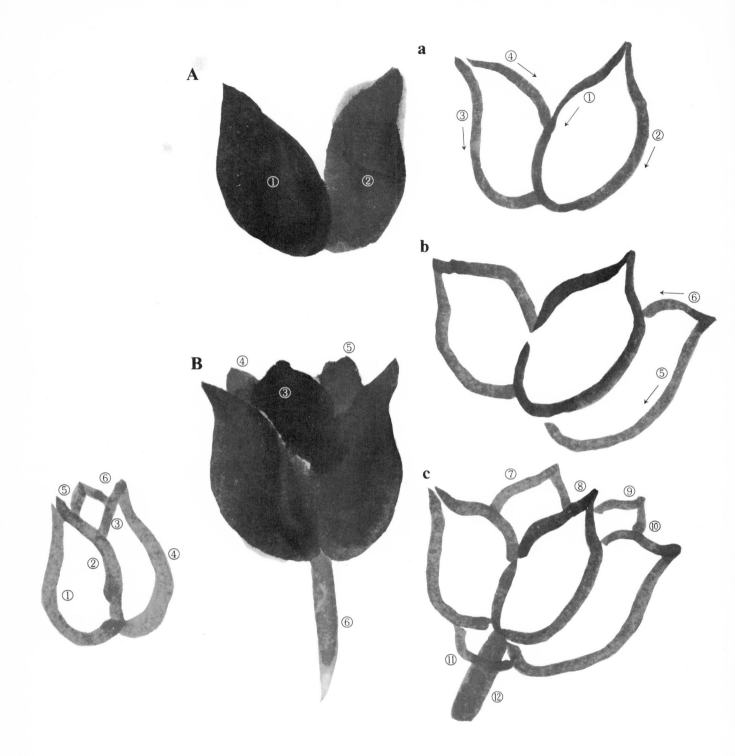

tulip

THE FLOWERS. The tulip in the center is painted in dark ink to represent a deep red color.

A *mokkotsu* brush is charged with light, medium and dark shades of *sumi* ink. Each petal is painted using two strokes in a left-right sequence, as shown in steps #1 and #2 in the diagram.

Petals #3, #4 and #5 are painted next, with two strokes used for each petal as shown.

The brush should not be recharged while painting the petals, for the intensity of the ink decreases with each stroke, giving the flower a natural appearance.

THE STALK AND THE LEAVES. The stalk is painted in a straight line that starts at the base of the flower. Light ink is used. Each of the leaves is painted with two strokes, using dark ink for the leaf surfaces and light ink for the undersides.

The large tulip is painted in light ink to represent a yellow tulip.

Charge the brush with medium intensity ink and paint the outline of petal #1 using two strokes. Paint the outlines of petals #2 and #3 in the same way. Outline the remaining petals in order, then paint the stalk. Using light ink, paint in the outlined surfaces. Next, charge the brush with light, medium and dark ink and paint the leaves, using two strokes to form each leaf.

Paint the remaining tulips using the same technique.

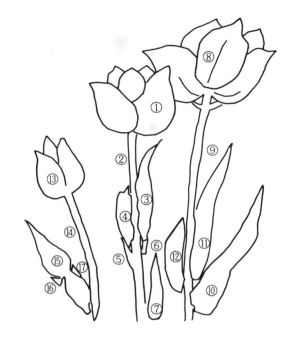

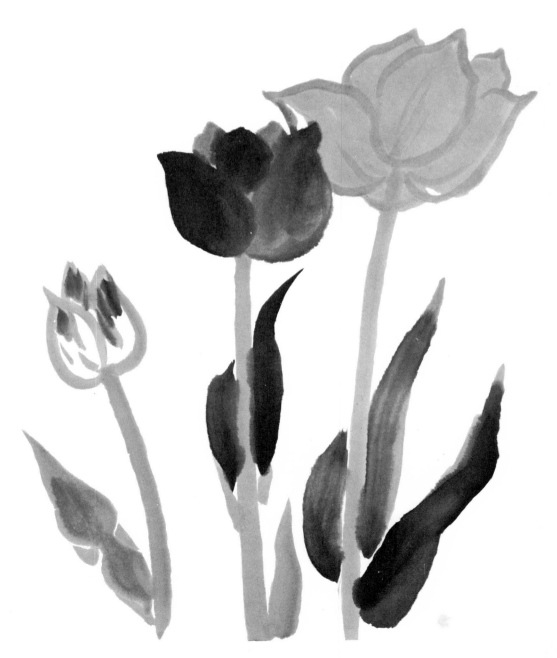

Painting Practice 2

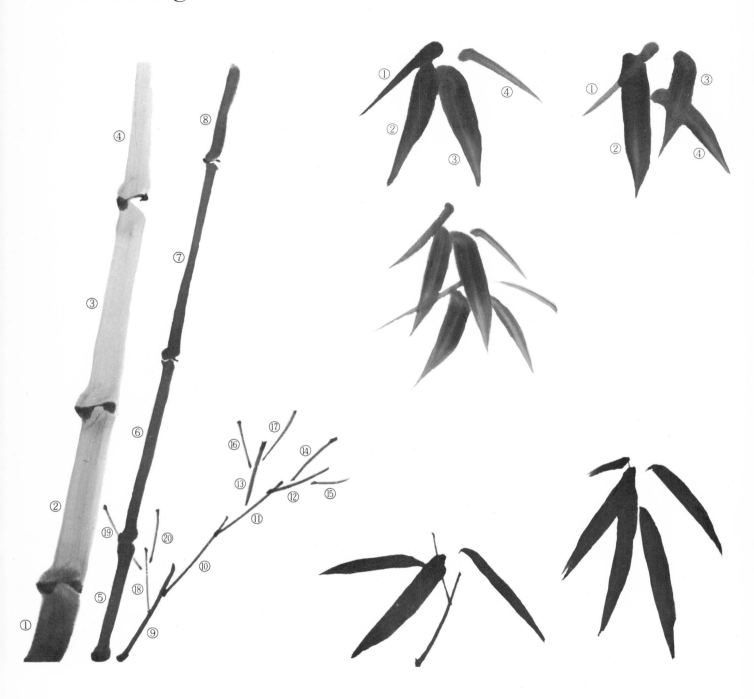

bamboo

BOLE. Charge the brush with light, medium and dark shades of ink, then test it for suitability of ink intensity. Start at the bottom of the bole and paint one section at a time, making each successive section longer than the last.

When the bole sections have been painted, dip the tip of the brush in dark ink and paint the joints. Be careful to paint the joints in such a way that the bole has a rounded effect.

LEAVES. Wash the brush and charge it with medium ink, then dip it in the dark ink. Holding the brush in the upright position, paint the two leaves pointing up so that they roughly resemble a fishtail, then paint the remaining three leaves as shown in the diagram.

Paint the downward pointed leaves in a spread "M" shape.

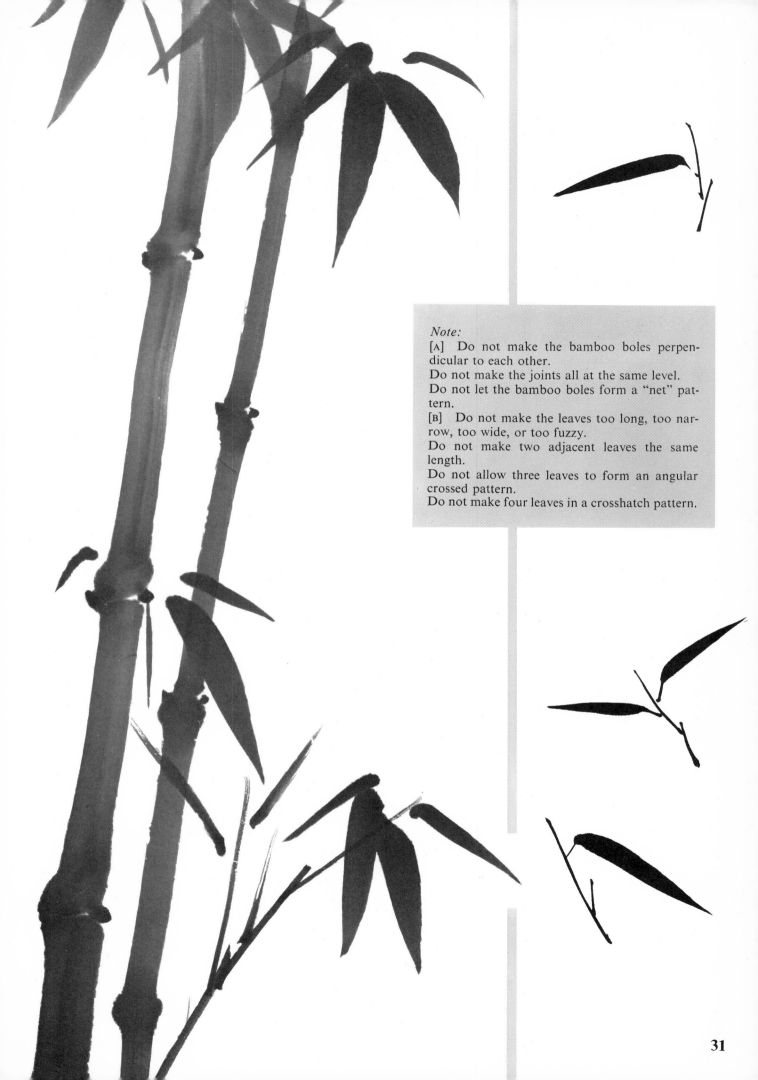

Note:

[A] Do not make the bamboo boles perpendicular to each other.

Do not make the joints all at the same level.

Do not let the bamboo boles form a "net" pattern.

[B] Do not make the leaves too long, too narrow, too wide, or too fuzzy.

Do not make two adjacent leaves the same length.

Do not allow three leaves to form an angular crossed pattern.

Do not make four leaves in a crosshatch pattern.

A

B

C

Painting leaves

grapes

LEAVES. Wash a *mokkotsu* brush and wipe it with a damp cloth, then charge it with a suitable amount of water. The lower half of the brush is charged with medium intensity ink and the tip dipped in dark ink.

Make the first stroke, starting on the upper inside edge of the leaf, by holding the brush in the oblique position and curving it around slightly, as shown by the arrow in diagram A.

Holding the brush in the same way, make the second stroke, allowing the tip of the brush to overlap the area of the first stroke, as shown in diagram B.

Make the third stroke downward, again allowing the brush to overlap, as shown in diagram C.

The fourth stroke is made with more pressure, enough to bring the shoulder of the bristles down against the paper, and the brush is directed around in a curve. Do not recharge the brush while painting the leaf; the effect will be one of a slightly worm-eaten, natural leaf.

After the leaf form is finished, paint in the veins with dark ink.

D

THE FRUIT. The fruit may be painted using either the *mokkotsu* or the outline method.

[A] Charge a *mokkotsu* brush with light, medium and dark shades of ink. Holding the brush in the oblique position, start the stroke from the left side, keeping the center of the bristles in the middle and the tip at the outer edge of the circle, and twist down and around as indicated by the arrows in the diagram. Since the tip will produce a darker shading, the center of the grape will appear a lighter color, resulting in a three-dimensional effect. Finally, touch in a spot of dark ink at the lightest point in the grape.

[B] Holding the brush in an oblique position, make an outline of the grape by moving the tip of the brush around in a circle.

After the techniques for painting leaves and fruit have been practiced, combine them in painting a composition like the one shown in the diagram below.

Painting fruits

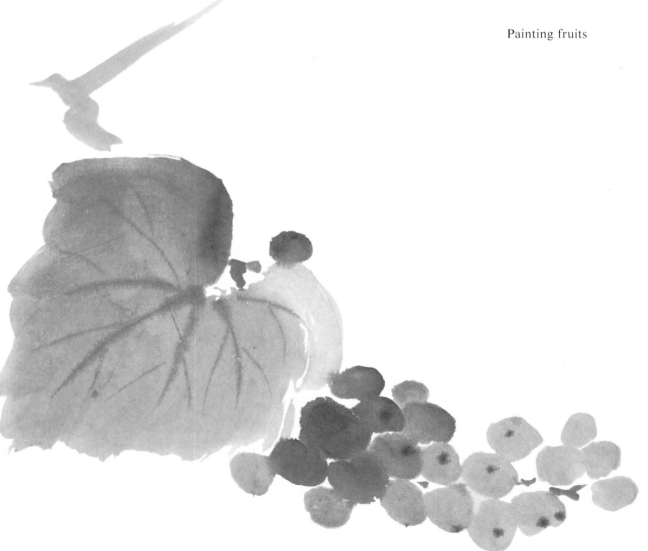

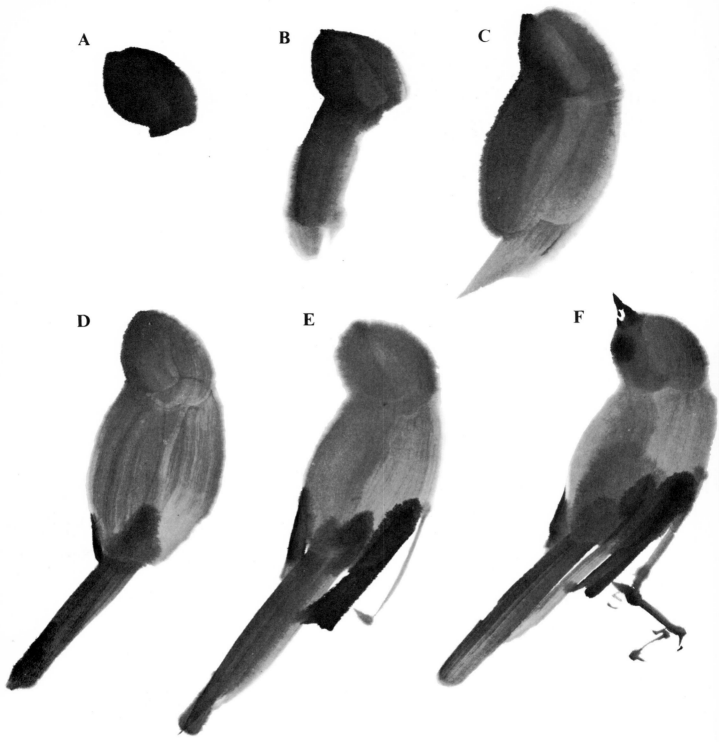

A B C

D E F

bird

Charge the brush with medium ink and paint the head using two strokes, in left-right sequence. Using two strokes, form the body in an elongated egg shape as shown.

Wipe the brush with a rag and dip the tip of the brush in dark ink. Paint the tail using two strokes, then the wings, the stomach and the legs.

Finally, paint the beak and eye using dark ink.

Note: Care must be taken to make the strokes for the leg strong and clear, for the manner in which the leg is painted will determine the sense of movement and the life-like appearance of the bird.

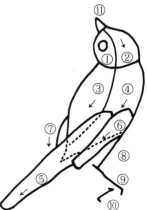

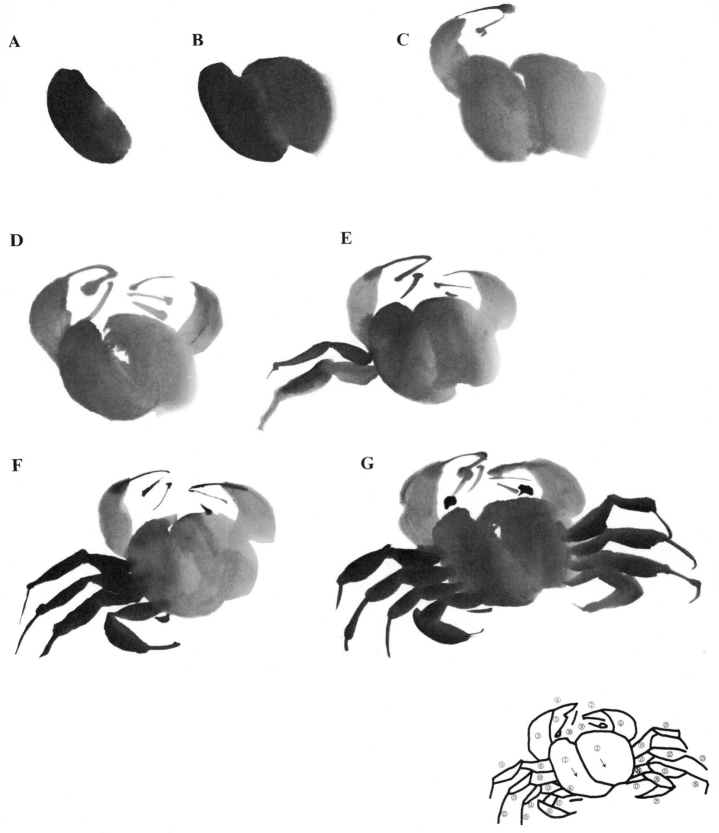

crab

Charge a *mokkotsu* brush with medium ink and paint the shell using two strokes, as shown in the diagram. Paint the left claw as shown in the diagram. Next charge the brush with dark ink and paint the legs in sequence from top to bottom, directing the brush out from right to left. The legs on the right side are made in the same way, except that the brush is directed out from left to right. The eyes are painted in with dark ink.

Composition

1. BASIC COMPOSITION

The problem in composition the artist faces is how he will position his subject and how he will effect the intended expression of form on paper.

Since particular value is placed on the beauty of white areas in Japanese ink painting, and on achieving brief and lucid expression through ink shading and rapid, strong brush strokes, composition plays an important part in *sumi-e*.

[A] *Good Composition*

1) Combination of three forms in the "host, guest and servant" (*shukakuju*) positions.

2) Composition in which large and small, major and minor, and so on are contrasted.

3) Composition showing stability of triangular form. Do not position the triangular form in the center of the paper. The triangular form should be of the scalene type in order to provide variation and a sense of movement.

4) Variation and movement can by produced through the use of "lightning flash" forms.

5) Perspective, the arrangement of foreground, middle ground and background, should be given careful consideration.

6) Vertical or lateral positions should be determined according to the nature of the subject.

7) Understanding of the beauty of white areas and space should be gained through intuition.

8) Acquire an understanding of composition for long, vertical surfaces. There is the traditional bird's-eye view and there is also the type of composition in which the eye is lead from point to point. A mountain, for example, is built up in receding stages, and the eye travels back through the composition in a rhythmical zigzag fashion.

[B] *Bad Composition*

1) Subject positioned in the center of the paper.

2) Subject positioned along a central horizontal or vertical line.

3) Subject positioned along diagonal lines crossing at the center.

2. SQUARE PAPER COMPOSITION

Select one element from a scene and plan the composition in such a way that the whole scene is suggested as being just beyond the outside edge of the paper. This permits the size of things to be represented and looseness of composition to be avoided.

A rhythmical composition that imbues the white areas with vitality and that emphasizes the main subject is desirable.

[A] Good composition

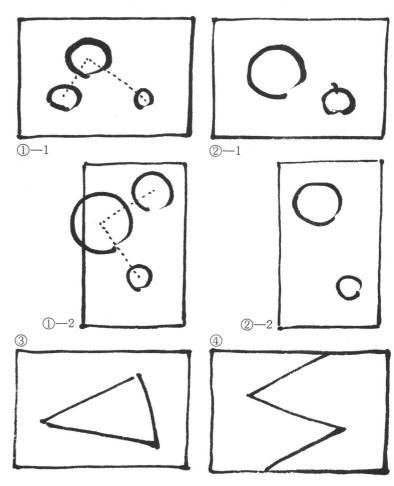

[B] Bad composition

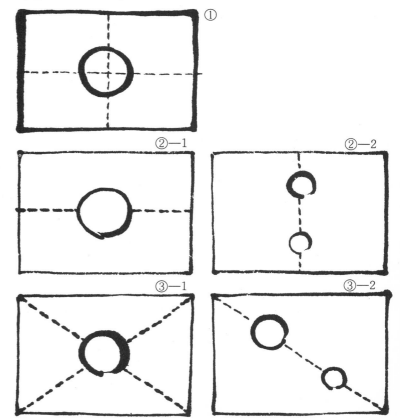

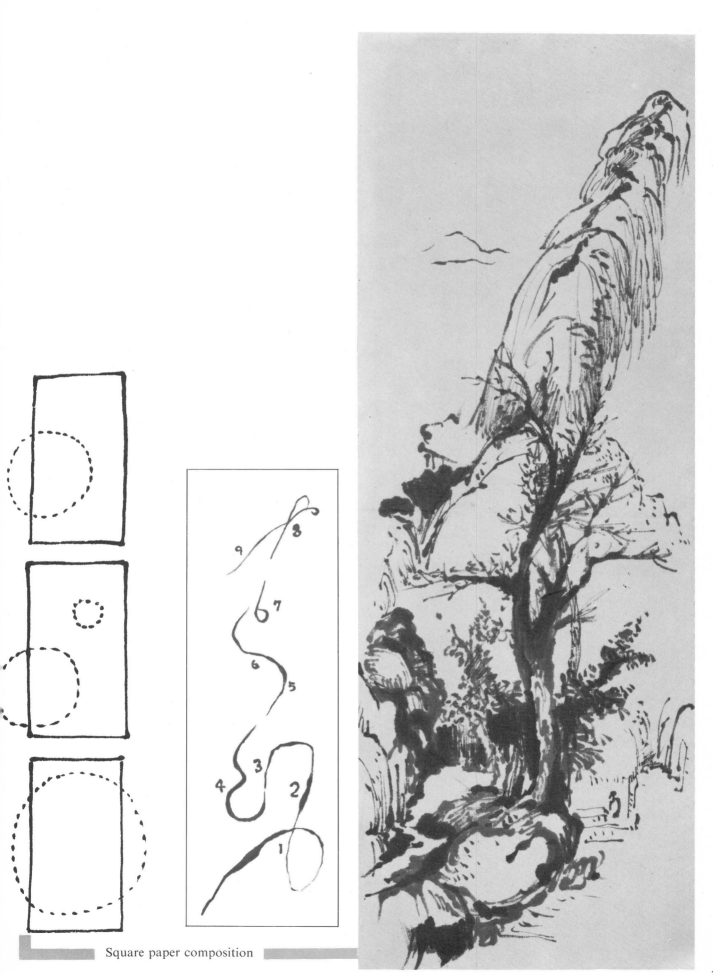

Square paper composition

Examples of *Sumi-e* Painting

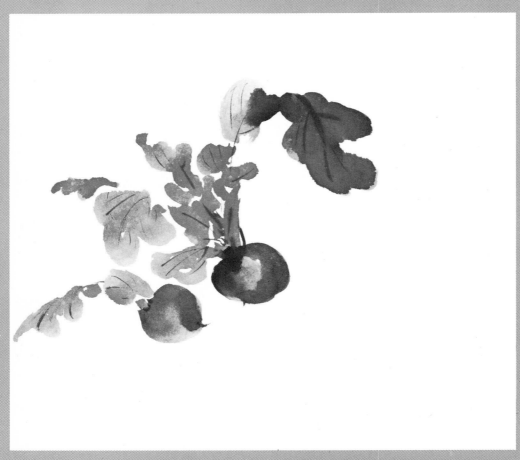

RED TURNIP

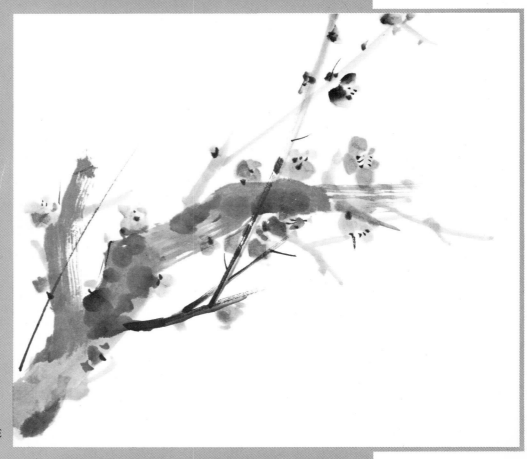

PLUM TREE

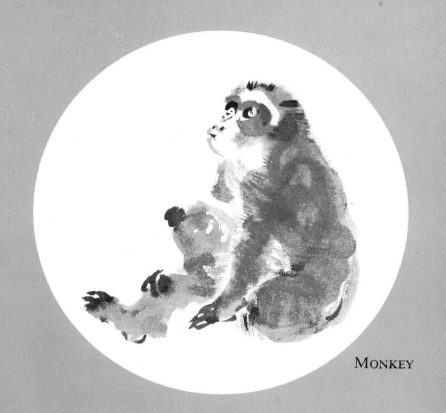

MONKEY

WISTERIA

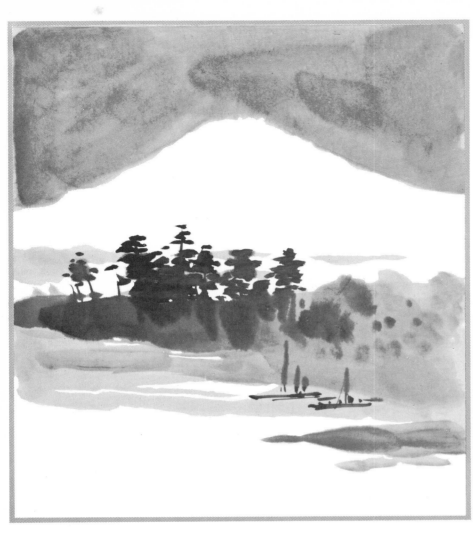

LANDSCAPE (Mt. Fuji)

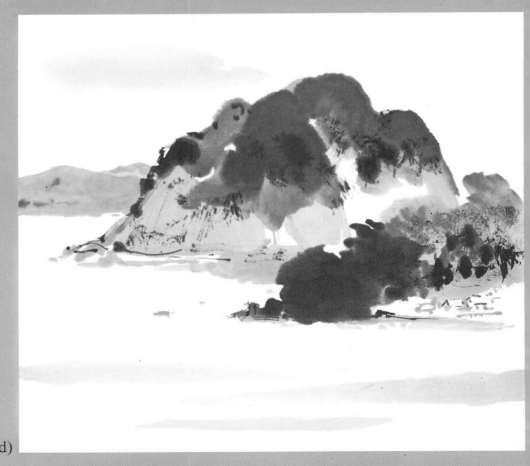

LANDSCAPE (Island)

40

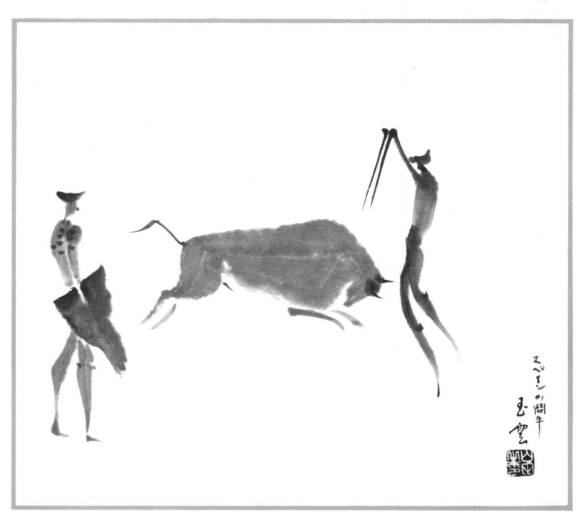

BULLFIGHT

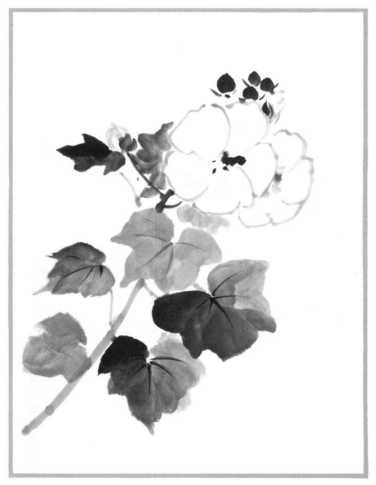

ROSE MALLOW

41

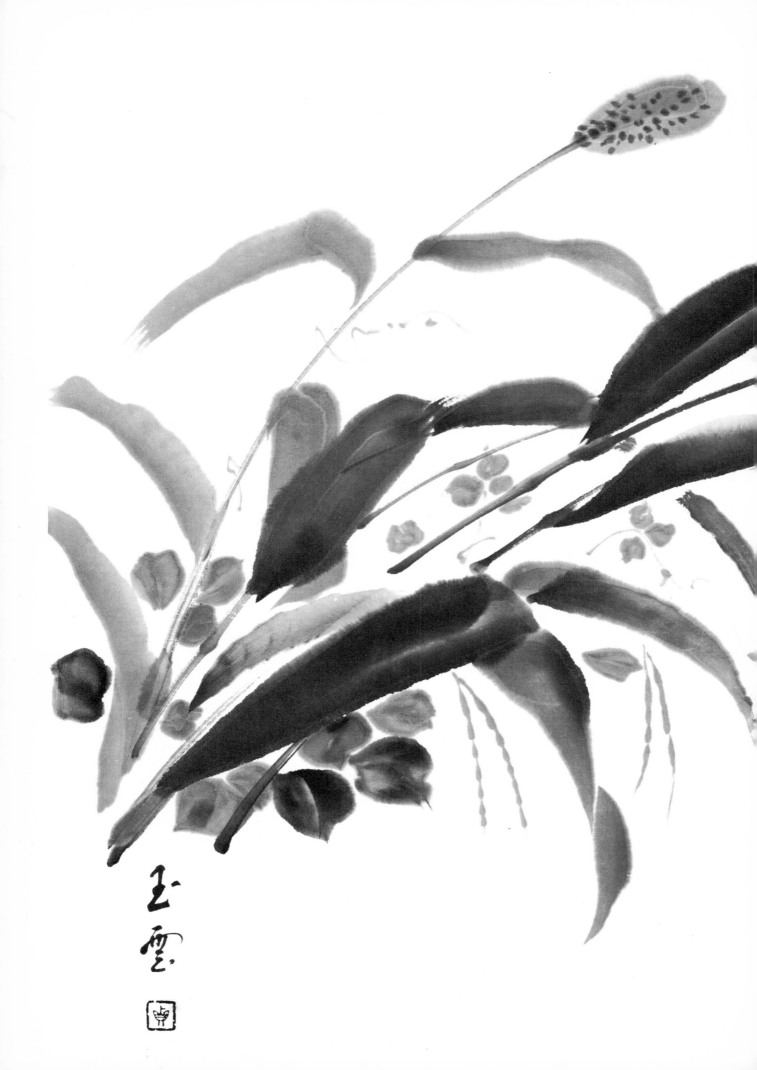

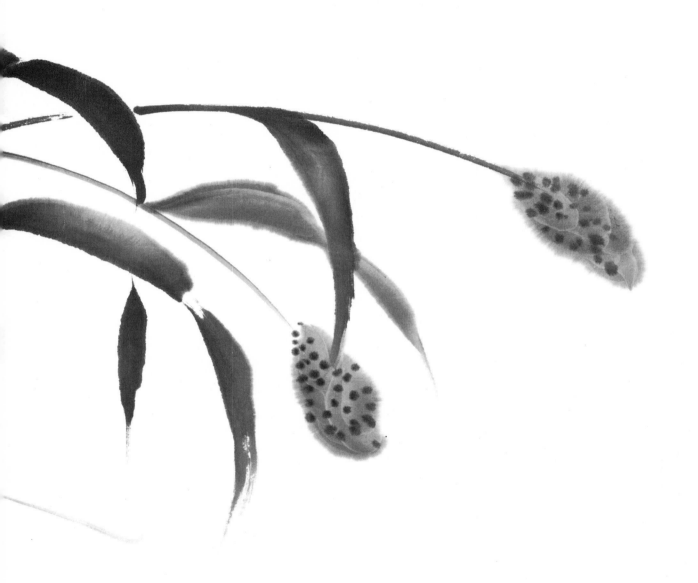

FLOWER

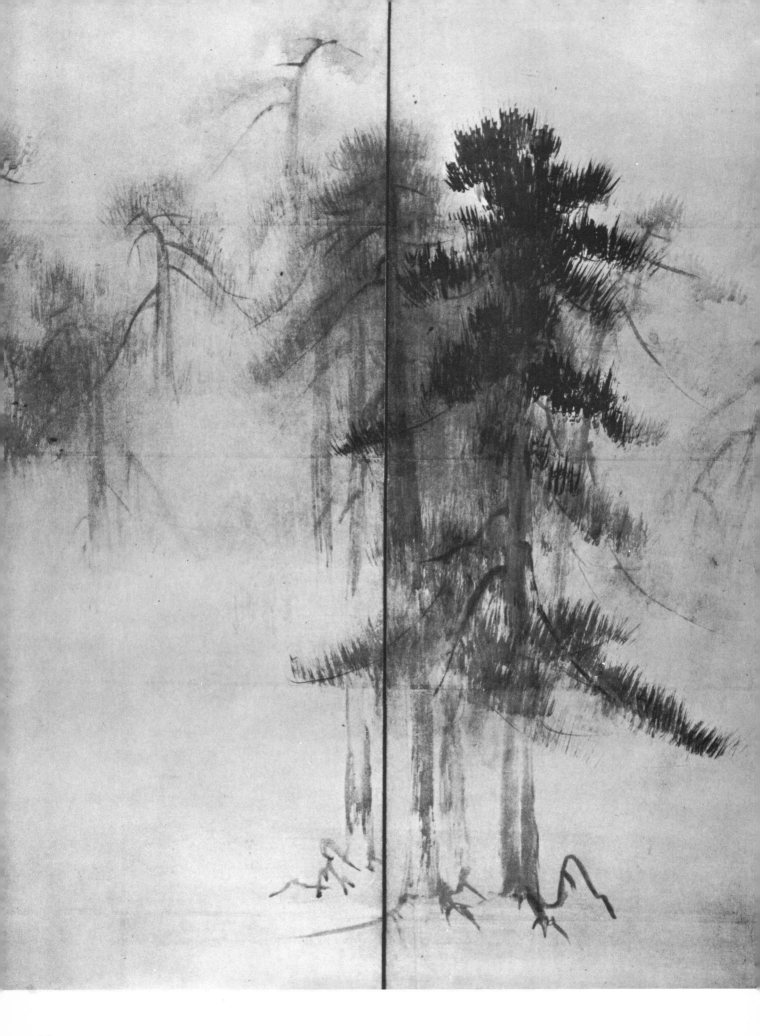

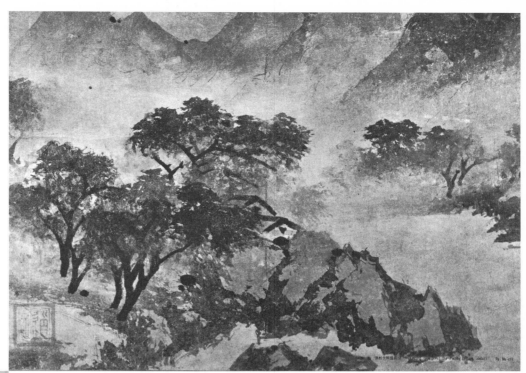

EVENING GLOW
OVER FISHING VILLAGE (*detail*)
by Mu-ch'i

The History of *Sumi-e*

If the term *sumi-e* could be applied to any painting in which only the ink known as *sumi* was used, the oldest paintings of the type in Japan that are still extant date from the Asuka (592–710) and the Nara (710–784) periods. These paintings are of the outline type known as *hakubyo*. Compared with the Chinese *suiboku-ga* (water-and-ink paintings), which have as their most important characteristic the variation of shadings within the monochromatic medium, the *hakubyo* paintings can not perhaps be considered in the same category.

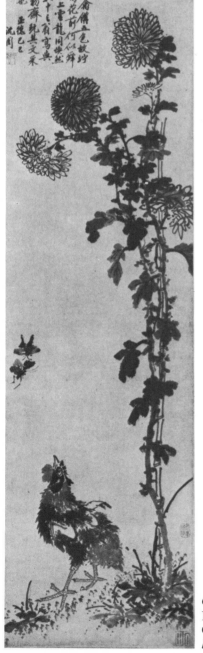

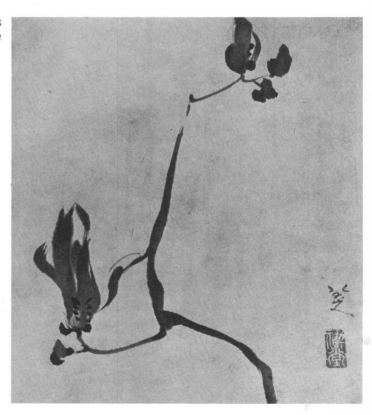

MAGNOLIAS
by Pa Ta Shan Jen

COCK
BENEATH
CHRYSANTHEMUMS
by Shen Shih-tien

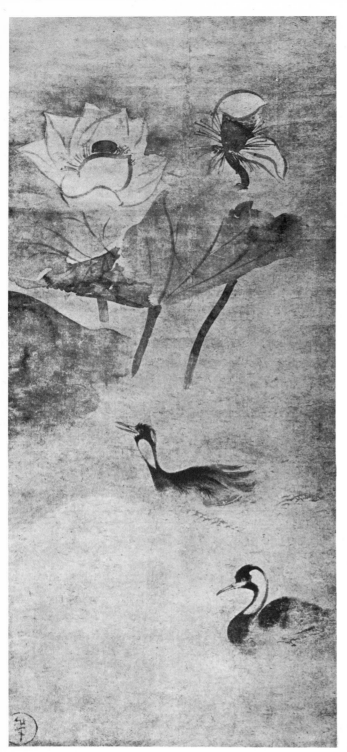

The two main schools of ink painting to make their appearance were the *Hokuju-ga* and the *Nanju-ga*. The former, called in English the "Northern School," founded during the T'ang period (618–907) by Li Ssu-hsiun and was followed by such illustrious painters as Chao Kan, Ma Yuan, Hsia Kuei, and Chang Yuan. Noted primarily for its strong, dignified strokes, the style called for the subjects being painted to be outlined in dark ink and then shaded.

The style was introduced into Japan along with Zen during the Muromachi period (1392–1572), from which time it flourished. Japanese Zen priests, who took up ink painting as a form of religious or philosophic expression, favored that form of the "Northern" style known as Sung-Yuan. Kao, Mincho, and Josetsu introduced new elements to formulate a Japanese-style *sumi-e* characterized by elegant simplicity and expressiveness and infused with the mystery of Zen philosophy. This type of painting was raised to even greater heights through the efforts of Shubun and Sesshu, both of whom produced many masterpieces. In works by Sesshu during his later years one can also see the influence of the *Nanju-ga* or "Southern School."

The *Nanju-ga* style also saw its beginnings in the T'ang period. It was founded by Wang Wei, who was followed by Tung Yuan, Chu Jan, and Mi Fei in the Northern Sung period and by the Four Great Artists, Huang Kung-wang, Wang Ming, Ni Yun-lin, and Wu Chen in the Yuan period. All contributed to the greatest epoch in the entire history of the style. The popularity of the style was further increased during the Ming period (1368–1644) by Shen Shih-tien, Wen Cheng-ming, Tung Chi-ch'ang, and during the Ch'ing period (1616–1912) by the Four Wangs (Wang Shih-min, Wang Chien, Wang Hui, and Wang Yuan-ch'i), Wu Li, and Yun Ke. The influence of these men on Japanese painters should not be overlooked.

In style, the paintings of the "Southern School" were calm and soft, with their poetic expression and intimate, friendly spirit contrasting sharply with the severe, sharp style of the "Northern School." Although these were the two orthodox schools, the Zen priests deviated from them and gave their

WATER FOWLS ON LOTUS POND
by Tawaraya Sotatsu

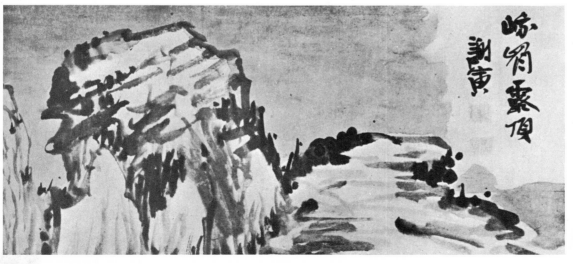

DEWY PEAKS OF EMEI SHA
by Yosa Buson

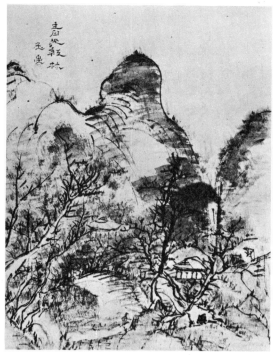

MOUNTAIN OF AUTUMN LEAVES
by Urakami Gyokudo

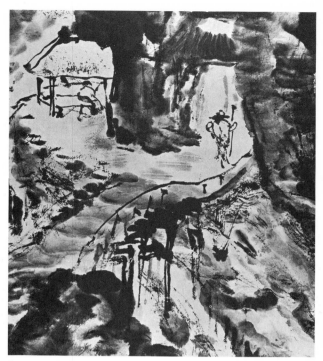

REFINEMENT (*detail*)
by Tomioka Tessai

works a rich originality and freedom of expression. Among them were Shih Ke (Northern Sung), Mu Hsi and Wang Chien (Southern Sung), Pa Ta Shan Jen, Wan T'ao and Shih Hsi (Ming), and Mei Ch'ing (Ch'ing). Free and original in expression, abundant in poetical sentiment, and rich in tonality, their style contributed much to the development of ink painting in Japan.

Influenced by the *Nanju-ga*, the "Literary" (*Bunjin-ga*) and "Southern" (*Nan-ga*) styles enjoyed a great popularity in Japan during the Edo period (1615–1868). It is common in Japan to use the term *Nan-ga*, which is not used in China at all, in referring to the Chinese "Literary" and "Southern" styles of painting without making any distinction between them. In China, the terms *Nanju-ga* and

Hokuju-ga were used only in connection with paintings of scenery (*sansui-ga*), but in their nearly synonymous Japanese usage they had a far wider scope, including birds-and-flowers paintings (*kacho-ga*) and other types as well as scenery paintings. Ike-no Taiga and Yosa Buson were the two greatest Japanese painters of the *Nan-ga* style and were largely responsible for its popularity. Among others who left great artistic works to posterity were Okada Beisanjin, Urakami Gyokudo, Aoki Mokubei, Chikuden, Buncho, and Kazan. Highly original achievements were left behind by painters of modern times, such as Hogai, Gaho, Gyokusho, Taikan, Tessai, Gyokudo, and Seiho. Their styles varied greatly from those of the great classical masters in China.

WHEEL OF LIFE (*detail*)　　*by Yokoyama Taikan*

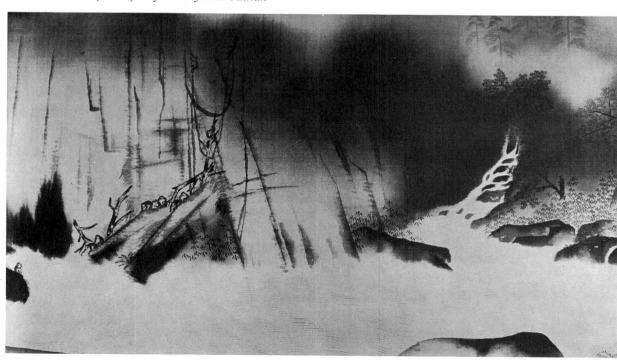

Painting Practice

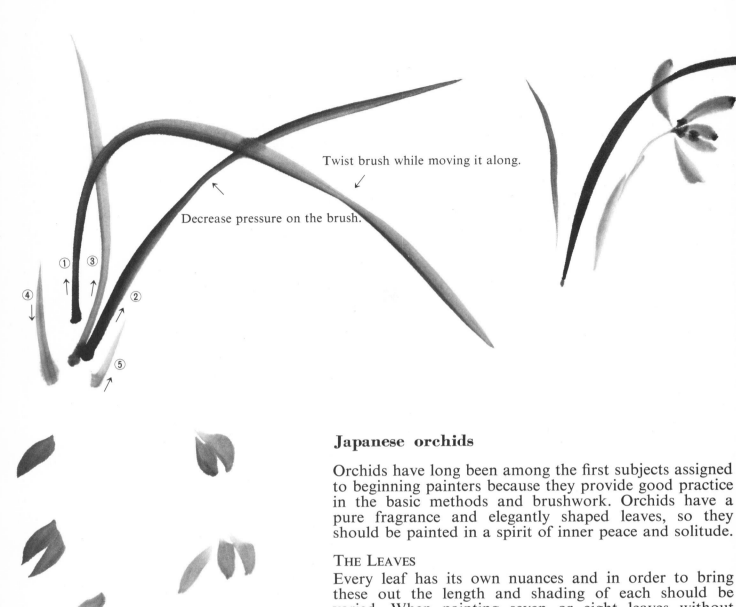

Twist brush while moving it along.

Decrease pressure on the brush.

Japanese orchids

Orchids have long been among the first subjects assigned to beginning painters because they provide good practice in the basic methods and brushwork. Orchids have a pure fragrance and elegantly shaped leaves, so they should be painted in a spirit of inner peace and solitude.

THE LEAVES
Every leaf has its own nuances and in order to bring these out the length and shading of each should be varied. When painting seven or eight leaves without recharging the brush, there will be almost no ink left in the brush at the time the last leaf is done. The gradation of tones created in this way will have a pure, natural effect.

Leaves are painted with upward strokes, as shown in the illustration.

THE FLOWERS
The brush is readied by first washing it and squeezing out the water with a cloth. Dip the tip in a suitable amount of water and then charge it with dark ink. Next work the brush in a dish to mix the water and ink properly, testing for the right intensity of color. Start painting only after the right color has been made.

All the flowers will be painted without recharging the brush. There are five petals, two pointed inward and three outward. First paint the two pointed inwards, as shown in the illustration, moving the brush toward the center of the orchid. Then paint the remaining three petals, doing the top one first, the left one second, and the bottom one last. Dark ink is used to paint the center of the flower, making three dots.

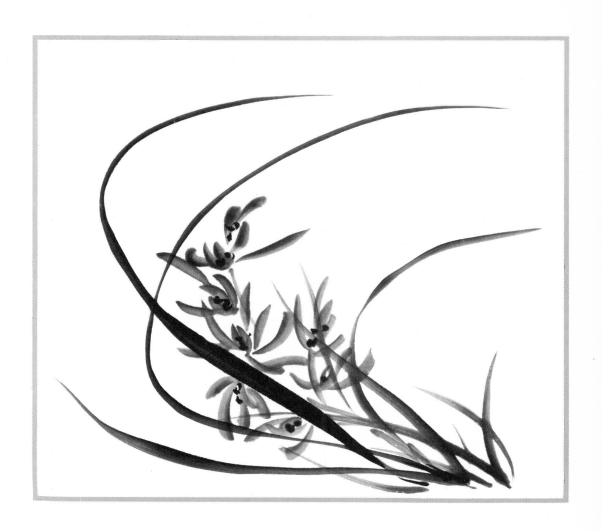

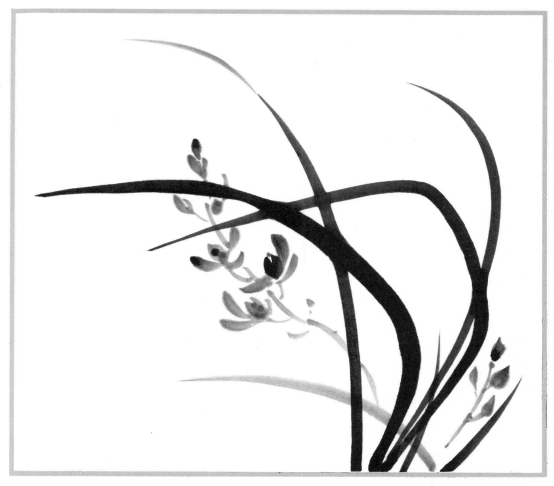

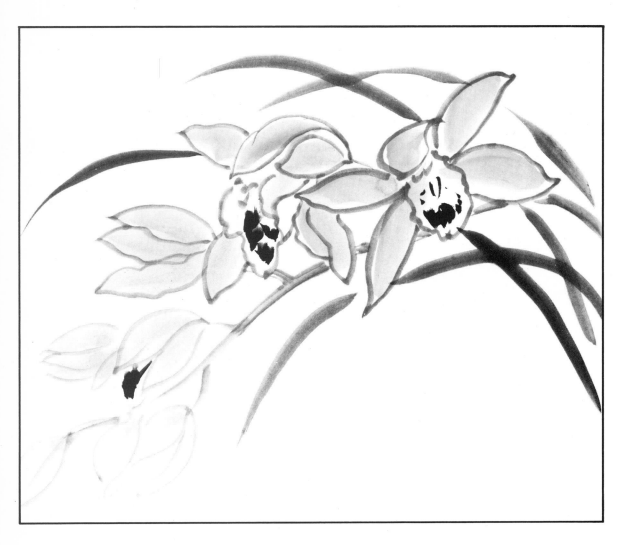

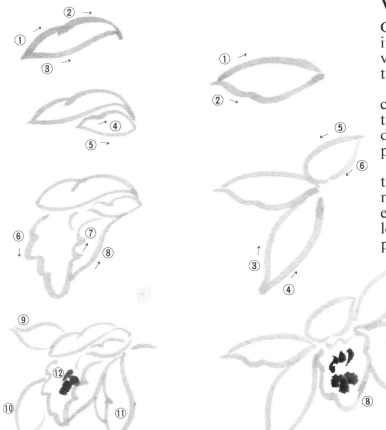

Western orchids

Compared with the Japanese orchids, those in the West are larger in size and greater in variety. The petals are outlined, as shown in the illustration.

Start by outlining the upper petal of the central flower, then do the center section of the flower directly below it. Proceed next to do the petals to the left and right. Finally, paint the stem and buds.

Before painting the leaves, wash the brush thoroughly and charge it using the three-ink method. Without recharging the brush, paint each leaf by moving the brush from right to left, being careful to give each leaf its own personality.

50

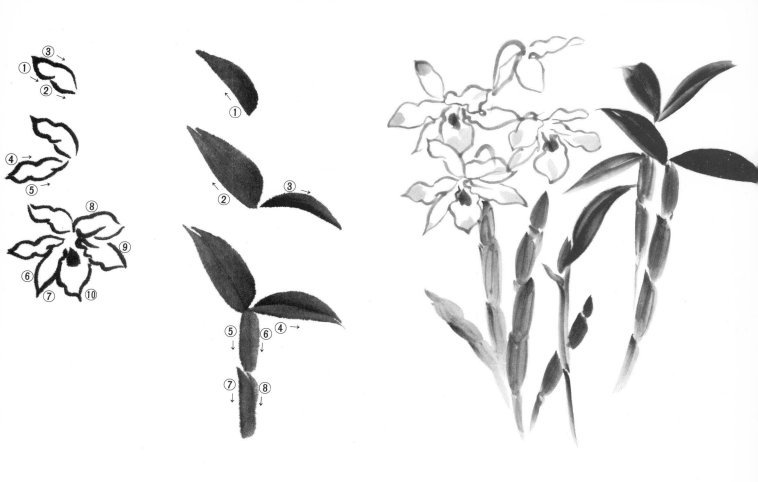

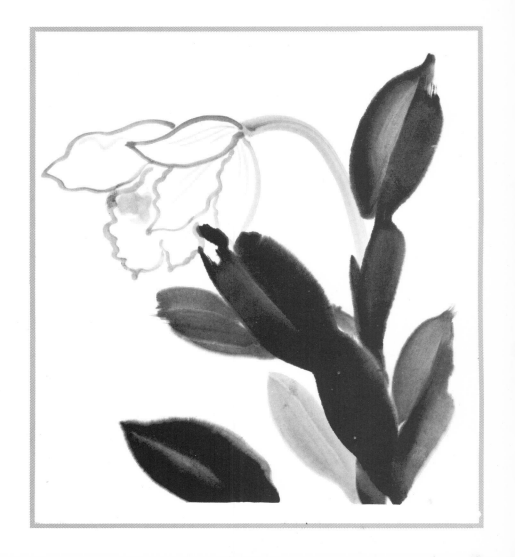

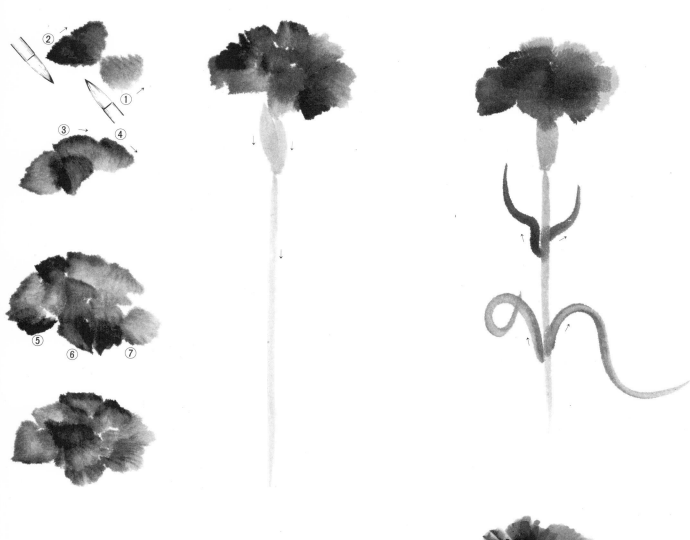

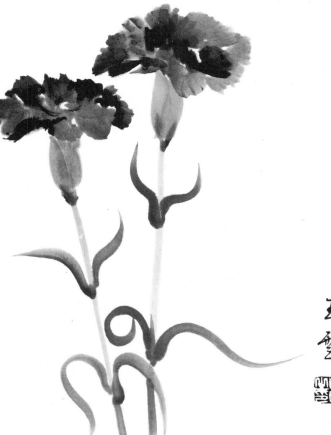

carnation

Before starting to paint the carnation, it is advisable to study the real flower closely in order to understand and grasp its essence.

After washing the brush well, charge it with the three intensities of ink—dark, medium, and light. Paint the petals holding the brush in the oblique position, as shown in the illustration, following the proper sequence and applying sufficient pressure to the brush to produce the desired effect.

Next, paint the calyx, the stem, and the leaves.

freesia

The freesia is a clean, pure flower with a wonderful fragrance. When painting one, it is first outlined and then, using ink of medium intensity, painted in such a way as to give it a slightly rounded appearance.

Start by painting the flower in the upper left hand corner, as shown in the illustration, then proceed to do the one on the lower right. Holding the brush in the upright position, next paint the stems in a single downward stroke. The smaller flowers are painted in the same way as the larger ones. A light intensity ink is used to accentuate the flowers.

The leaves are painted by holding the brush in the upright position and using a single downward stroke.

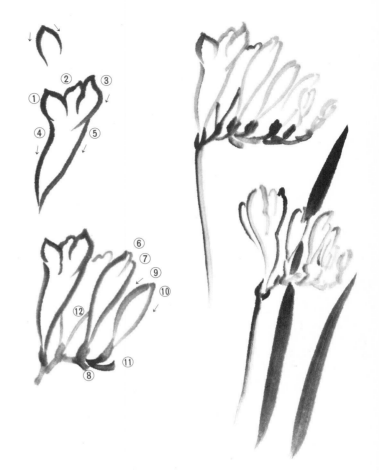

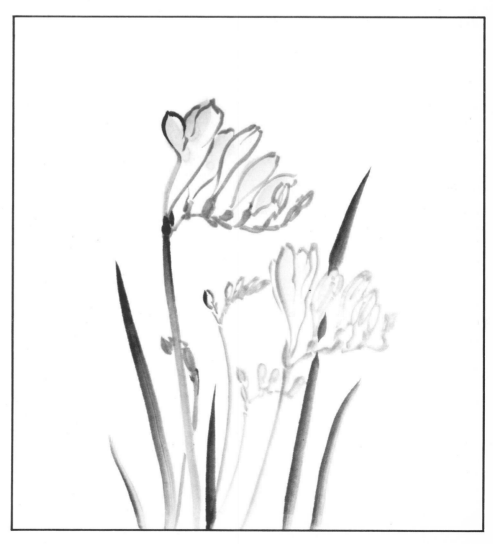

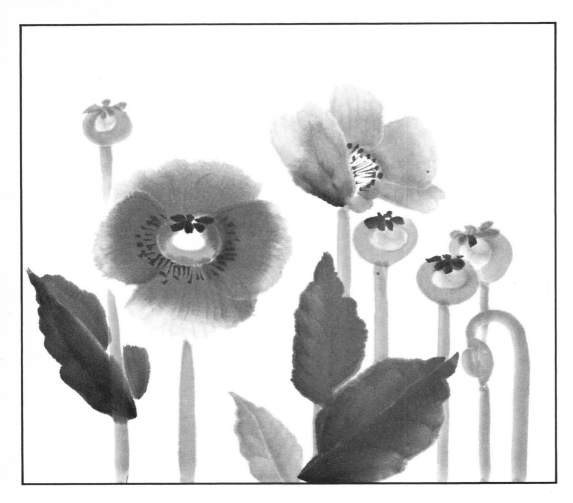

poppy

Before starting the poppy, wash the brush thoroughly and charge the lower part of the tip with medium ink, then dip the very tip in dark ink. Start by painting the petals. Using medium ink, first paint the center circle. The left and right petals are made by slanting the brush sideways, as shown in the illustration, with the tip facing the center and the brush moved in a circular motion. Sufficient pressure must be applied to get the desired effect. Use the same technique to paint the top and bottom petals, which are made to slightly overlap the left and right ones. Paint the seeds and stem and add the leaves, using dark ink.

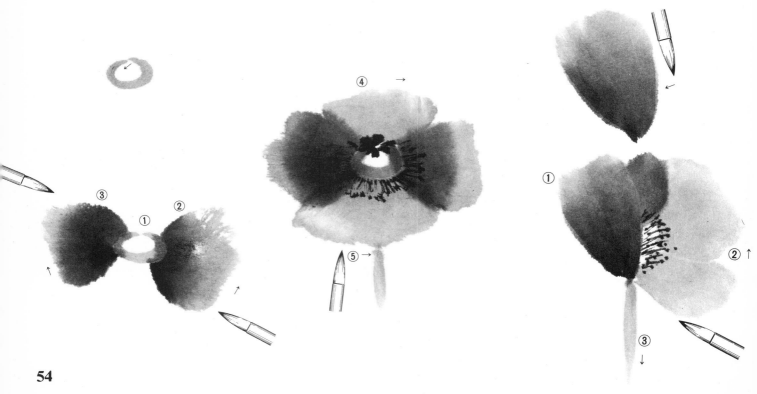

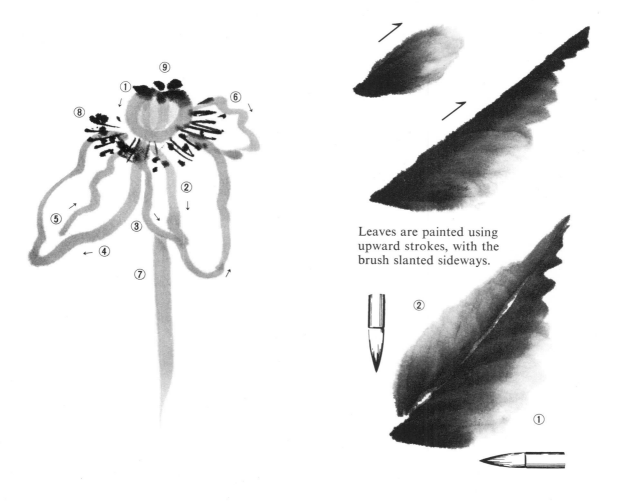

Leaves are painted using
upward strokes, with the
brush slanted sideways.

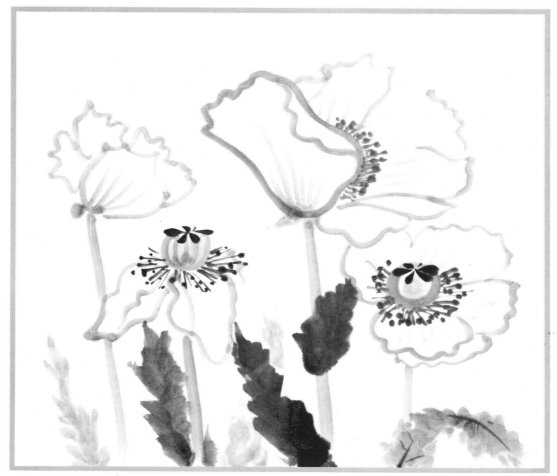

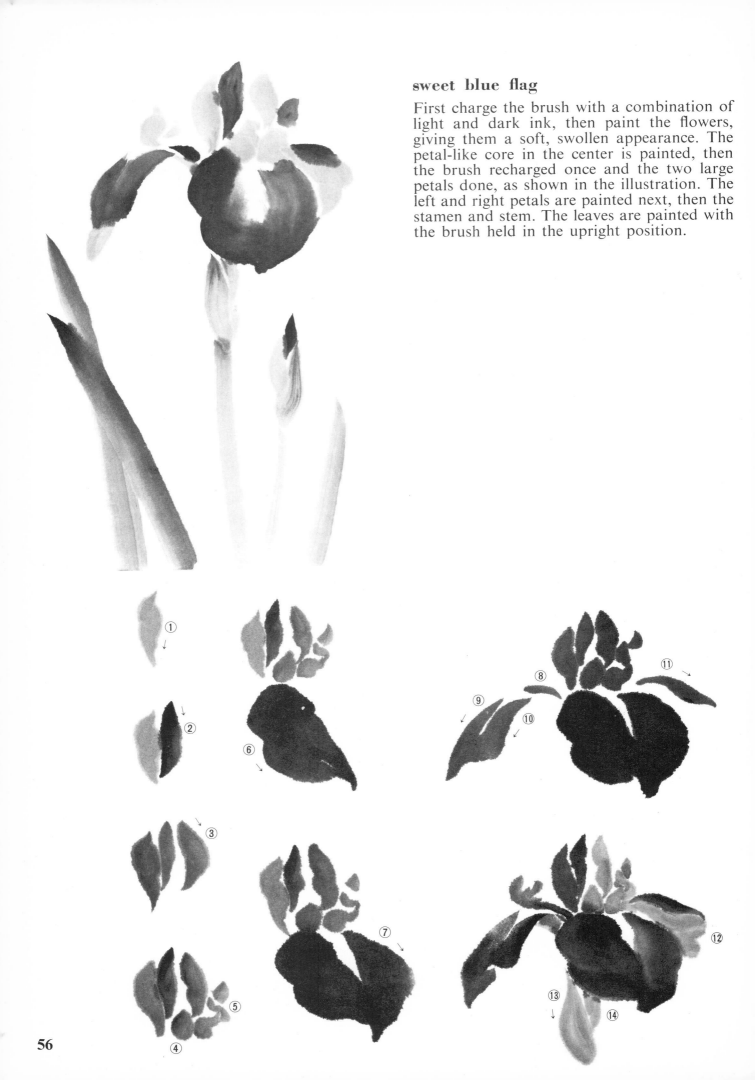

sweet blue flag

First charge the brush with a combination of light and dark ink, then paint the flowers, giving them a soft, swollen appearance. The petal-like core in the center is painted, then the brush recharged once and the two large petals done, as shown in the illustration. The left and right petals are painted next, then the stamen and stem. The leaves are painted with the brush held in the upright position.

56

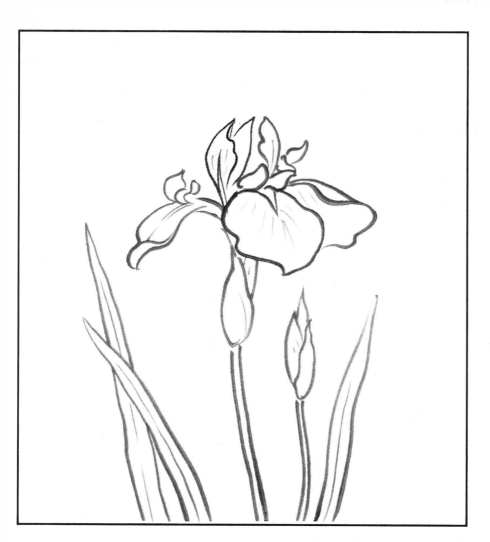

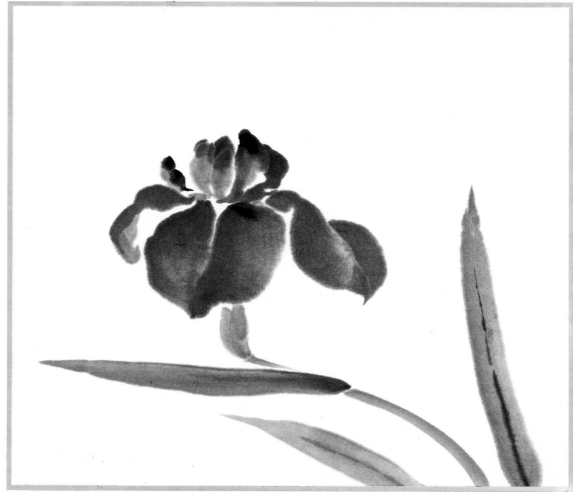

morning glory

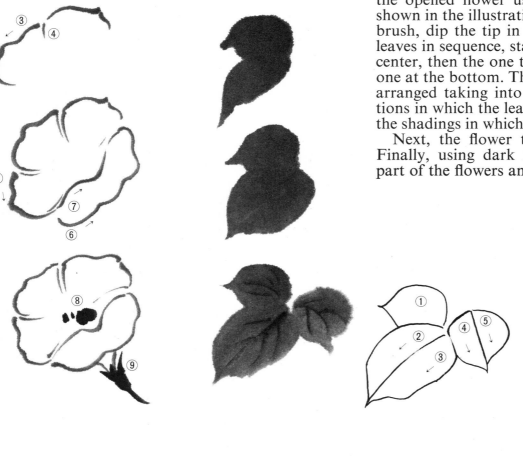

In painting the morning glory, the outline method is used for buds and flowers and the "boneless" method for leaves and stems. First charge the brush with medium ink and paint the opened flower using modulated lines, as shown in the illustration. Without washing the brush, dip the tip in heavy ink and paint the leaves in sequence, starting with the one in the center, then the one to the left, and finally the one at the bottom. The composition should be arranged taking into consideration the directions in which the leaves are to be pointed and the shadings in which they are to be rendered.

Next, the flower to the right is outlined. Finally, using dark ink, paint in the center part of the flowers and the leaf veins.

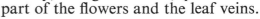

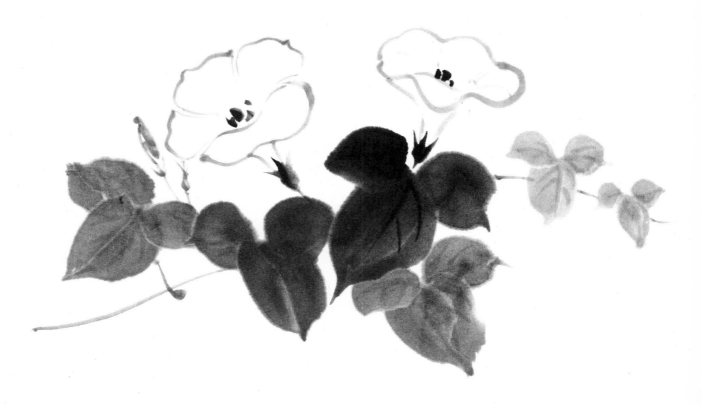

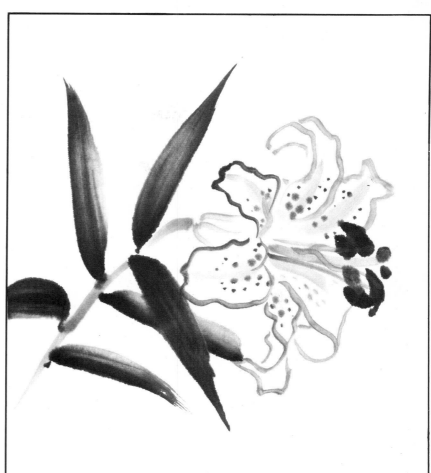

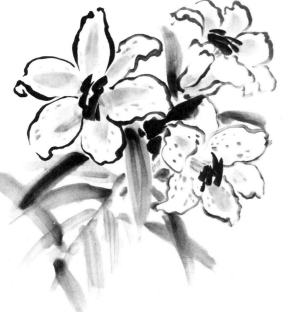

lily

The lily has six petals, three large inner and three small outer ones, as seen in the illustration. Charge the brush with medium ink and dip the tip in dark ink, then in sequence outline the large lily on the upper left, the one on the upper right, and finally the one on the lower right. It is necessary to give the lines variety through modulation and shading. When shading is added the whiteness of the lilies will stand out.

Charge the brush using the three-ink method to paint the leaves. First paint those nearest the flowers, then those farther away, without recharging the brush. The leaf veins are added with fine strokes. Complete the painting by putting in the stamen and pollen and dotting the petals with dark ink.

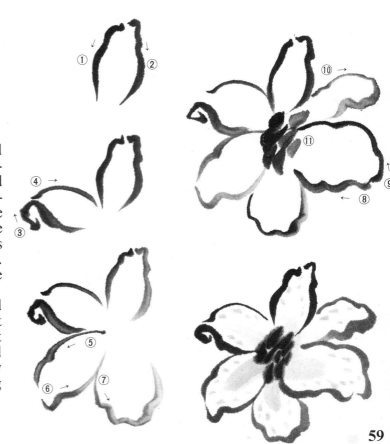

59

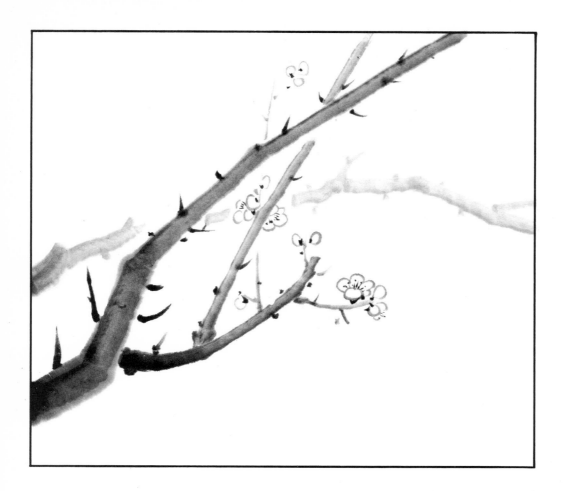

plum branch and blossoms

PAINTING THE BLOSSOMS

Charge the brush with medium ink and paint the five petals, as shown in the illustration. forming each with a half circle that is neither too pointed nor too rounded. Use dark ink to paint in the stamens and the calyces, making the latter somewhat pointed. Take care to give variation to the flowers, particularly in regard to the direction in which they point and to the size of the buds. Avoid painting two adjoining flowers or buds so that they point in the same direction.

To paint these or red plum blossoms as they would appear in the evening, use light ink for the petals, dark ink for the stamens, and calyces.

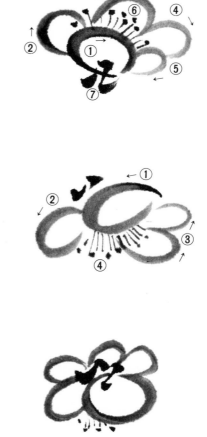

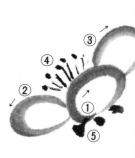

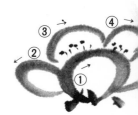

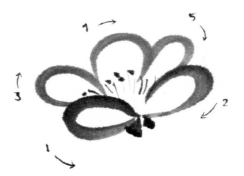

PAINTING THE BRANCHES

The brushwork should be of the kind that will give the branches a rough, thorny appearance, so do not move the brush too fast. Vary the width and length, the shading, the direction, and the angle of the individual strokes. Work out the composition of the painting so that the branches will cross.

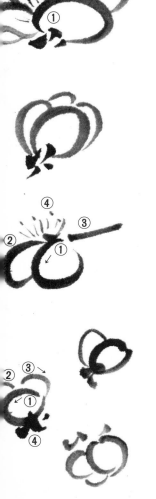

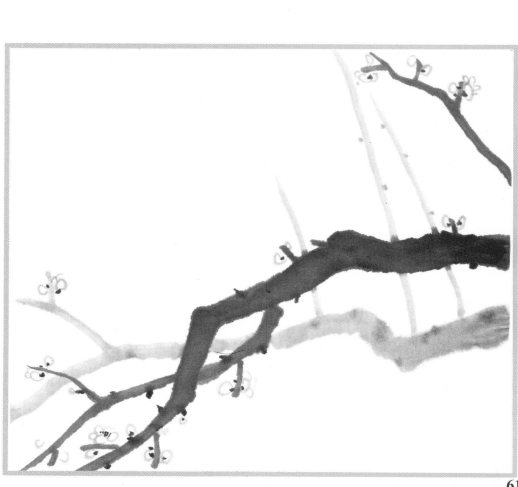

61

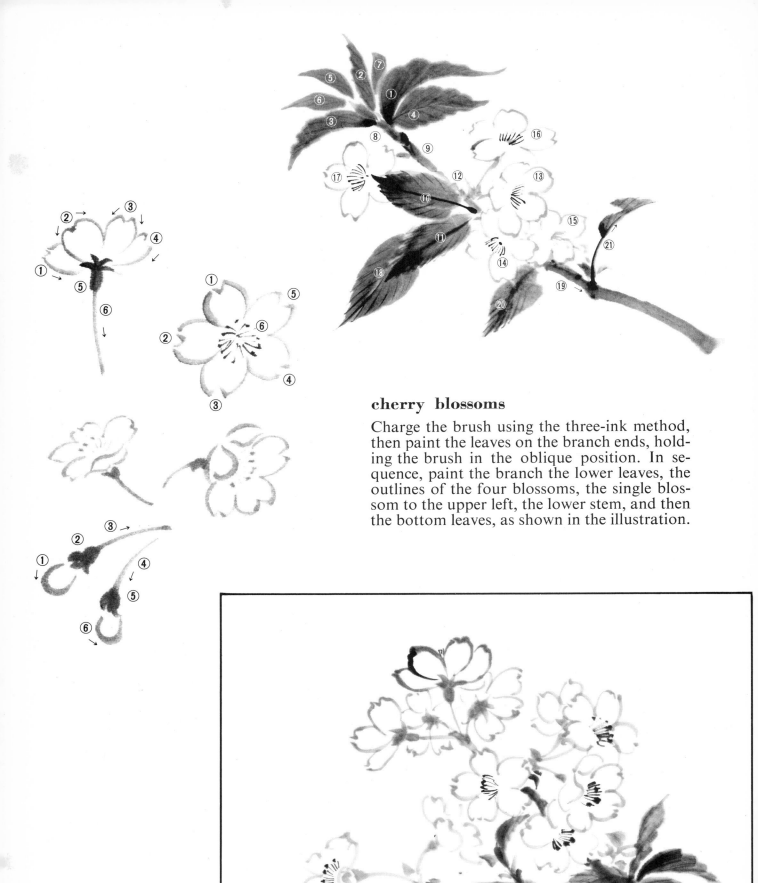

cherry blossoms

Charge the brush using the three-ink method, then paint the leaves on the branch ends, holding the brush in the oblique position. In sequence, paint the branch the lower leaves, the outlines of the four blossoms, the single blossom to the upper left, the lower stem, and then the bottom leaves, as shown in the illustration.

camellia

Camellia leaves are formed using two strokes of the brush. Once the technique has been practiced and mastered, the painting of other tree leaves should be very easy to do.

Wash the brush thoroughly, charge it to the middle with medium ink, and dip the tip in dark ink (three-ink method). Holding the brush in the upright position, touch the tip to the paper, pull the brush down to the oblique position in the middle of the stroke, and then return it to the upright position to finish out the tip of the leaf. This technique is shown in the illustration.

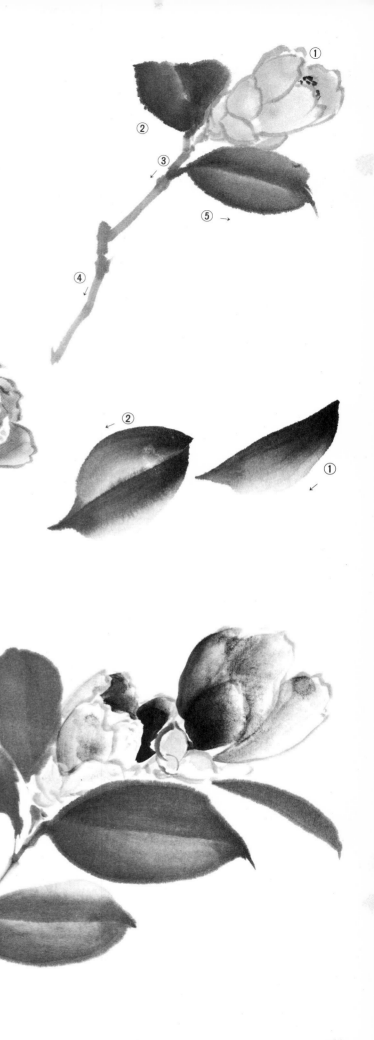

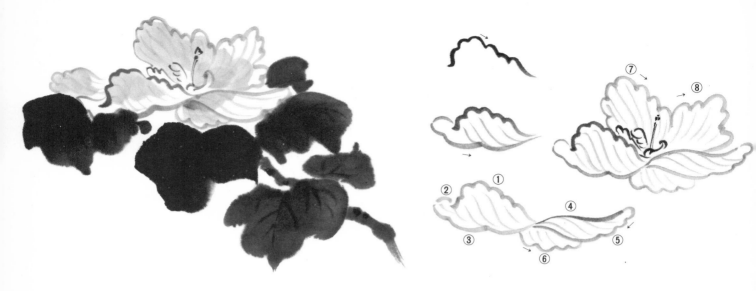

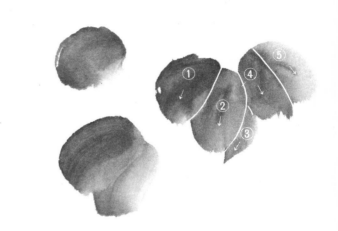

rose of Sharon

Charge the brush with light ink and then dip the tip in medium ink. Start by painting the petals, as shown in the illustration. Next paint the dark leaf overlapping the flower in front, proceed to the left and right leaves, and then do the bottom leaf and branch.

The veins of the leaves should be painted in before the ink applied previously dries completely. The flowers may be given touches of light ink or of red water color.

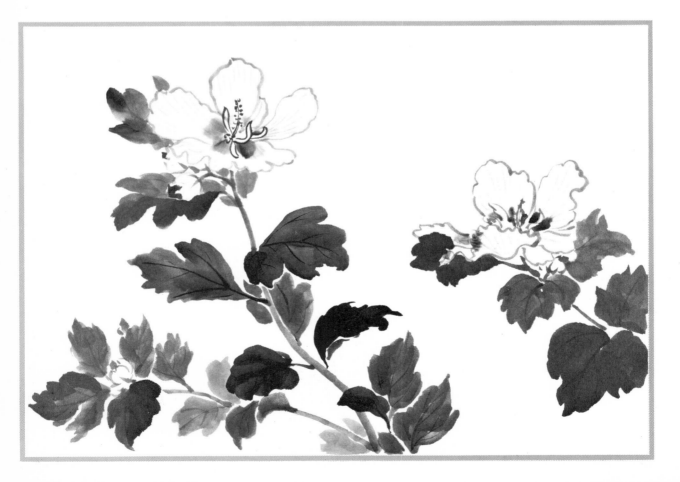

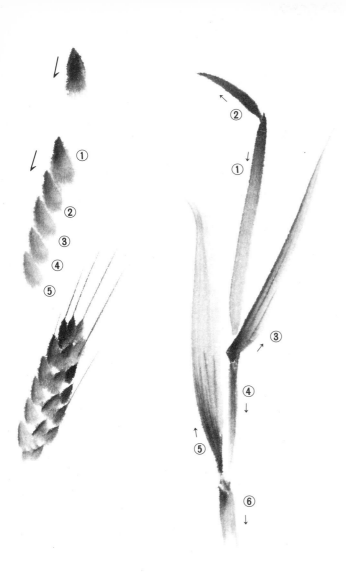

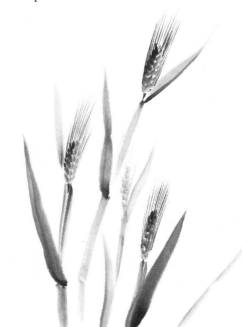

wheat

After thoroughly washing the brush and squeezing it as dry as possible with a cloth, charge it with medium ink and dip the tip in dark ink. Then start painting the ear of wheat, working from top to bottom in dotting strokes. Follow the sequence shown in the illustration. The stem is formed with downward strokes, stopping each stroke at the joint and then continuing on down the leaf.

To paint the spikes on the ears, first wash the brush and squeeze out the water, then dip the tip in dark ink and make spikes with strong, sharp strokes.

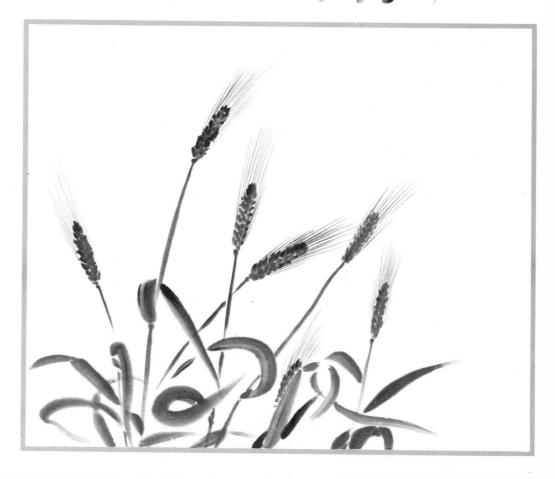

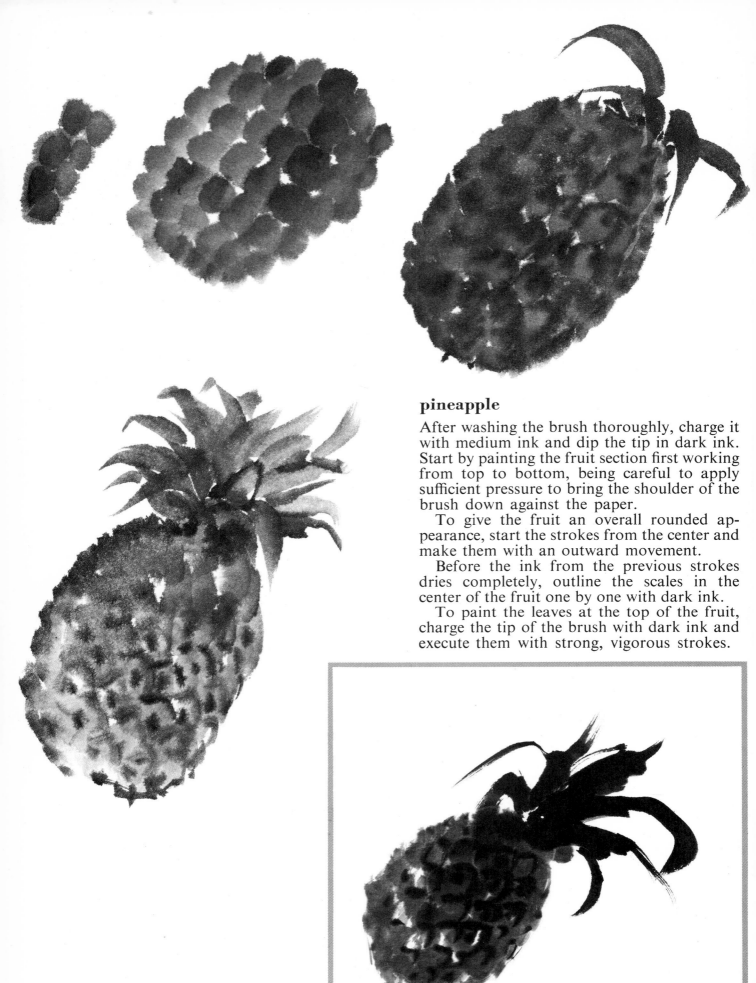

pineapple

After washing the brush thoroughly, charge it with medium ink and dip the tip in dark ink. Start by painting the fruit section first working from top to bottom, being careful to apply sufficient pressure to bring the shoulder of the brush down against the paper.

To give the fruit an overall rounded appearance, start the strokes from the center and make them with an outward movement.

Before the ink from the previous strokes dries completely, outline the scales in the center of the fruit one by one with dark ink.

To paint the leaves at the top of the fruit, charge the tip of the brush with dark ink and execute them with strong, vigorous strokes.

chestnuts

Charge the tip of the brush with dark ink and paint the chestnuts first, starting with those in the center and then those to the left and right, as shown in the illustration. Then, using light ink, paint the outside coverings, giving them a rounded appearance as seen in the illustration. To paint the spikes, first wash the brush and squeese it almost dry, dip the tip in dark ink, and then paint the spikes with strong, sharp strokes.

strawberries

After washing the brush thoroughly with water, charge the lower part with medium ink and then dip the tip in dark ink. Paint the berries, applying sufficient pressure to produce the desired appearance. Next, with dark ink, touch in the spots and the calyx. The arrangement of the strawberries should be kept firmly in mind in regard to the composition as a whole.

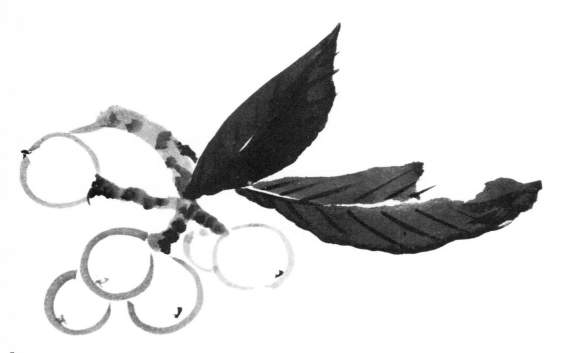

loquats

Charge the brush with light ink and dip the tip in dark ink. Start the painting by outlining the loquats. Next, paint in the stems, as shown in the illustration. To paint the leaves, charge the brush with medium ink and then dip the tip in dark ink. The brush should be recharged once while painting the leaves. Finish the leaves by painting in the veins with dark ink, using strong strokes. The dark knobs on the stems are added using a medium ink before the previously applied ink has dried completely. This produces a three-dimensional effect.

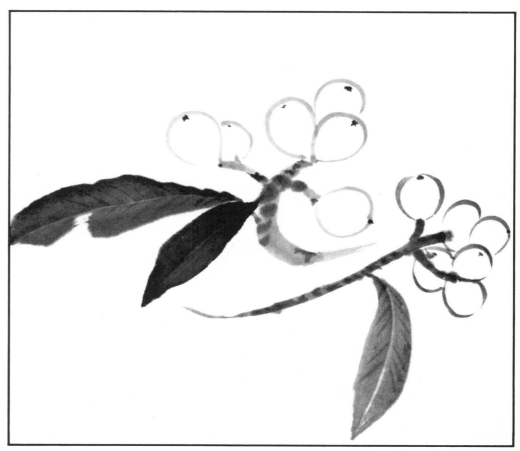

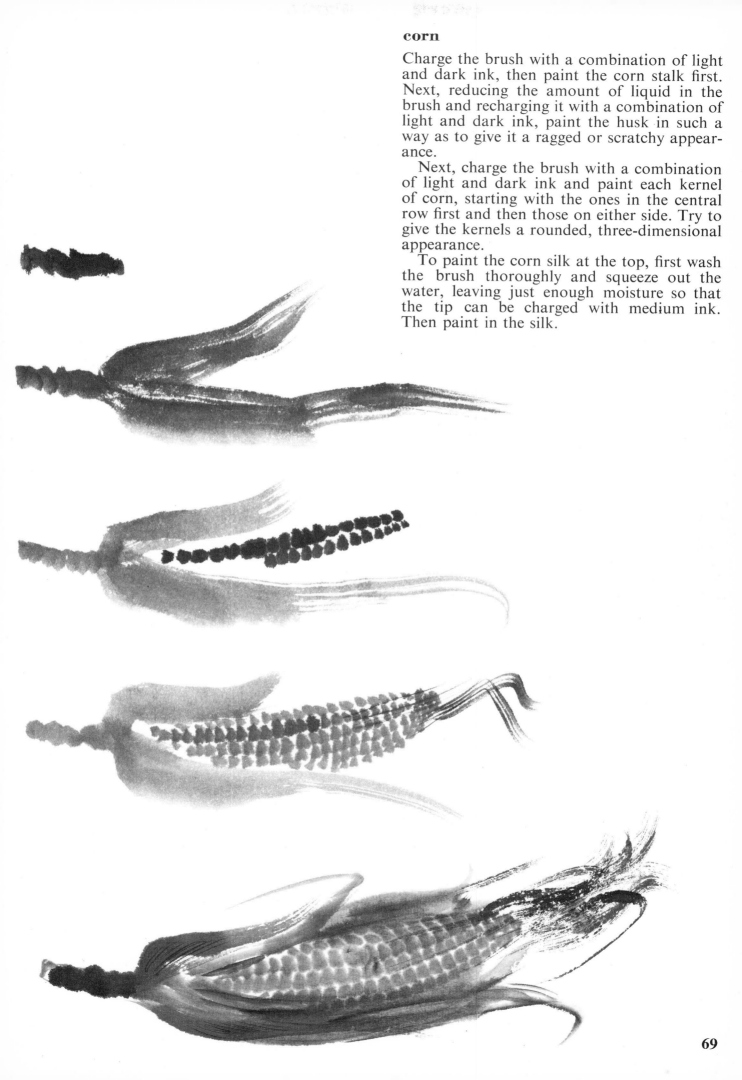

corn

Charge the brush with a combination of light and dark ink, then paint the corn stalk first. Next, reducing the amount of liquid in the brush and recharging it with a combination of light and dark ink, paint the husk in such a way as to give it a ragged or scratchy appearance.

Next, charge the brush with a combination of light and dark ink and paint each kernel of corn, starting with the ones in the central row first and then those on either side. Try to give the kernels a rounded, three-dimensional appearance.

To paint the corn silk at the top, first wash the brush thoroughly and squeeze out the water, leaving just enough moisture so that the tip can be charged with medium ink. Then paint in the silk.

Examples of *Sumi-e*

CORN AND CHESTNUTS

MILLET

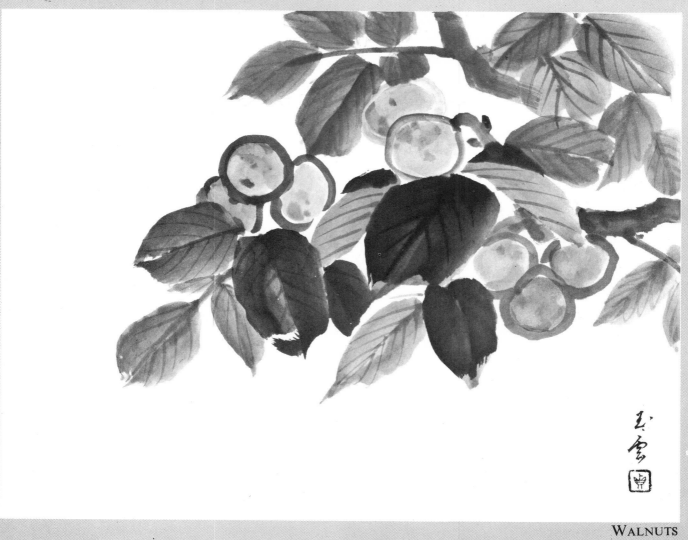

WALNUTS

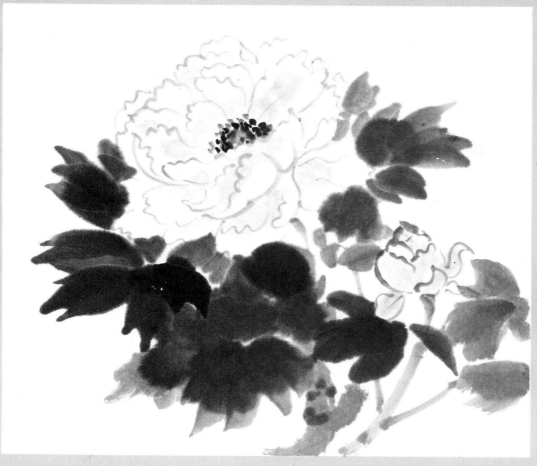

PEONIES

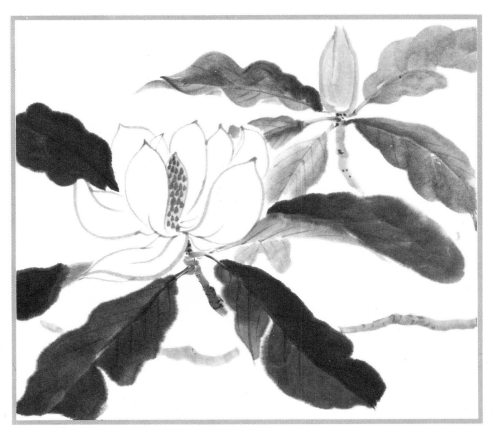

MAGNOLIA

PERSIMMON TREE

72

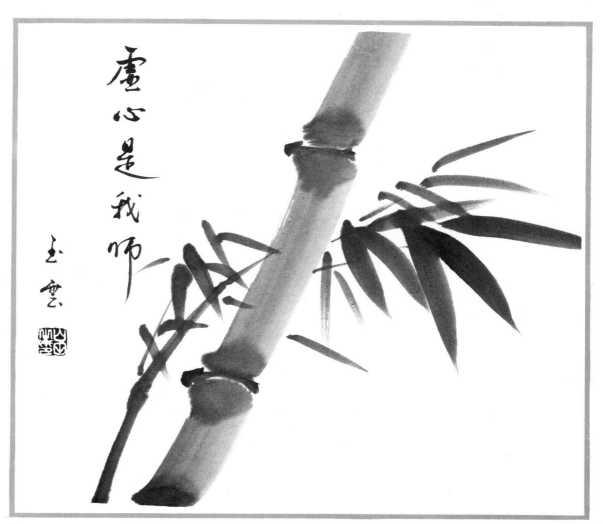

虚心是我师

玉云

Bamboo

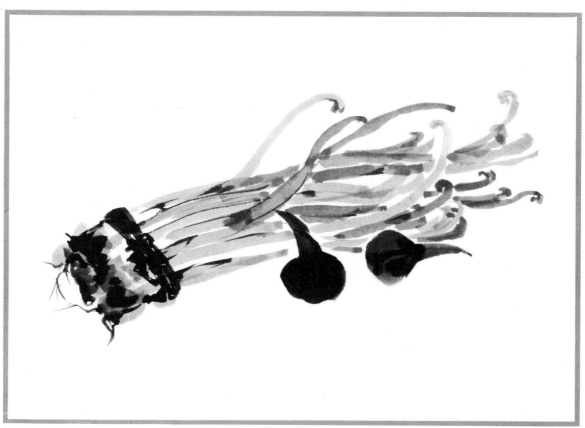

Leeks

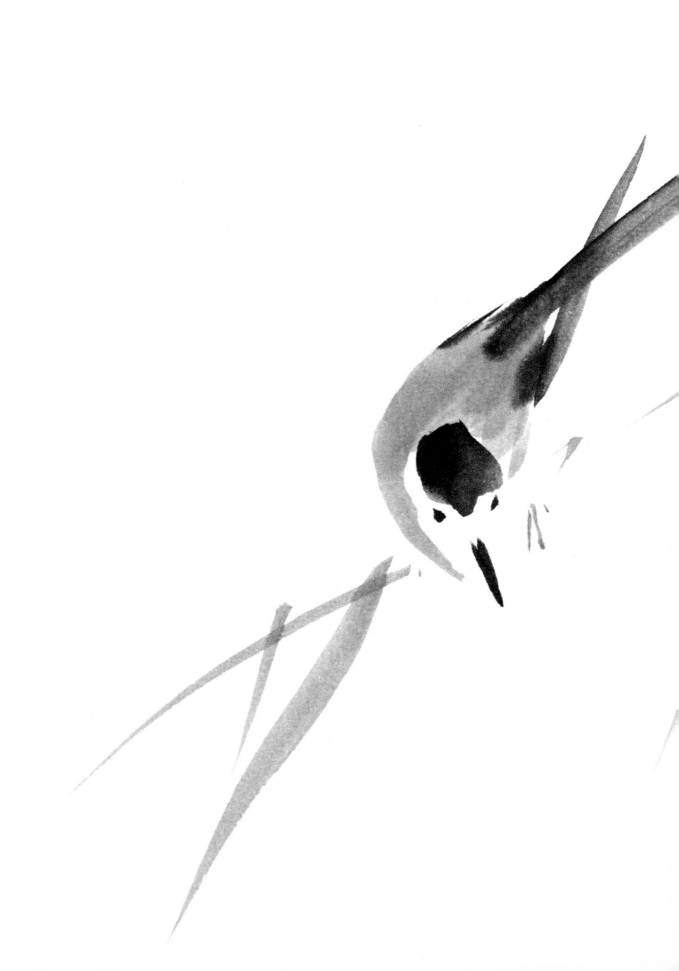

ANIMAL

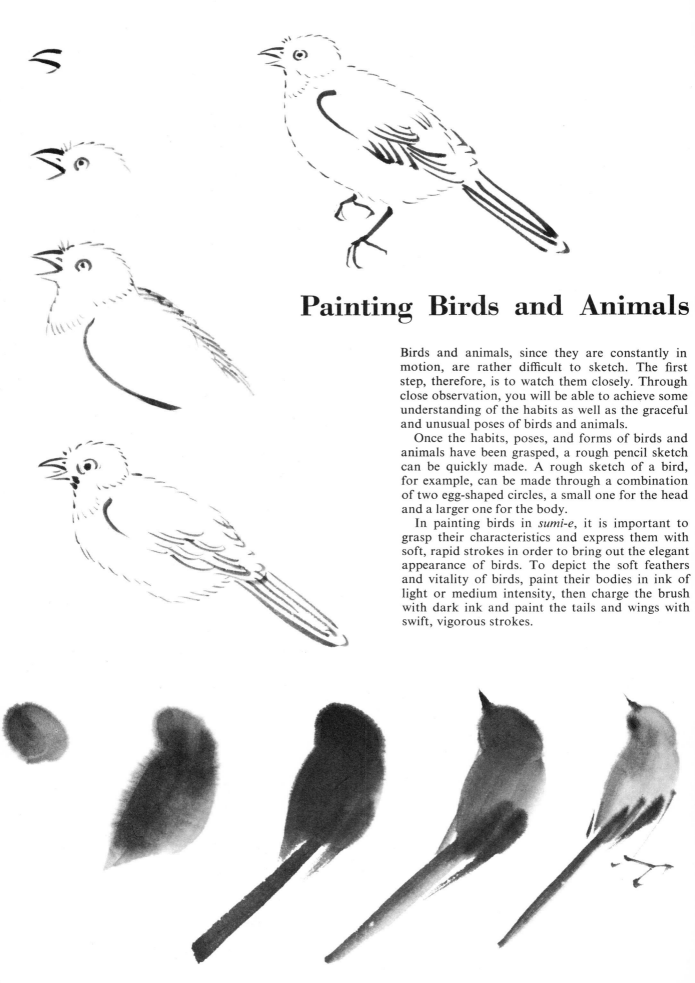

Painting Birds and Animals

Birds and animals, since they are constantly in motion, are rather difficult to sketch. The first step, therefore, is to watch them closely. Through close observation, you will be able to achieve some understanding of the habits as well as the graceful and unusual poses of birds and animals.

Once the habits, poses, and forms of birds and animals have been grasped, a rough pencil sketch can be quickly made. A rough sketch of a bird, for example, can be made through a combination of two egg-shaped circles, a small one for the head and a larger one for the body.

In painting birds in *sumi-e*, it is important to grasp their characteristics and express them with soft, rapid strokes in order to bring out the elegant appearance of birds. To depict the soft feathers and vitality of birds, paint their bodies in ink of light or medium intensity, then charge the brush with dark ink and paint the tails and wings with swift, vigorous strokes.

The way in which the legs and beak of a bird are painted is most important in determining how lifelike it will look. Thus, the legs should be studied closely and the tip of the brush used to depict the firm strength of a bird's legs, even though only fine strokes are used. Since the bird's posture will depend on how the legs are painted, care must be taken in regard to their position and angle. The angle in which the beak is painted determines the mood of the bird.

To paint animals using the *mokkotsu* or "boneless" method, first study the subjects closely and make pencil sketches of their various poses. The impression of liveliness is better achieved by sketching moving rather than sleeping animals. It is a good idea to first make a basic sketch on paper with charcoal.

Once the overall characteristics have been grasped and the painting of the animal commenced, it is important to keep in mind the ratio and balance of details when painting them in. There is a saying that goes, "Paint in the hair and you lose the form." Again, the way the face and legs are painted will determine whether the vigor of the animal is brought out or destroyed.

Occasionally, the technique known as *rempitsu* is used when depicting the soft appearance of an animal's hair. In the *rempitsu* technique, two or three medium-size brushes are joined to form a larger brush.

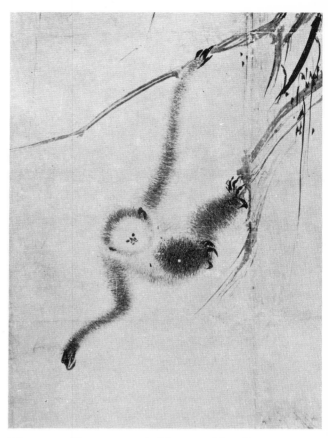

WITHERED TREES AND A MONKEY (*detail*) *by Hasegawa Tohaku*

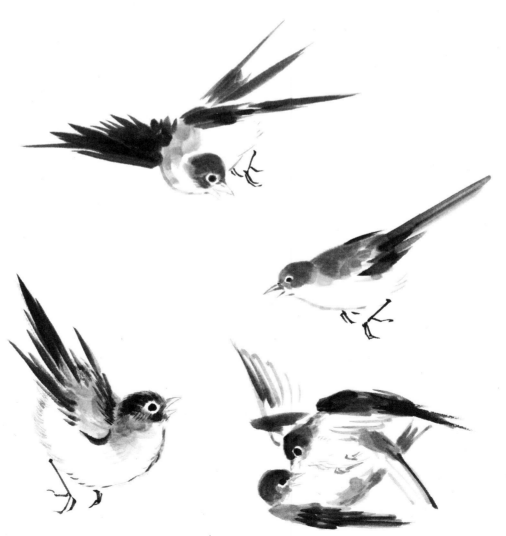

Observing, Understanding, and Painting *Sumi-e*

There are several important factors in ink painting. Shading is one. Another is the absorbency of the paper—the way the paper takes the ink and allows it to spread. Whether a true ink painting is created or not depends on how the brush is charged with ink, on how the tonality of ink is expressed with subtle brushwork, and on how the refined vitality of the subject is depicted.

Refined vitality is the hidden force in ink painting that draws the attention of viewers.

The unique beauty of ink paintings derives from a certain harmony created through the contrast of the whiteness of the paper and the blackness of the ink. From the scientific point of view, white is considered to contain all colors, but from our point of view, white is simply white. But black, on the contrary, hides within it various "colors." A bamboo depicted in monochrome ink, for instance, can be made to appear either light and dry, as on a fine day, or heavy and damp, as on a rainy day. At the same time, it can be made to express the complex inner mind of the painter. The complexity of black is the greatest among all colors, yet it is

also simple and capable of delicate expression in the hands of a painter.

Painting is an art in which the objects of nature are subjectively expressed through the character of the painter. For this reason, the way the object appears in the eyes of the painter and the way in which he grasps the nature of the object deeply influence the quality of the finished work.

A few examples will show how important it is to observe and grasp the nature of things. Some tree leaves are thin and soft, while others are thick and hard. Among flowers, certain blossoms look neat and innocent, others look gorgeous and full-blown, such as the peony. Verdant trees crowned with abundant leaves are unlike dead trees with their desiccated, severe appearance. Since all possess their own beauty and different characteristics, it is important to view them with a penetrating eye in order to grasp their true natures.

The painter should know and be able to use the various techniques for expressing the different characteristics of the objects he has observed. When painting a grapefruit or pumpkin, which

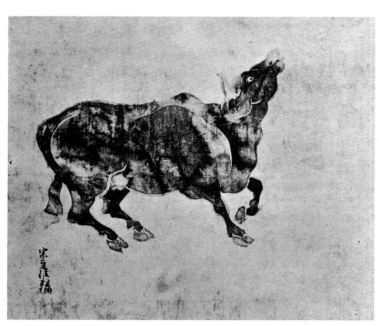

Cow (*detail*) *by Tawaraya Sotatsu*

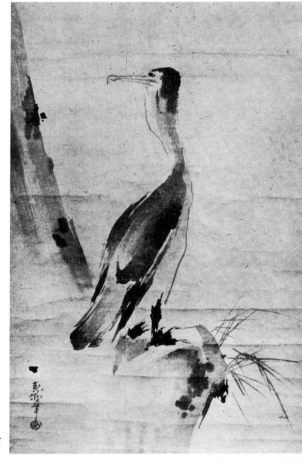

CORMORANT (*detail*) *by Miyamoto Musashi*

have thick skins and soft insides, for example, the technique differs from that used when painting apples, which have thin skins and hard flesh. Thick lines made with light ink are made when depicting the former, while comparatively thin strokes made with dark ink are made in the case of the latter. In this way, the diverse qualities of the subjects can be expressed effectively.

Another example of how technique determines effective expression is found in the painting of leaves. The different characters of flat leaves, thick leaves, and thin, soft leaves can be expressed depending upon the position of the brush (whether oblique or upright), the way it is charged, the speed of the various strokes, and the gradations of the ink. It is also important to develop an eye for seeing the proper direction in which flowers, fruit, birds, and so on are facing and to develop a sense for grasping the vitality even of still objects. Rhythmic variations in combinations of branches and leaves must also be considered carefully and given unity in their diversity. Perspective, ink shading, and the speed and strength of the strokes

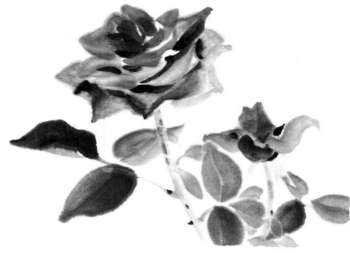

Gorgeous Flowers (Roses)

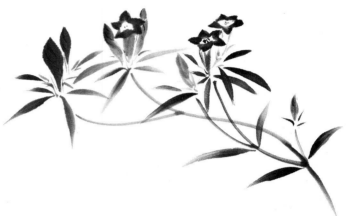

Pure Flowers (Gentian)

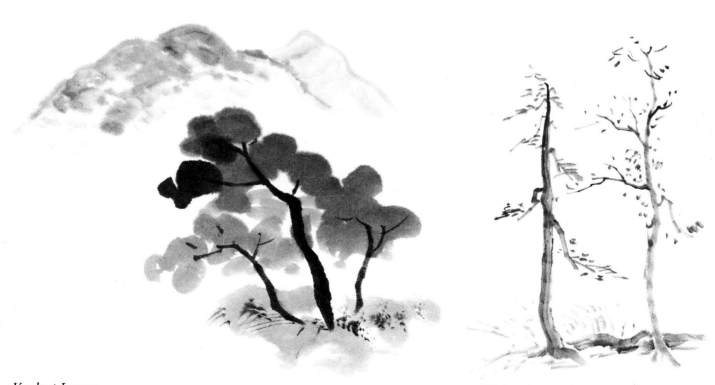

Verdant Leaves

Withered Leaves

Thick-skinned Fruit (Chinese Citron) ———————

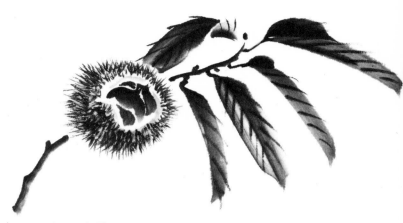

Thin-skinned Chestnut ———————

all combine to enrich through the color of the ink the feeling of the painting.

Unlike Western painting, where lightness and darkness are expressed through tonal variations of light and shade, ink paintings are given their sense of light through conceptual expression. The white of the background plays a significant part. In ink shading, dark ink is generally used when painting the subject in the center of the composition in order to give the subject a sense of vitality and motion.

To fully express the individual characteristics and vitality of the subject in ink painting, the two most important things are to first thoroughly study and make a sketch of the subject, then to paint it with abbreviated brush strokes. The key is

suggestion. When painting a pine, for example, you cannot express the true beauty of the tree merely by faithfully reproducing each branch in the painting. Simplification through the selection of only necessary branches and then painting them in such a way as to create the overall characteristic shape of the tree will allow the painting to suggest reality.

Before starting to paint, make as many detailed and faithful sketches as possible in your sketch-book in order to grasp the true nature of your subjects. Then simplify your subjects when painting *sumi-e*, giving them form with brief strokes. Close observation of the subject is essential in producing fine ink paintings.

Thick Leaves (Leeks)

Thin Leaves (Millet)

Painting Practice

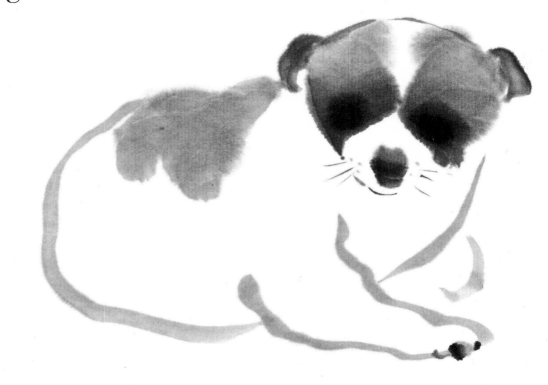

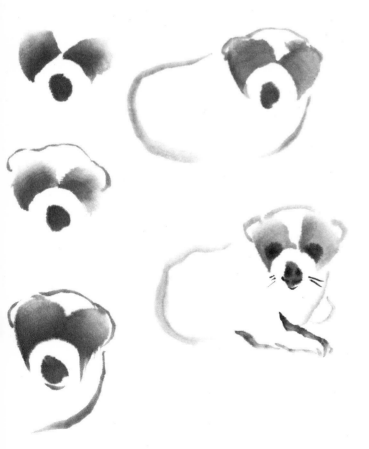

dog

With charcoal, make a light, rough sketch of the dog you are going to paint. Then charge your brush with ink of medium intensity and paint the nose and mouth. Next, dip the brush in light ink and paint the face with two strokes, holding the brush in the oblique position. The ears and head of the dog are painted with lines, using a light touch.

To paint the body, stroke in the chest, the back and the stomach. Next, paint the front legs and the spots on the back. Finish the painting by putting in the eyes, nostrils, and chin.

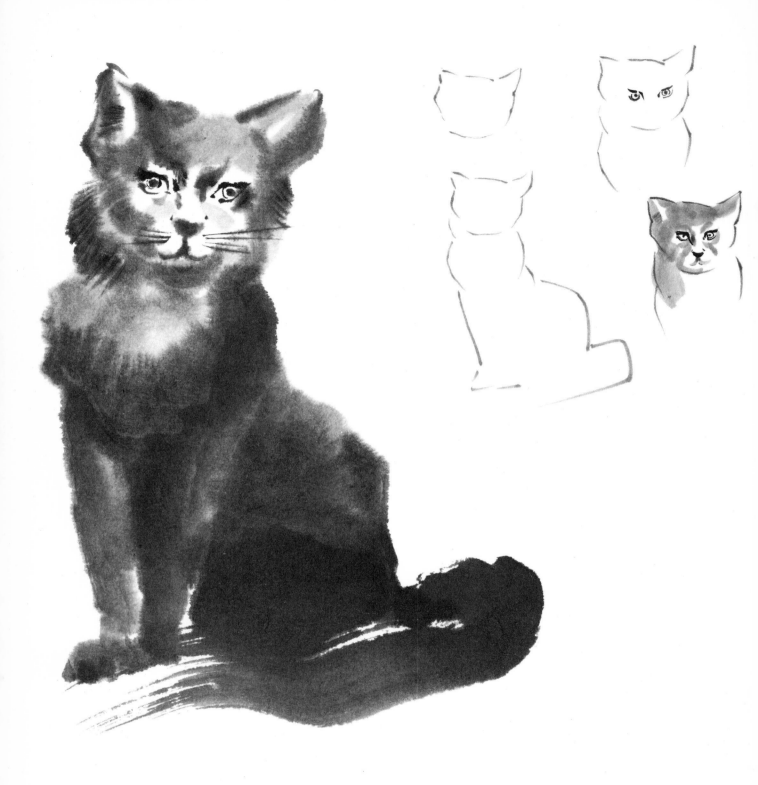

cat

Charge the brush with light ink and paint the line from the head to the chest, then continue on by painting the body and tail. Paint in the eyes with dark ink and the nose and mouth with medium ink. To give the cat a soft, furry look, first charge the brush with light ink and then dip it in medium ink. Holding the brush in a slanted position, make the appropriate strokes starting at the face and working down toward the chest. An appearance of furriness can be emphasized by making the strokes with only the tip of the brush. The spreading and blurring of the inks of different intensity will create the effect of softness usually associated with cats.

mice

Charge your brush with ink of medium intensity and paint the egg-shaped body, the triangular face, and ears, starting at the front. Next, add the hind legs and tail, bringing out the rounded effect of the tail with a vigorous stroke that is allowed to grow thinner toward the tip. Paint in the eyes and mouth with medium ink.

The mouse in the rear is painted by first charging your brush with medium ink and then painting the features in sequence—face, ears, back, and forelegs. Next, charge the brush with dark ink and paint in the mouth, eyes, ears, and legs, being careful to take into consideration the balance and form of the subject.

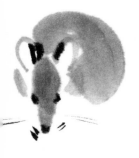

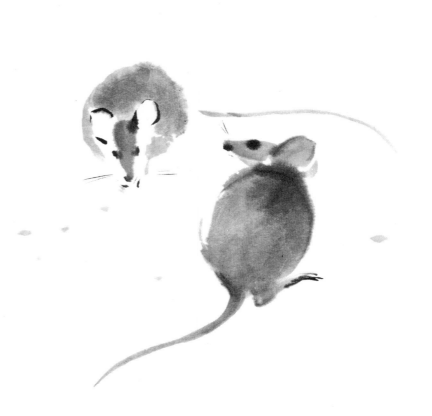

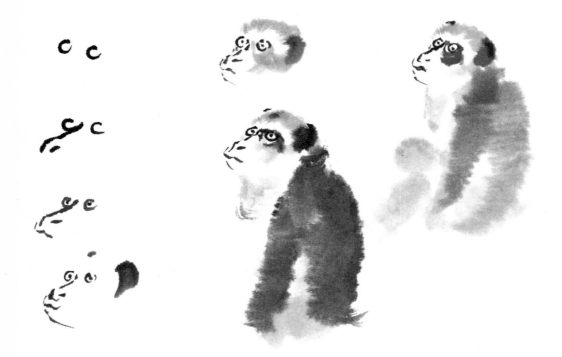

monkey

First, make a rough sketch with charcoal of the monkey to be painted. Then, using dark ink, paint the eyes, nose, mouth, and ears. To produce the furry effect of the head, face, arms, back, stomach, legs, and so on, hold the brush in the oblique position and make roughly spread strokes. To complete the painting, paint the fingers, heels, and hips with a brush charged with dark ink.

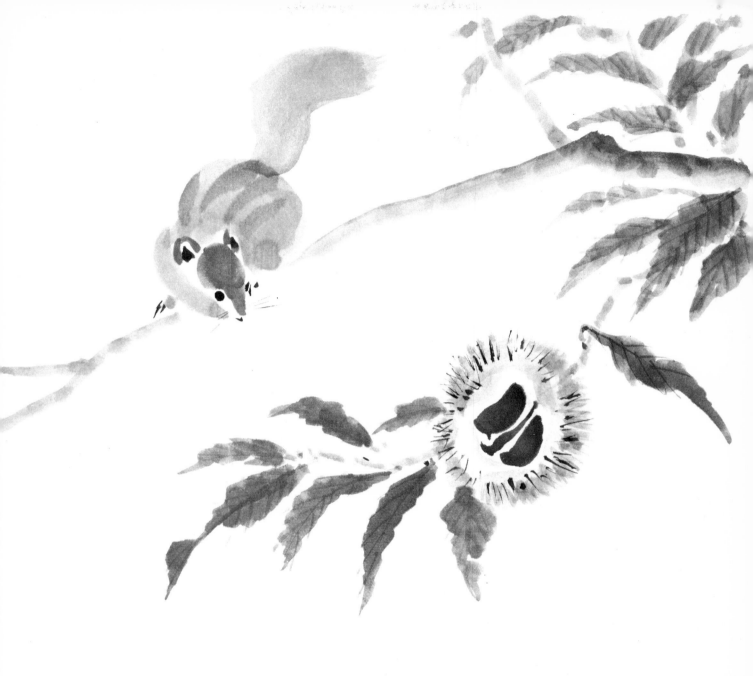

squirrel

Charge your brush with ink of medium intensity and paint the head and face, then add the ears and the rounded back holding the brush in the oblique position, next paint the breast. To paint the tail, charge the brush with light ink and make a single, swift brush stroke.

The eyes, mouth, and legs are painted with dark ink, and the stripes on the back are painted in with medium ink. Again with a brush charged with medium ink, paint the tree branches, making your strokes from the upper right down toward the lower left. Ink of three different intensities—dark, medium, and light—are used to paint the leaves. The chestnut spikes are made with a brush charged with heavy ink.

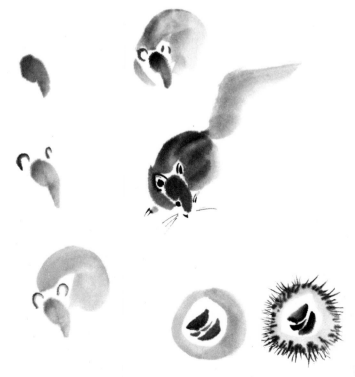

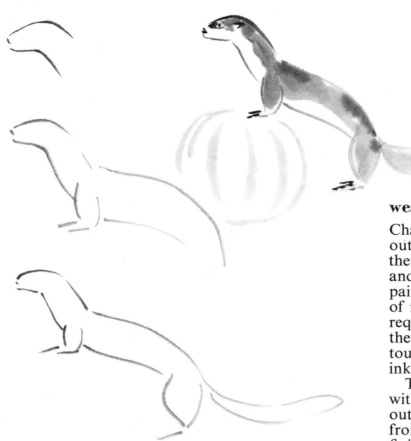

weasel

Charge your brush with light ink and roughly outline the area from the head to the neck, then go on to do the forelegs, body, hind legs, and tail. Next, dip the brush in dark ink and paint in the eyes and ears. Thin the ink to one of medium intensity and paint the areas that require a furry effect—the head, the back and the legs. Before the ink dries completely, touch in some accents on the back with dark ink.

To paint the watermelon, charge the brush with medium ink and paint the rounded outline. Paint in the stripes while the ink from the previous strokes is still wet. To finish, add the leaves and stem.

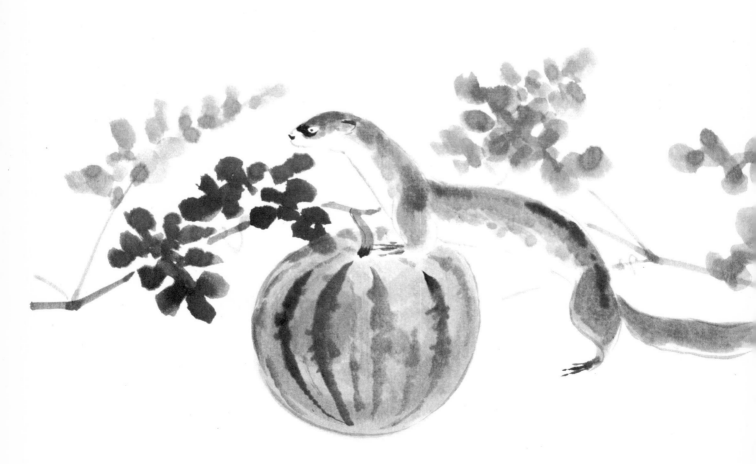

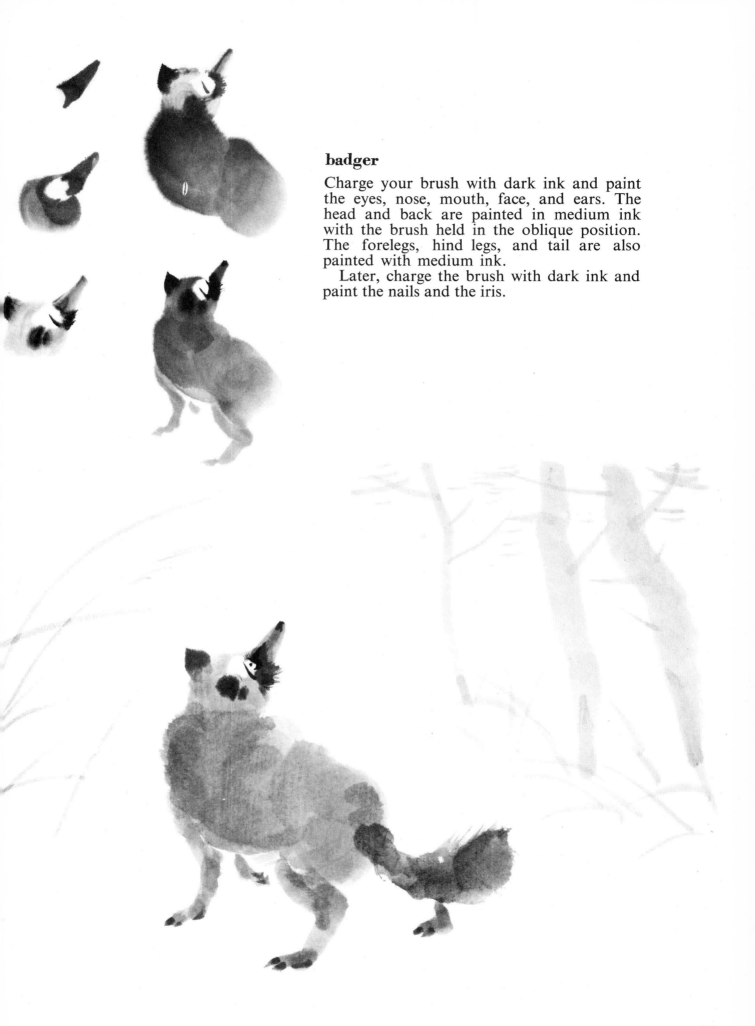

badger

Charge your brush with dark ink and paint the eyes, nose, mouth, face, and ears. The head and back are painted in medium ink with the brush held in the oblique position. The forelegs, hind legs, and tail are also painted with medium ink.

Later, charge the brush with dark ink and paint the nails and the iris.

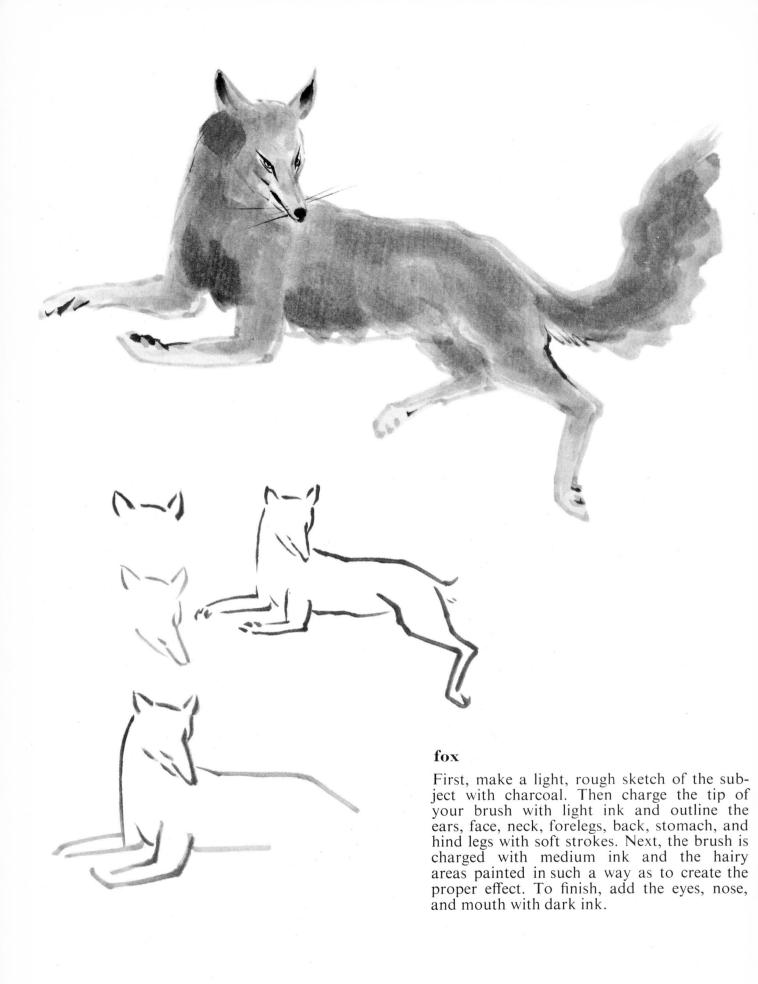

fox

First, make a light, rough sketch of the subject with charcoal. Then charge the tip of your brush with light ink and outline the ears, face, neck, forelegs, back, stomach, and hind legs with soft strokes. Next, the brush is charged with medium ink and the hairy areas painted in such a way as to create the proper effect. To finish, add the eyes, nose, and mouth with dark ink.

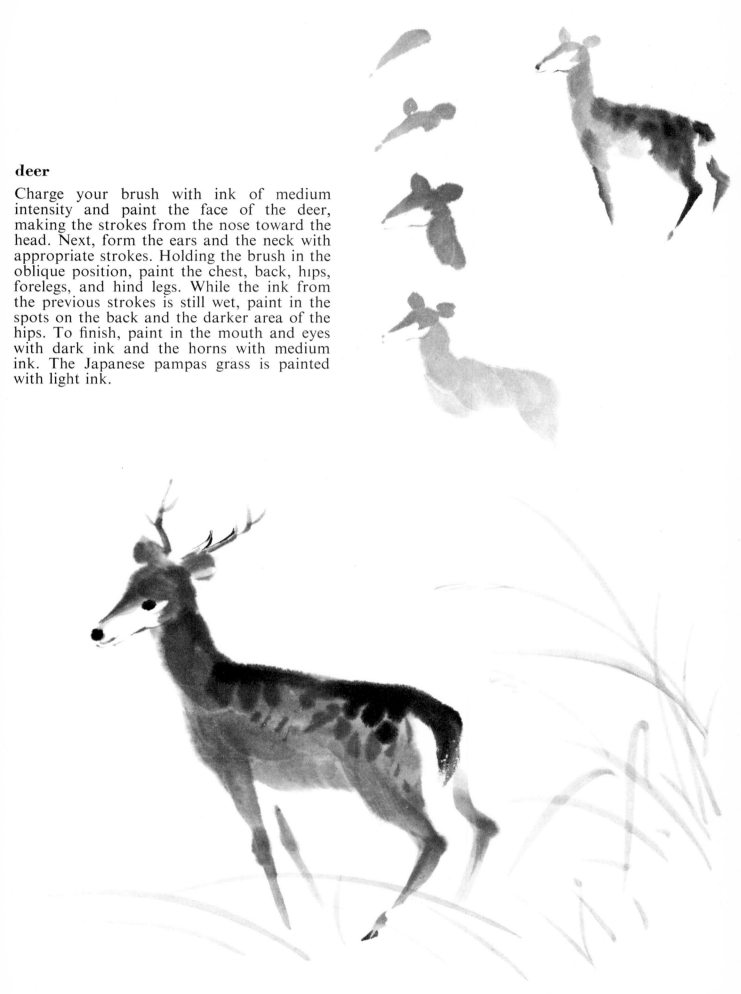

deer

Charge your brush with ink of medium intensity and paint the face of the deer, making the strokes from the nose toward the head. Next, form the ears and the neck with appropriate strokes. Holding the brush in the oblique position, paint the chest, back, hips, forelegs, and hind legs. While the ink from the previous strokes is still wet, paint in the spots on the back and the darker area of the hips. To finish, paint in the mouth and eyes with dark ink and the horns with medium ink. The Japanese pampas grass is painted with light ink.

horse

When a horse is the subject, the vitality of the animal is better expressed by simple strokes rather than detailed painting. First, your brush is charged with dark ink and the ears, the line between the nose and mouth, and the eyes are painted. Next, with vigorous and comparatively thick strokes, paint the area from the chest to the forelegs, the stomach, the back, and the hind legs. The mane and tail are painted in with single, vigorous strokes, using light ink.

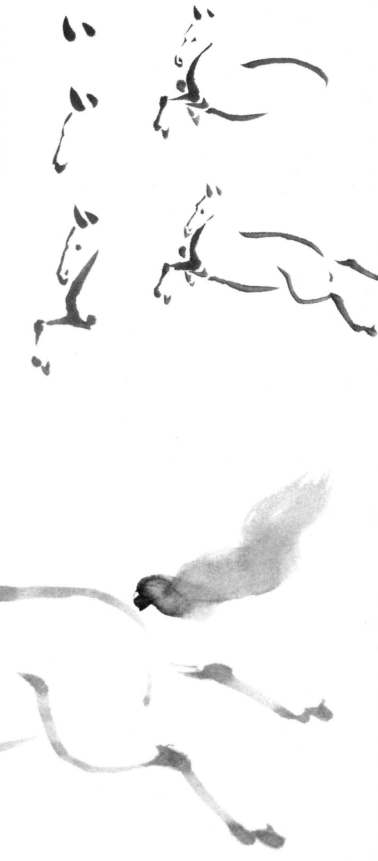

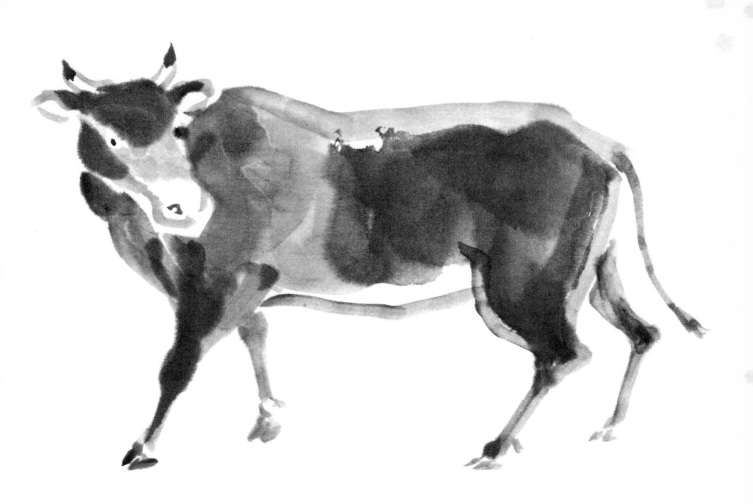

cow

Charge your brush with light ink and outline the overall shape of the animal with comparatively thick lines. Start with the horns, and then do the head, ears, and the face. Proceed next to the chest, forelegs, back, stomach, hind legs, and tail. After the overall shape has been outlined, charge the brush with medium ink and fill in the face and body. While the ink from the previous strokes is still wet, paint in the spots and other details. To finish, paint in the eyes with heavy ink.

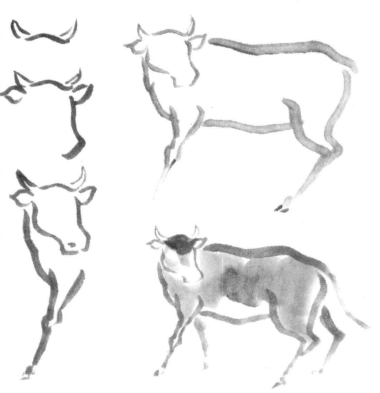

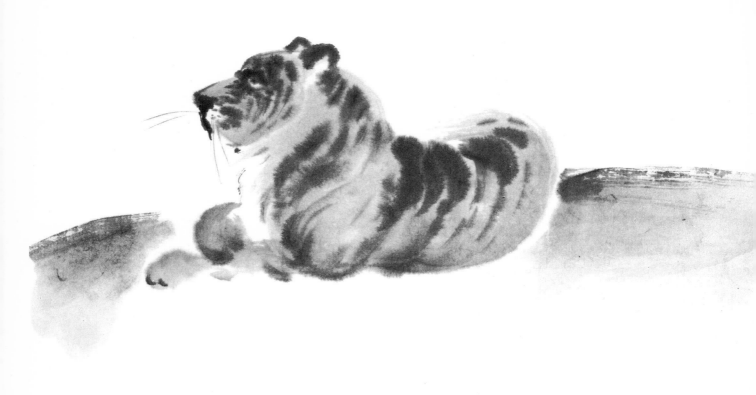

tiger

Charge your brush with dark ink and paint the eyes, nose, mouth and ears. Then, with medium ink paint the face and neck, the breast, forelegs, back, and stomach. Before the ink from the previous strokes dries, paint in the stripes.

The eyes should be painted in such a manner as to make them appear fierce and the nose and mouth should be painted in such a way as to make them look strong.

lion

First, make a rough sketch of the animal with charcoal. Then charge your brush with medium ink and paint the eyes, nose, mouth, and ears. Add the mane, being careful to paint it in such a way as to give the face the proper proportions. The forelegs, back, hind legs, and tail are painted with thicker strokes. Charge the brush with light ink and fill in the body of the animal.

Care should be taken to paint the lines of the animal's body with strong, firm strokes and the mane with light strokes.

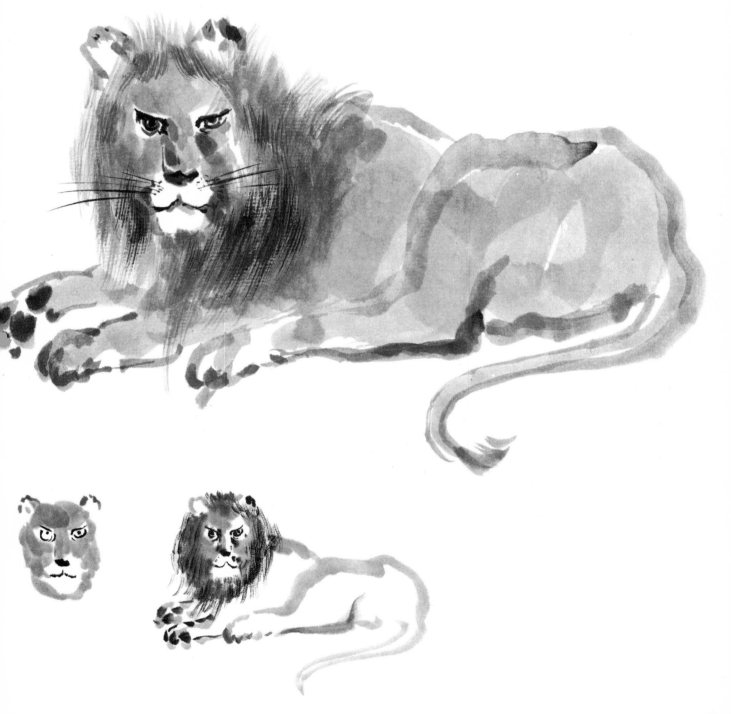

hen

Charge your brush with dark ink and paint the beak. Then, with medium ink paint the area around the eyes, the comb and wattles, the neck, the breast, the back, and the wings. Recharge the brush with medium ink and dip the tip in dark ink and, holding the brush in the oblique position, paint the tail feathers. To finish, add the eyes and legs with dark ink.

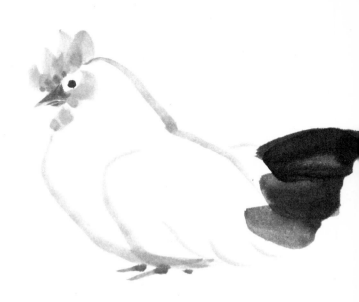

fighting cock

Charge your brush with ink of medium intensity and make the beak with one vigorous stroke. Next, paint the area around the eyes and the comb, then the neck, breast, and back with medium ink. Before the ink from these strokes dries, paint in the feathers, wings, and tail with dark ink. The legs are painted with medium ink, using strokes that will give them an appearance of strength.

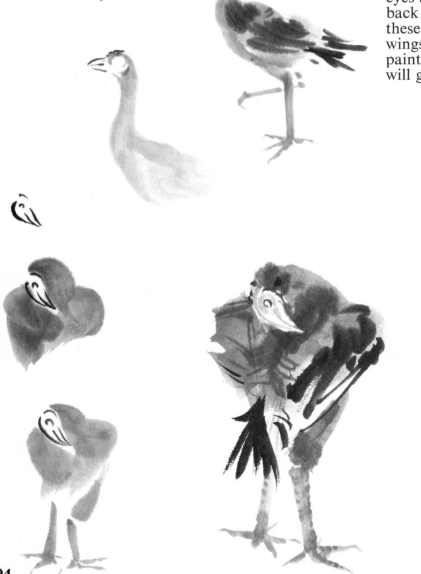

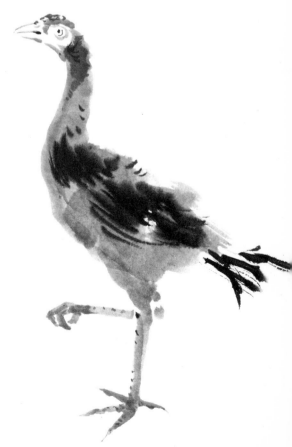

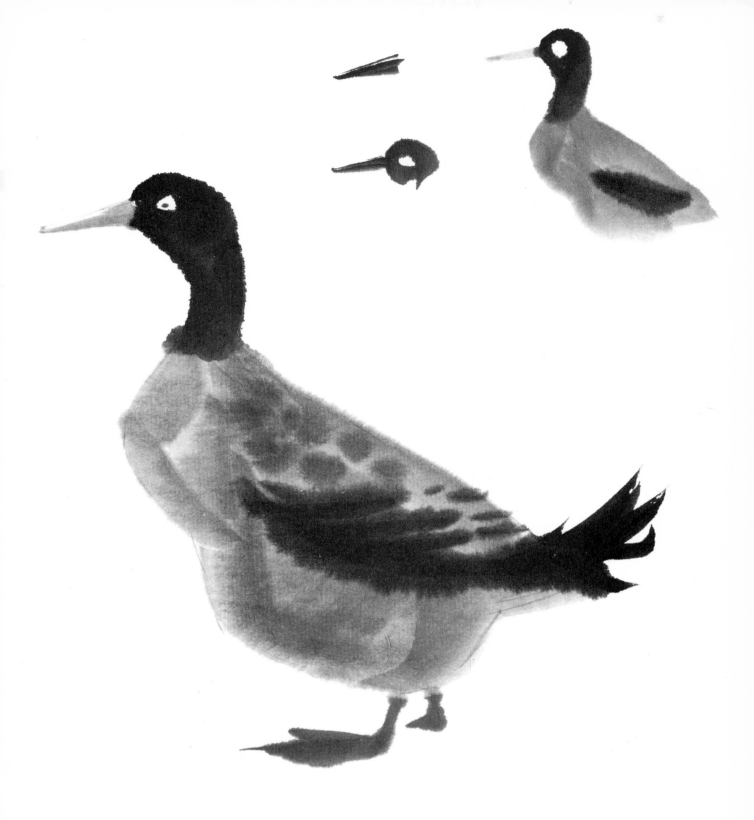

duck

Charge the brush with ink of medium intensity and paint the beak. Dip the tip of the brush into dark ink and paint the head and neck. The whites of the eyes are left unpainted, that is, white. Next, paint the breast, the back, and the stomach with medium ink. The wings, wing feathers, tail, and legs are painted in with dark ink. Put in the eyes with dark ink. The body should be painted with the brush held in the oblique position.

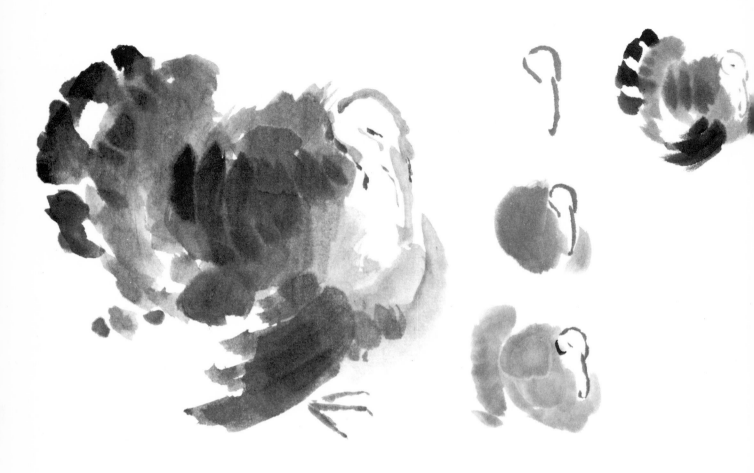

turkey

Charge the brush with light ink and paint the head and face. The rounded body and the hind area are painted with medium ink. Next, charge the brush with medium ink and dip the tip in dark ink to paint the tail, wings, and legs. The overall shape of the turkey should be round. A small amount of red color should be applied to the face.

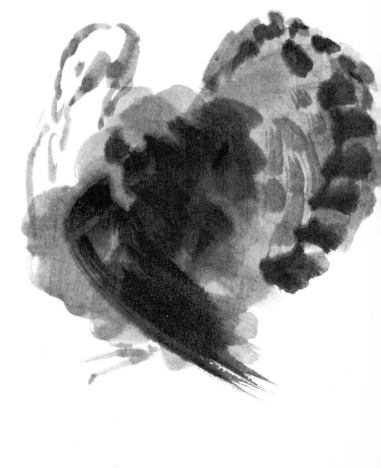

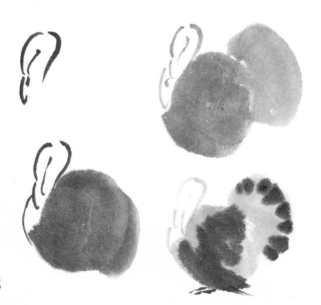

pigeon

Charge your brush with ink of medium intensity and paint the beak, head, breast, and back, without recharging the brush. Next, proceed to do the wings and tail feathers, paying particular attention to the feathers. Before the ink dries from these strokes, dip the brush tip in dark ink and paint in the spots. Also paint the wings with dark ink. Charge the brush with medium ink and paint the legs, being careful to give them an appearance of strength.

The branches of the maples are painted by making the brush strokes down, working from the upper right to the lower left. The leaves are added last.

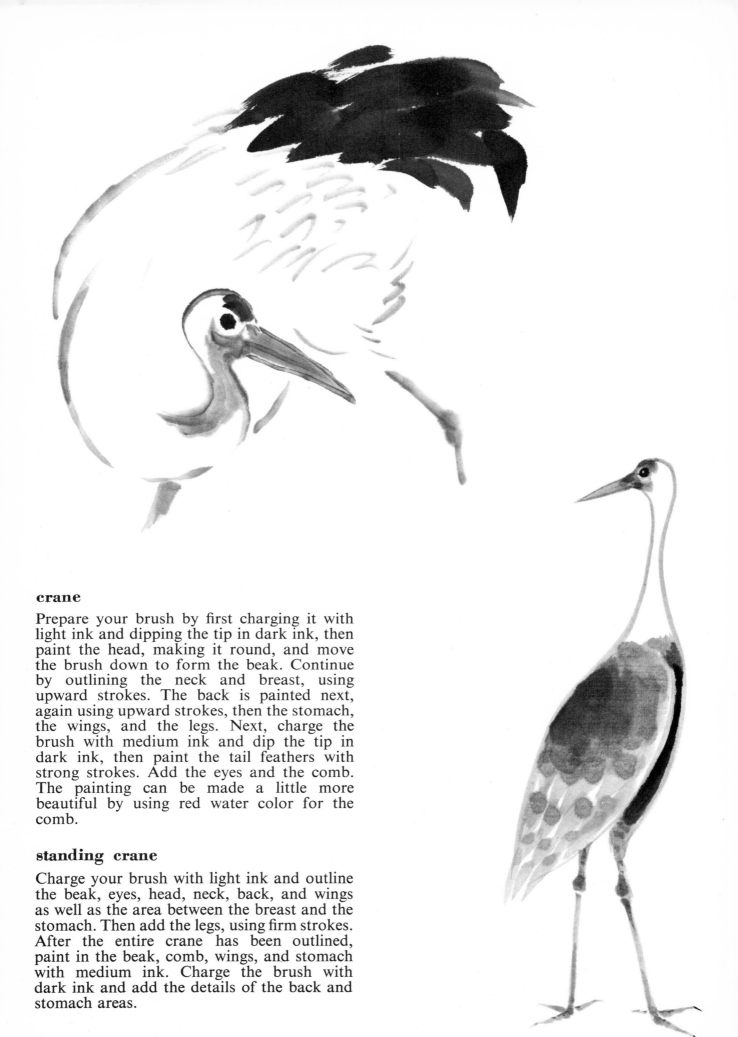

crane

Prepare your brush by first charging it with light ink and dipping the tip in dark ink, then paint the head, making it round, and move the brush down to form the beak. Continue by outlining the neck and breast, using upward strokes. The back is painted next, again using upward strokes, then the stomach, the wings, and the legs. Next, charge the brush with medium ink and dip the tip in dark ink, then paint the tail feathers with strong strokes. Add the eyes and the comb. The painting can be made a little more beautiful by using red water color for the comb.

standing crane

Charge your brush with light ink and outline the beak, eyes, head, neck, back, and wings as well as the area between the breast and the stomach. Then add the legs, using firm strokes. After the entire crane has been outlined, paint in the beak, comb, wings, and stomach with medium ink. Charge the brush with dark ink and add the details of the back and stomach areas.

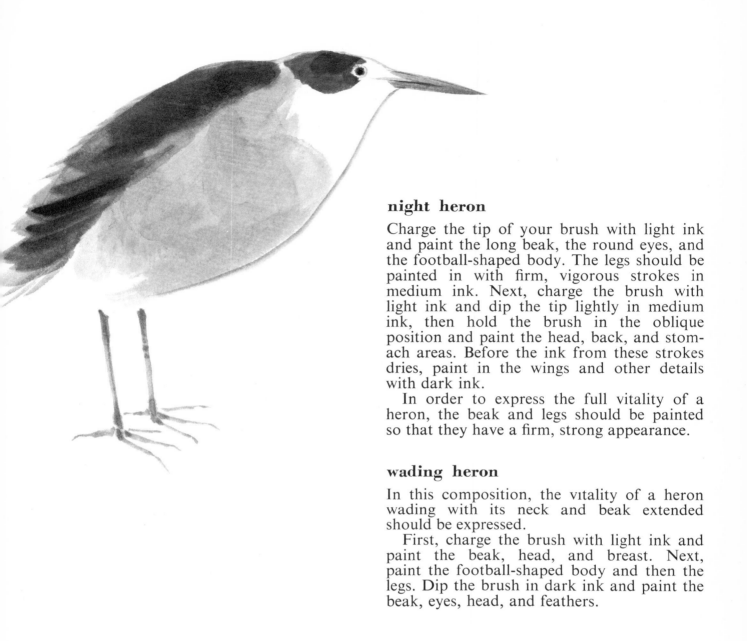

night heron

Charge the tip of your brush with light ink and paint the long beak, the round eyes, and the football-shaped body. The legs should be painted in with firm, vigorous strokes in medium ink. Next, charge the brush with light ink and dip the tip lightly in medium ink, then hold the brush in the oblique position and paint the head, back, and stomach areas. Before the ink from these strokes dries, paint in the wings and other details with dark ink.

In order to express the full vitality of a heron, the beak and legs should be painted so that they have a firm, strong appearance.

wading heron

In this composition, the vitality of a heron wading with its neck and beak extended should be expressed.

First, charge the brush with light ink and paint the beak, head, and breast. Next, paint the football-shaped body and then the legs. Dip the brush in dark ink and paint the beak, eyes, head, and feathers.

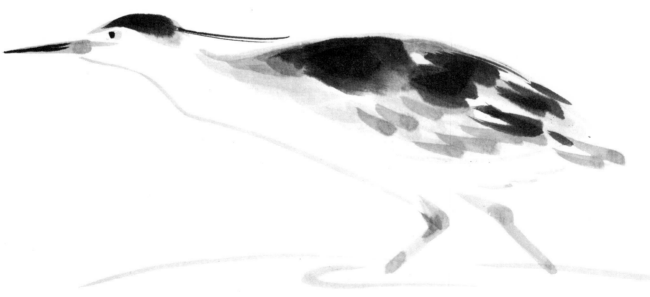

Japanese white-eye

Charge your brush with medium ink and paint the beak and eyes. Next, paint the egg-shaped head, leaving the area around the eyes white. Outline the breast with light ink and paint the back. With dark ink, paint in the wings, tail, and legs. The branches are made with downward strokes, starting at the upper right and working down toward the lower left, and the flowers painted in.

Care should be taken to paint the beak and legs with vigorous strokes in order to give the bird an alert appearance.

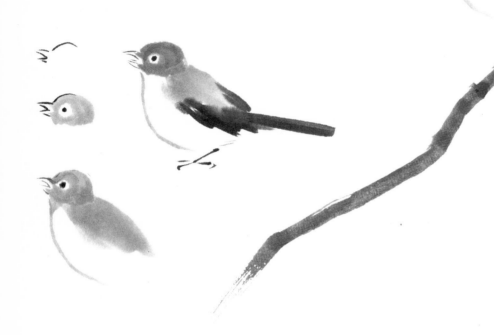

bunting

Charge your brush with medium ink and paint the beak. Next, dip the tip of the brush in light ink and outline the head and breast. With medium ink, paint the body, leaving the cheeks and the top of the head white, and the back. With dark ink, paint in the wings and the tail feathers, using rapid brush strokes. To finish, paint the legs.

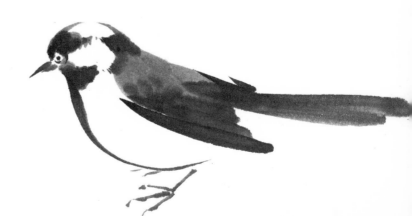

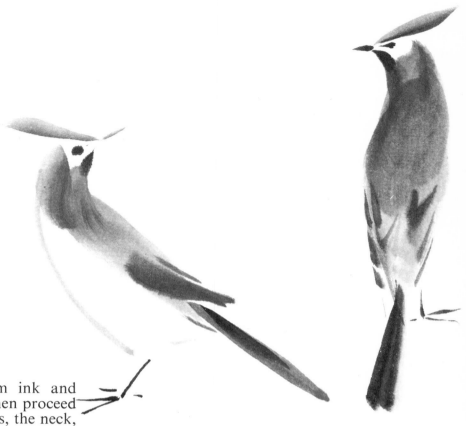

cedar bird

Charge your brush with medium ink and start the painting with the beak, then proceed on to do the head feathers, the eyes, the neck, the breast, the stomach, and the back. The wings and tail should be painted with dark ink, using rapid strokes. Finish the painting by adding the legs with firm strokes. The entire bird should be painted using nimble brushwork.

sparrow

Charge your brush with medium ink and paint the short beak, then the rounded head, the breast, and the egg-shaped back. With dark ink, paint the wings, tail feathers, and the area around the eyes. Adding dark specks to the body will help give the painting a sense of realism. The legs should be painted in with sharp strokes.

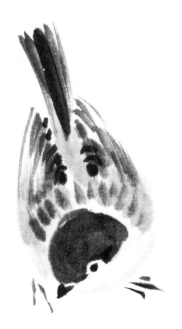

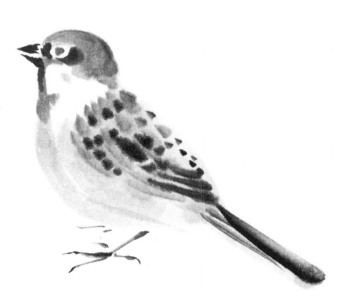

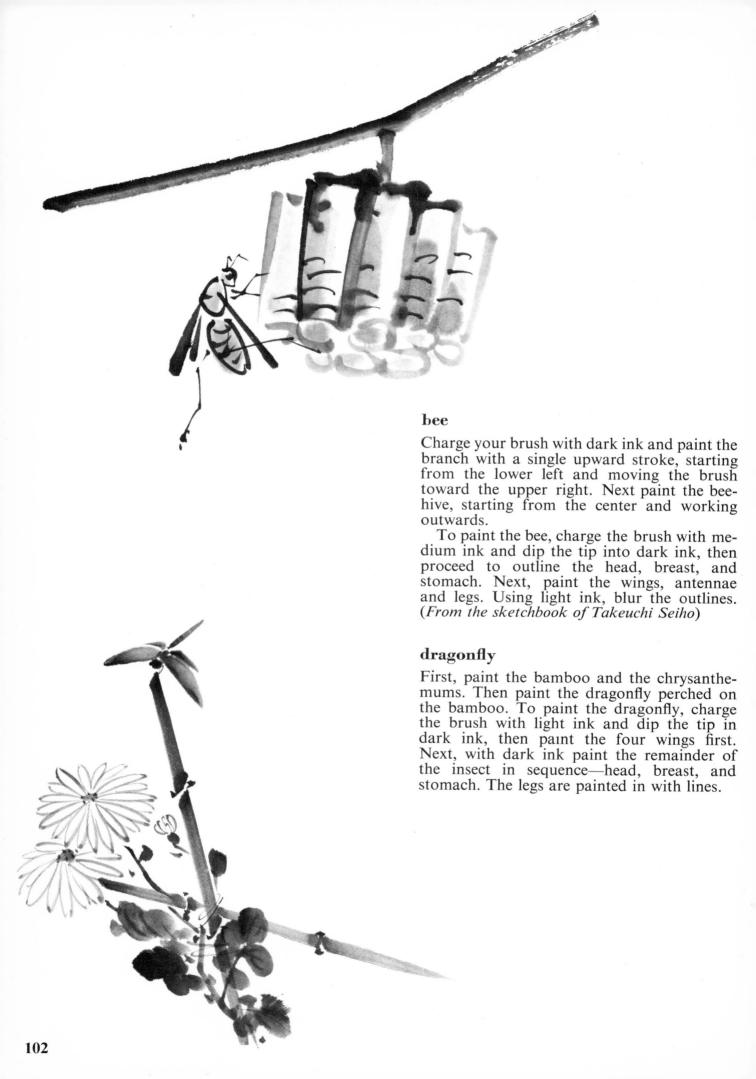

bee

Charge your brush with dark ink and paint the branch with a single upward stroke, starting from the lower left and moving the brush toward the upper right. Next paint the bee-hive, starting from the center and working outwards.

To paint the bee, charge the brush with medium ink and dip the tip into dark ink, then proceed to outline the head, breast, and stomach. Next, paint the wings, antennae and legs. Using light ink, blur the outlines. (*From the sketchbook of Takeuchi Seiho*)

dragonfly

First, paint the bamboo and the chrysanthemums. Then paint the dragonfly perched on the bamboo. To paint the dragonfly, charge the brush with light ink and dip the tip in dark ink, then paint the four wings first. Next, with dark ink paint the remainder of the insect in sequence—head, breast, and stomach. The legs are painted in with lines.

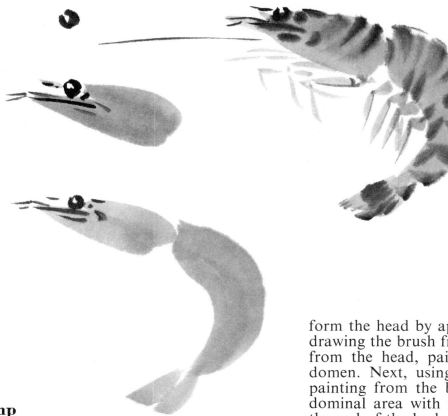

shrimp

The shrimp has been used in Japan since time immemorial for special happy occasions because of its large size and beautiful color. The tension of its feelers and its great vigor give it an appearance of courage so that it is often used as a symbolic decoration on New Year's. When painting a shrimp, that same effect should be produced.

First, using dark ink, form the eye and dark detail around the eye, as shown in the diagram. Then, charging the brush fully with light ink, form the head by applying light pressure and drawing the brush from left to right. Working from the head, paint back towards the abdomen. Next, using the same light ink and painting from the back, form the lower abdominal area with a single brush stroke. At the end of the body, form the tail by drawing the brush inwards towards the body, using two or three strokes. Next, still using light ink, paint the legs below the forward part of the body. By this time, the ink used to form the chest and body will have dried slightly. Charge the brush with medium ink and a touch of dark ink at the tip. Form the leg joints and the marks along the back and abdomen, using one brush stroke for each. Make the brush strokes from the back towards the abdomen.

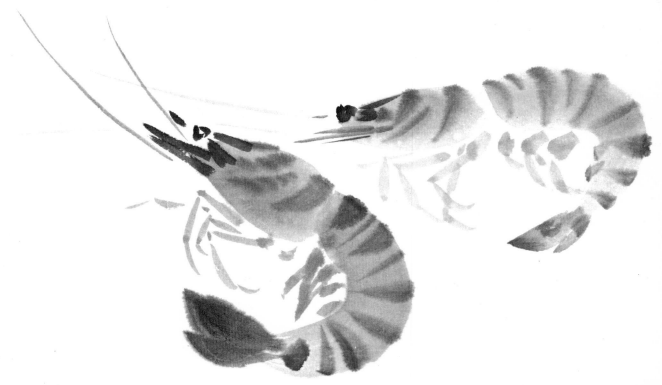

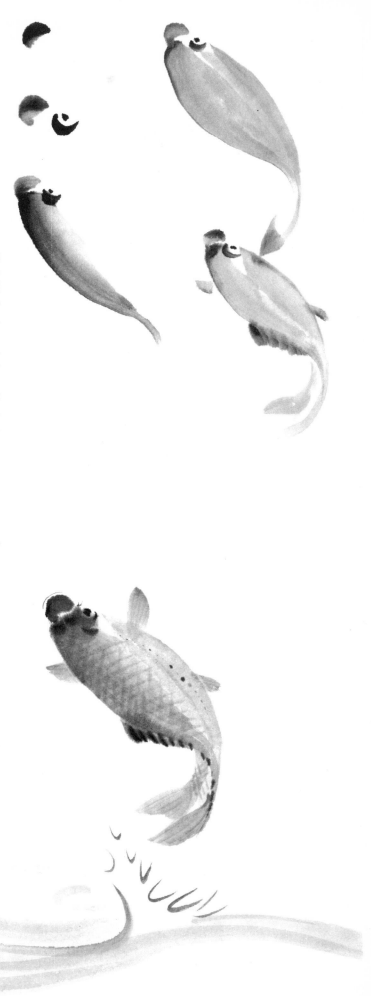

carp

The carp is a fresh water fish whose likeness has been used since ancient times to decorate gardens in the annual Boys' Day festival held in May. The carp, usually depicted leaping out of the water, also appears in many old masterpieces of Japanese ink paintings.

First clean the *mokkotsu* ("boneless") brush well, then charge it using the light-medium-dark ("three brush") inking technique.

Form the mouth first, then the eye and the area around it. Next, fully re-charge the brush with ink and form the back with a single brush stroke, drawing the brush firmly from the head towards the tail. Then, using the same ink, form the lower part of the body with a single stroke. Using two or three strokes, form the tail, then the pectoral, ventral, and dorsal fins, making your strokes inward. Before the ink dries completely, the scales should be painted. Form the lines of the scales and of the fins using dark ink with strong strokes. Finish the carp by making the abdominal spots. Depict the water with light ink.

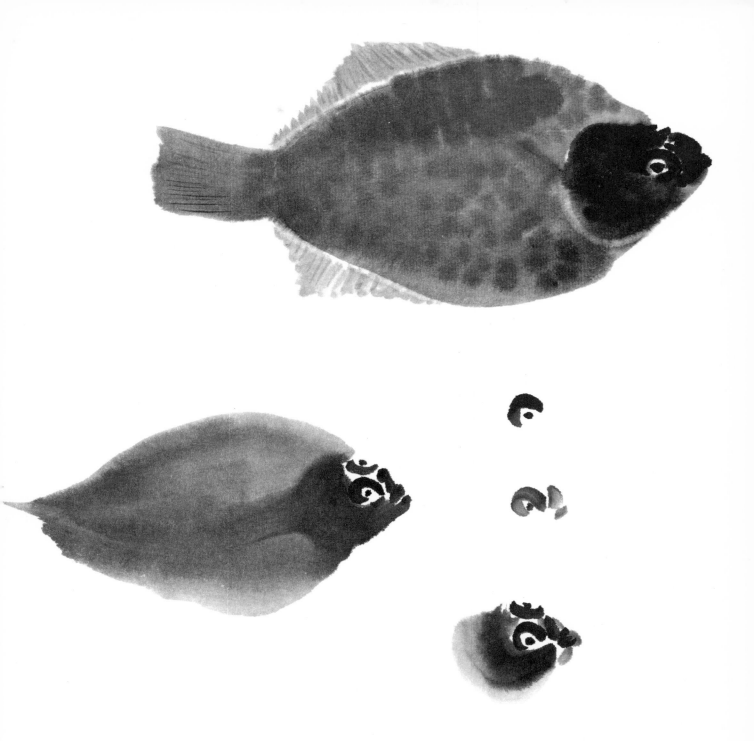

flatfish

This fish is a contrast in light and dark colors. Its eyes are very close together. On its back there are many black spots.

First form the eyes, using dark ink, and then the area where the nose and mouth meet. Wash the brush well and charge it with medium ink. Start painting from lower right to upper left. Turning the brush tip in the direction of the eyes, form the gills with one stroke, using the side of the brush. Next, using medium ink over light ink, form the back, working from the right of the head towards the tail. In the same fashion, form the lower part of the body, working from the left side of the head. In this fashion form the entire body in about three strokes, using the side of the brush. Next form the tail fins, the dorsal fin, the ventral fin, and pectoral fins, as shown in the illustration. When the ink previously applied to the body is about half dry, add the black spots to the body. Form the lines of the fins and tail.

When you paint the darker part of the fish's body in this manner, leaving a portion of the eye white, a bright, lively feeling is evoked.

sea bream

The sea bream's mouth and eyes are large, and its fins and tail are very pointed. It is beautiful in color shading, and has been used in Japan for ages on festive occasions and for congratulatory events.

First form the big eye, then line in the mouth and head. Working from the gills, complete the outline of the head. With light ink, form the back, drawing the brush from left to right, then make the lines of the abdomen. Next dip the tip of the brush, still charged with light ink, into medium ink, and paint the back, working from the head to the tail by tilting the brush on its side. Form the gradations along the abdomen using light ink. Wash the brush well and charge the tip of the bristles with medium ink, then form the tail fins, dorsal fins, and ventral fins in such a way as to give the fish a feeling of strength and courage. Before the ink applied previously to the back dries completely, form the scales by touching the brush tip lightly to make spots. Next add the lines of the fins using a little dark ink.

The willow branches in the background are added with the *mokkotsu* ("boneless") brush.

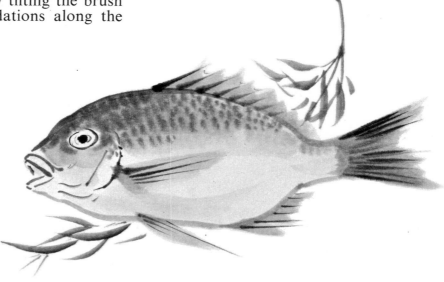

trout

The trout is a fish with a beautiful shape usually found in clear mountain streams.

First, form the mouth and eyes. Working from left to right, outline the back and stomach, using light ink. Next, form the gill covers. Wash the brush thoroughly and charge it with light ink, then apply a little medium and dark ink to the tip. While tilting the brush, shade in the back using the slanted brush technique. Form the tail with two brush strokes, then the dorsal, ventral, and pectoral fins.

These fish should be painted as a still-life subject, that is, they should look as though they are lying on a flat surface. You should, if you have the chance, observe a live fish carefully and make at least a rough sketch from nature. When painting two fish, thought must be given to the variation and unity within the composition. It is also important to consider carefully the relative positions or attitudes of two fish in a single composition.

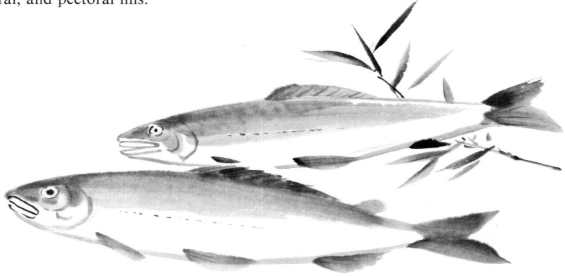

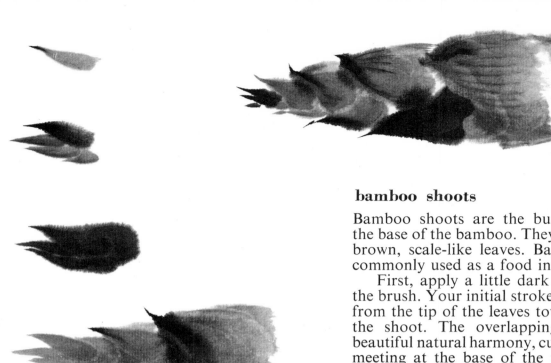

bamboo shoots

Bamboo shoots are the buds growing from the base of the bamboo. They are covered with brown, scale-like leaves. Bamboo shoots are commonly used as a food in the Orient.

First, apply a little dark ink to the tip of the brush. Your initial strokes should be made from the tip of the leaves towards the root of the shoot. The overlapping leaves have a beautiful natural harmony, culminating in their meeting at the base of the shoot, creating a pleasant orderly pattern. Clean the brush well and charge it with three gradations of ink, light, medium, and dark. Positioning the tip of the bristles and drawing the brush firmly from the tip with a spreading motion moving the brush from side to side, the rounded shape of the overlapping leaves can be formed. This gives the entire shoot a rounded effect. Accentuate the base with a number of black dots, as shown. Form the buds sprouting from the root of the bomboo.

When painting the peas, first form the calyx, then form the body of the pod with the side of the brush. Later shade in the darker areas suggesting the bulges of the peas inside the pod.

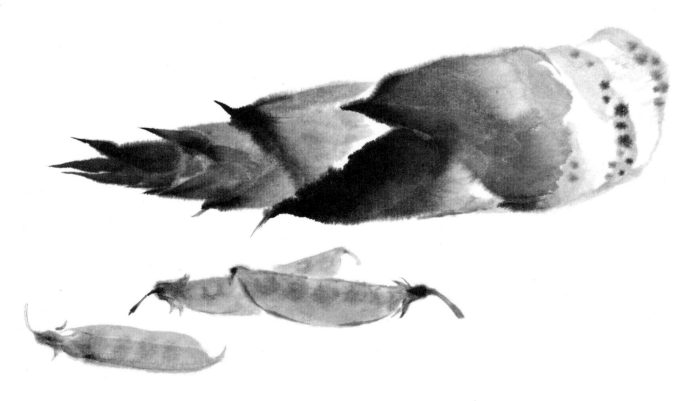

Examples of *Sumi-e*

SPANISH WOMEN

CAMELS

108

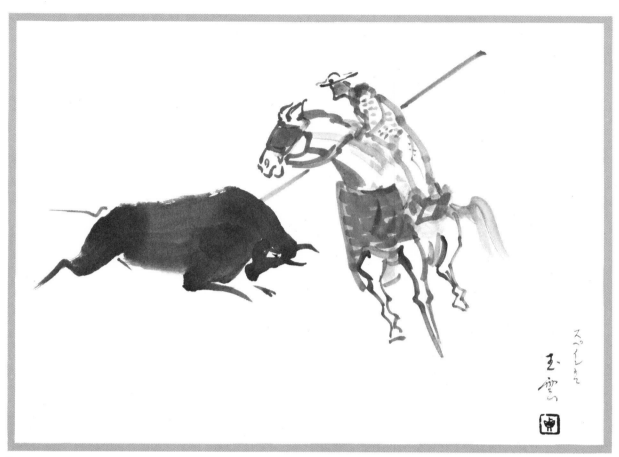

BULLFIGHT

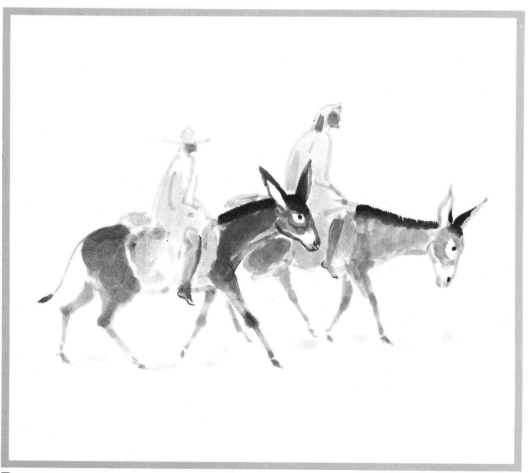

DONKEY

WILD DUCK

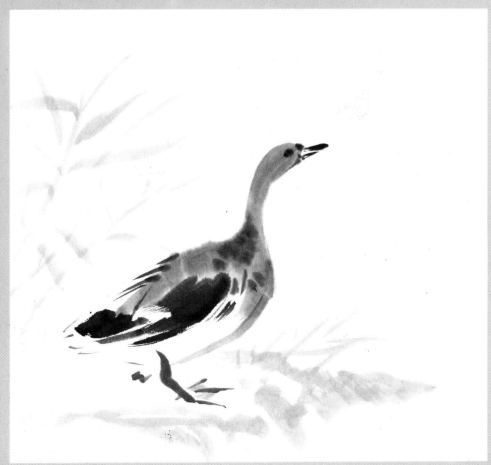

WILD DUCK

110

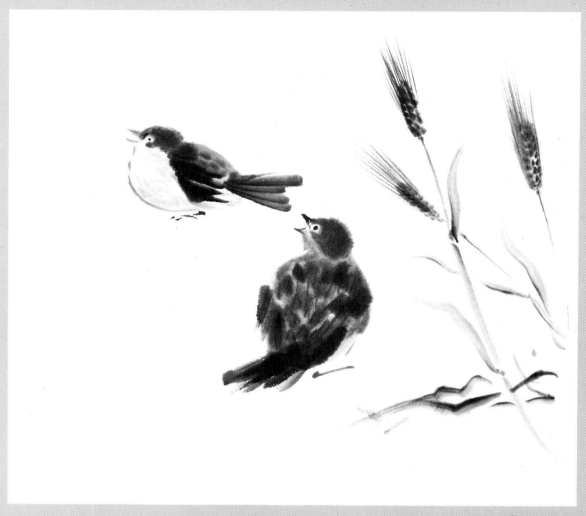

SPARROW

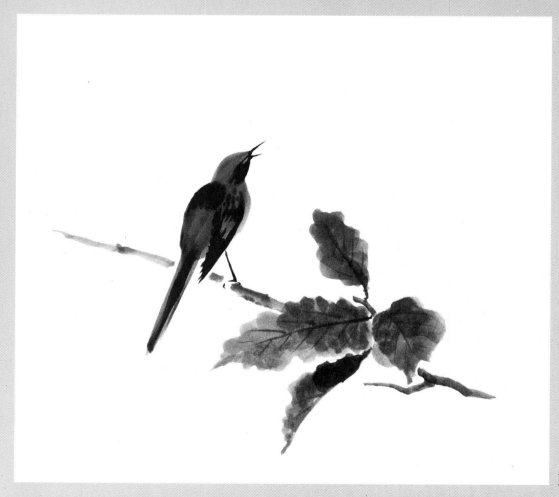

REDSTART 111

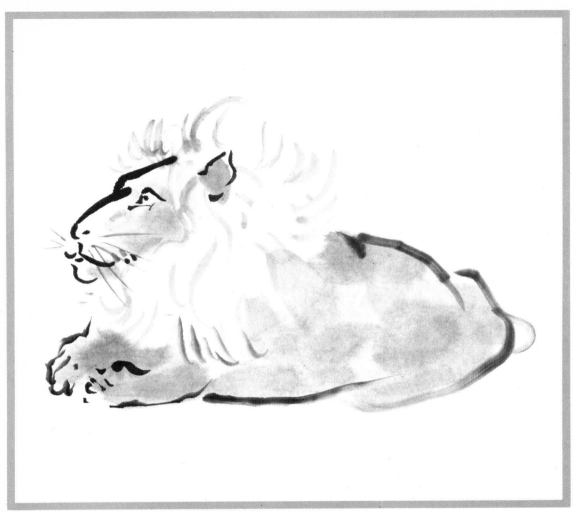

LION

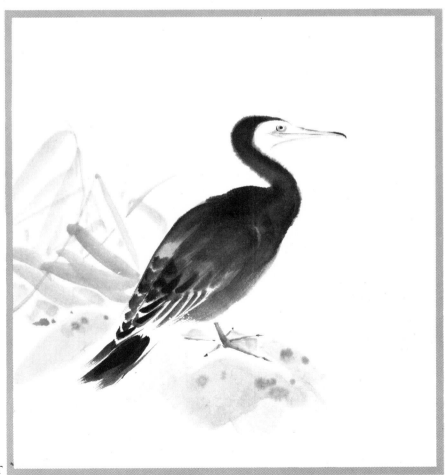

CORMORANT

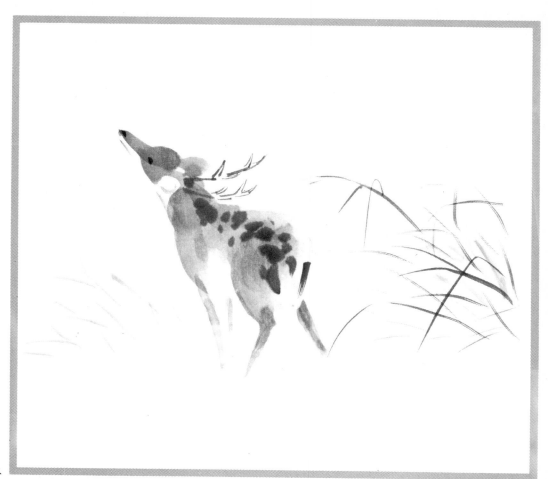

DEER

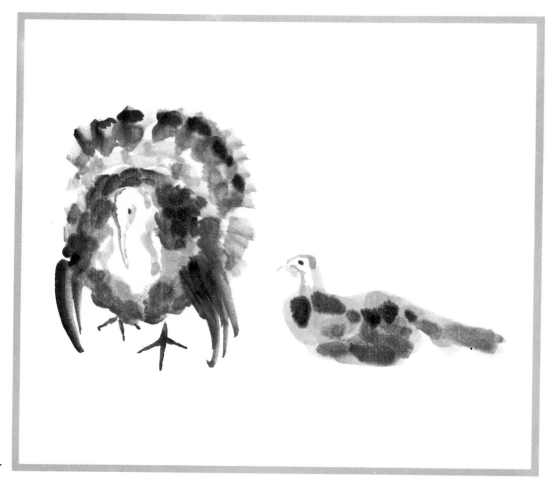

TURKEY

113

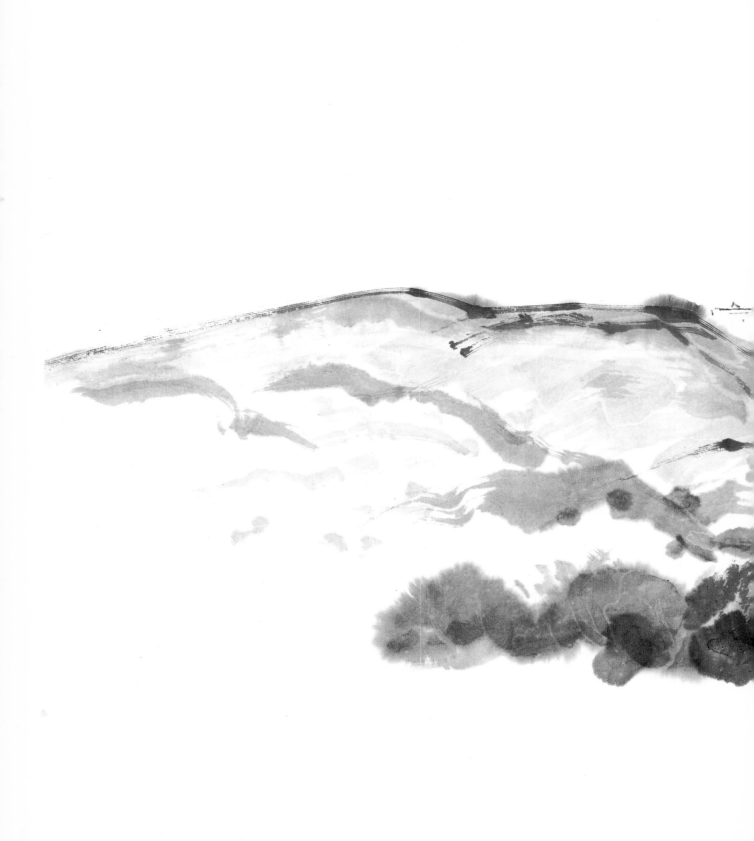

LANDSCAPE

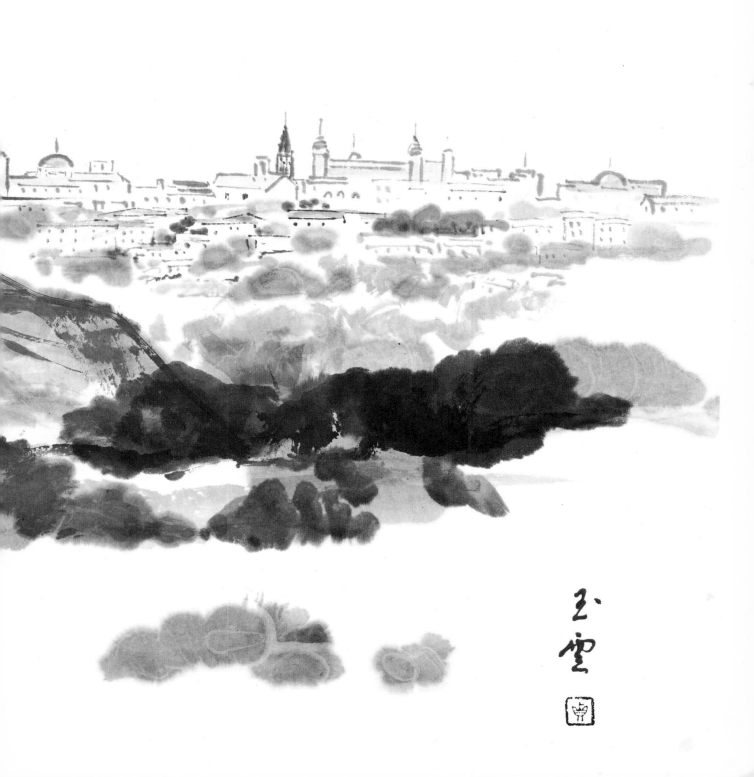

Sumi-e and Zen

The Zen sect of Buddhism exerted a strong influence on the development of ink painting, especially in Japan. Indian in origin, Zen concepts were introduced into China and became established as a religion there during the T'ang dynasty (618–906), with the sect later being divided into the Northern and Southern branches. Around the end of the twelfth and the beginning of the thirteenth centuries, Zen was introduced into Japan by the priests Eisai and Dogen, and during the Muromachi period (1336–1568) it rose to become one of the largest sects in the country.

Introduced into Japan together with Zen were portraits of the Zen masters (*chinzo*). Many portraits of this kind were painted by Japanese Zen priests, thus leading to the cultivation of painter-priests in this country. But the art produced by these priests was not linked with any aspect of worship. Rather, it had as its goal the conscious discipline of self, the same basic concept that gave Zen its unique flavor. Their method of painting continued to derive from the same approach apparent in the Chinese Sung-Yüan depictions of priests, the simple, intuitive expression through ink or a combination of ink and simple color.

The painter-priests started out with an art that

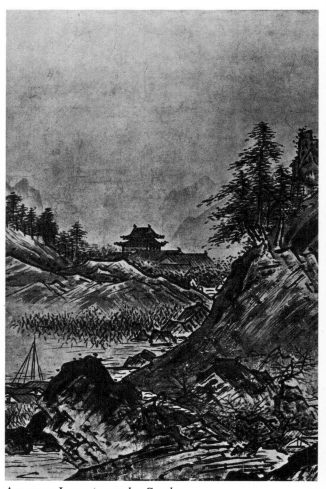

AUTUMN LANDSCAPE *by Sesshu*

LANDSCAPE WITH SNOW *by Urakami Gyokudo*

116

was more intuitive than figurative with the idea of achieving a greater understanding of the spirit of Zen. Since they were scholars and literary men as well as priests, however, their understanding of ink painting took on an additional dimension and their paintings became increasingly popular among people connected with the world of Zen. In time, the traditional simplicity and humility observed in the ancient arts of Japan combined with this newly born consciousness and creative spirit to stimulate the development of Japanese ink painting.

With the appearance of such great masters as Sesshu and Kano Motonobu, Japanese ink painting took an even sharper turn toward intuitional expression that embraced within it the harmonious sentiment characteristic of the Japanese people, particularly in regard to nature. Thus, the *suiboku-sansui* or ink-painting landscape, with its simplicity of form and richness of sentiment, was brought to perfection and later acted as the underlying foundation for modern Japanese art. In comparison with historical Western art, where expression meant the faithful delineation of subjects, Zen paintings had taken a different direction, where the goal was the expression of the transcendental

beauty of an object's essence.

The art of ink painting in the Edo period (1603–1868) developed along new lines that became known as *bunjin-ga* or *literati* paintings, which became increasingly popular around the eighteenth century. Behind this popular development lay the introduction of Chinese culture by the Obaku branch of the Zen sect. The purpose of the painters in this ink style, which was favored particularly by the writers and cultured men of the period as a hobby, was the free and fresh expression of feeling in painting. In short, the new style was free from the various rules of method and technique that had been developed. The painters were at liberty to try expressing their minds, feelings, and poetic emotions with simplicity and honesty.

The ideal of the *literati* painters was to detach themselves from fame, wealth, and the pleasures of life and seek freedom in their paintings. Their works were, therefore, characterized by simplicity and purity and possessed a superior quality of nuance that distinguished them as purely Japanese paintings, not a sub-stratum of Chinese *literati* paintings.

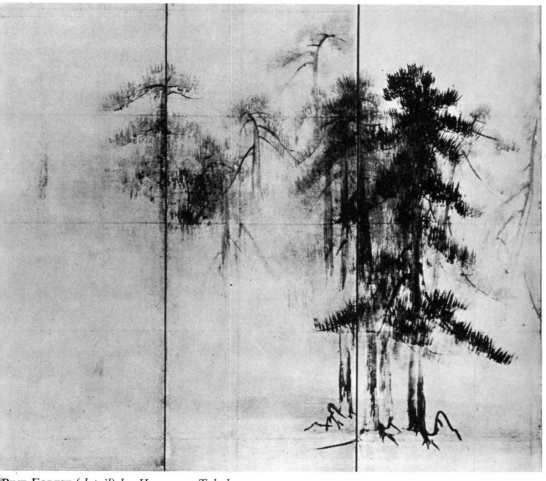

PINE FOREST (*detail*) *by Hasegawa Tohaku*

Sumi-e and "White Space"

In Oriental painting, the unpainted area in a work is called *yohaku* or "white space." The importance placed on this area in a painting is considered equal, and sometimes superior, to the actual painted area. The term for "space" in Buddhism has two meanings: one, that all formed things are merely space bound by life and death and are not eternal; and two, that all things are real because they are part of the absolute being.

In the second of the two meanings, "space" becomes equivalent to the absolute being. It is a metaphysical concept of the world and thus, in ink painting, is identified with the unpainted areas in a work. When the Buddhist term for space is traced back to its Sanskrit origin, the word *sunyata*, we find that it meant a mathematical zero. And just as the concept of zero is necessary for the understanding of algebra and geometry, so too is the concept of "white space," with its implications of "nothingness" and "emptiness," necessary for the understanding of ink paintings.

This will perhaps be better understood by referring back to a Chinese painter of the Ming dynasty, Tung Chi-chang, who described the painting of *sumi-e* animals and flowers as creating "one fullness and one emptiness." The same concept is found in calligraphy, where the ability to create a masterpiece lies in the ability to evoke the nuances of the written characters and balance them with the blankness in between. Here also the written characters are considered as "fullness" and the blank space as "emptiness," with both combined to create beauty.

The concept of "color," too, is also closely connected with "space" in ink painting. To quote another Chinese painter, Chang Yen-yuan, "There are five colors in ink." The color of *sumi* ink is not merely monochromatic *sumi* color, it is the height of color simplification and embraces within it all the nuances of shades of its rich, manifold beauty. One can find an infinity of "colors" in the monochromatic color of *sumi*. Indeed, the perfection of a monochromatic *sumi* painting, an extreme simplification of multi-color painting, is one of the greatest characteristics found in Oriental art. And it is the intimate relationship between the concepts of "color" and "space" that make this perfection possible.

Colors are what Buddhism describes as "all worldly concerns." It is the goal of Zen to seek

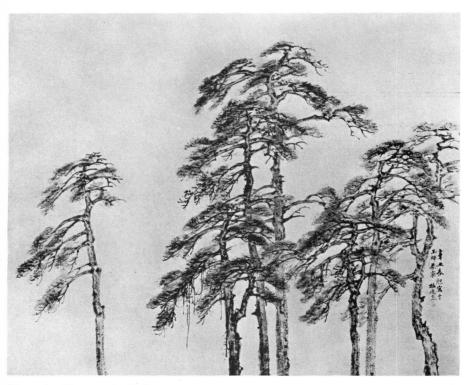

PINES *by Yamamoto Baiitsu*

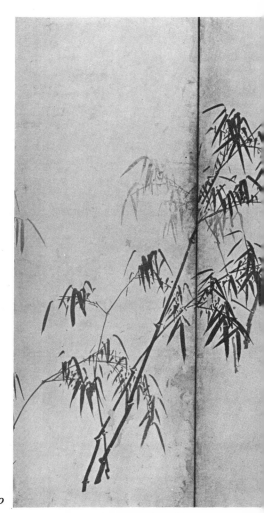

WIND-BLOWN BAMBOO IN THE RAIN (*detail*) *by Maruyama Okyo*

deliverance from all worldly concerns and to discover truth. When applied to ink painting, these concepts are given form through the interaction between the sheet of white paper, "space," and the outflow from the forms painted on the paper in monochromatic ink. If the deeply penetrated truth, the final goal of Zen, flows out from the painted forms, the unpainted area will be replete and become the space where the emotional nuance is solidified and concentrated. This white space should, therefore, absorb the lingering nuances of the ink and become the most perfected area and not just extra space left over after painting the subject. It is the white space that gives life and vitality to the painting.

To sum up, the true, exquisite beauty of an ink painting is created when the solution for the equation of the painted area (+) and the unpainted area (−) comes out zero. Ink painting can, from this standpoint, be described as "the art of the unpainted area." When asked what was the most difficult problem in painting, Ike-no-Taiga, a great master of the Edo period, pinpointed the importance of white space by simply answering, "The unpainted area is the most difficult part."

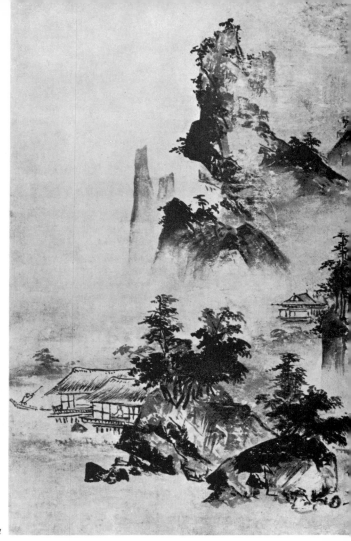

LANDSCAPE *by Gakuo Zokyu*

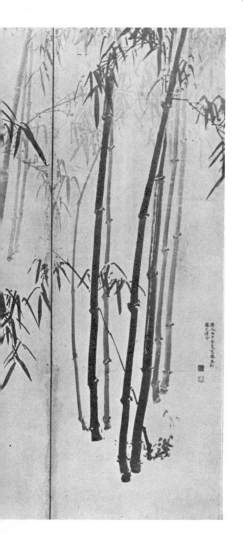

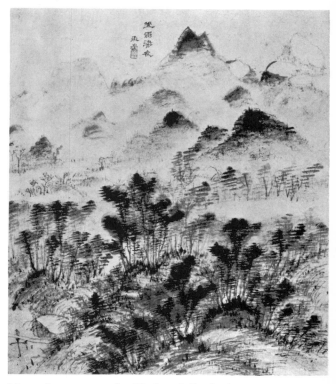

MISTY LANDSCAPE *by Urakami Gyokudo*

119

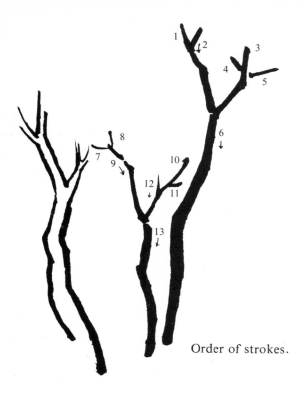

Order of strokes.

Painting Trees

Since trees are, naturally, important factors [in] the composition of landscape paintings, it is nec[es]sary as a first step in landscape painting to pract[ice] and master the techniques for painting trees. Ea[ch] tree is different and has its own peculiarities, [its] own character. Even among trees of the same kin[d,] for instance pines, there is wide variety—you[ng] and old pines, pines along seashores and [in] mountains, black pines, red pines, and so o[n.] The spread of a tree's branches and other pec[u]liarities that distinguish it from others should [be] observed and sketched carefully.

In oil painting, the over-all shape of a tree [is] usually painted first and then the trunk, but [in] Japanese painting this order is reversed, with th[e] trunk painted first and then the branches an[d] leaves. Since trunk sizes differ according to th[e] type of tree, and even qualitative differences appea[r] depending upon the season, the trunks should b[e] painted to express the proper sense of volume an[d] natural appearance. Tree roots, too, should b[e] depicted in such a way as to reflect the natura[l]

Crab's-claw technique.

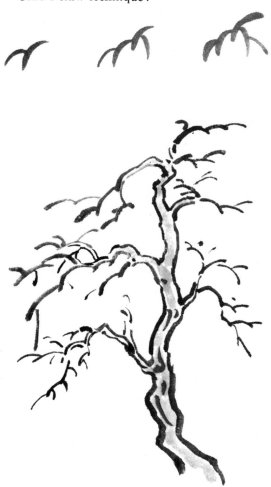

Deer's-horn technique.

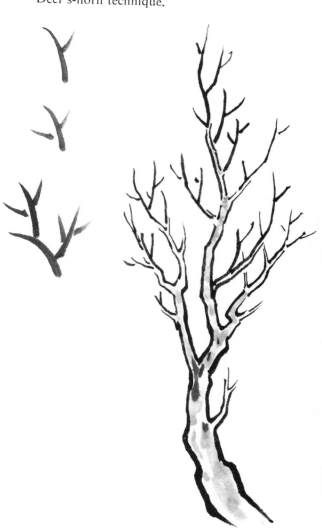

environment in which they are found. For instance, roots of trees in seashore or mountain landscapes should be depicted partially exposed, as they would appear in nature. Finally, trees that are to have a distant appearance in the painting should be depicted with lighter brush strokes than those which are to be painted in the foreground. This does not mean, however, the mere omission of a few twigs. The important thing is to grasp well the prominent characteristics of the tree and to use comparatively light ink.

TREES

Since a great variety of expression is possible, depending upon how the brush is charged, the speed with which it is moved across the surface of the paper, the strength of the stroke, and so on, it is a good idea to study well the illustrations before attempting to paint trees. The trunk of a tree may be painted in several ways. It may be simply outlined, it may be outlined and then given a blurred effect with medium or light ink, or it may be painted in a single stroke and then shaded. It is necessary to chose the appropriate method and to give the subject full expression.

The sequence of brushwork in painting trees starts with downward strokes, commencing at the top of the trunk and finishing at the bottom. The branches are painted in next, then the twigs, and later the leaves (see next section). Some old books on technique make clear the method for painting branch tips with such descriptive phrases as to how they should appear as a "crab's claw," a "deer's horns," and a "dragon's claw."

COMPOSITION

Since the manner in which trees are painted, especially when there are two or three trees overlapping, determines whether the composition will be successful or not, much care should be taken in planning their arrangement. Generally, a group of trees should form an scalene triangle.

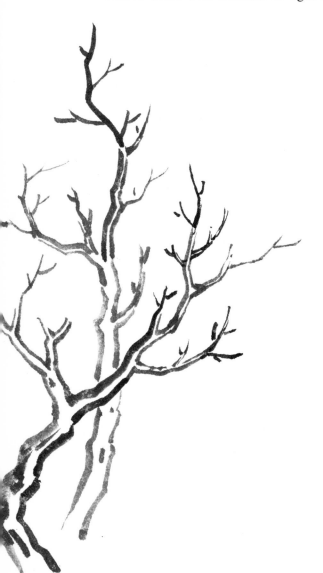

Composition for two overlapping trees.

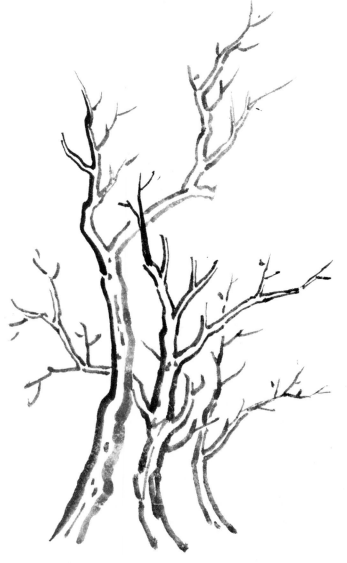

Composition for three overlapping trees.

Composition for three overlapping trees.

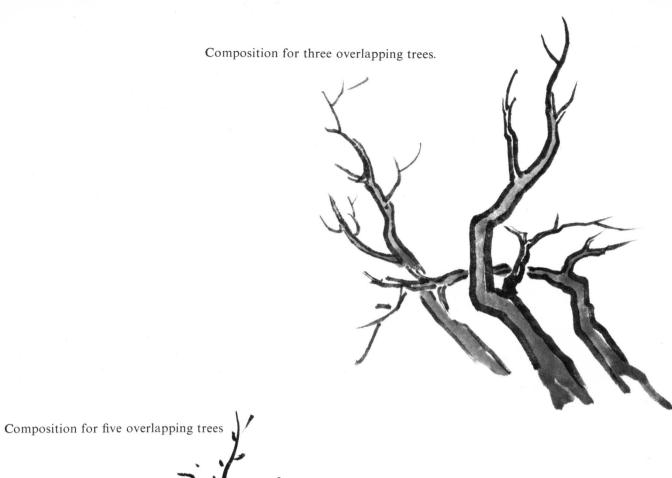

Composition for five overlapping trees

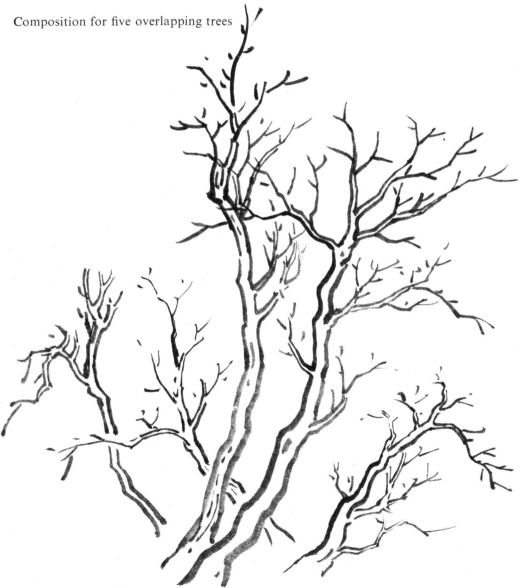

122

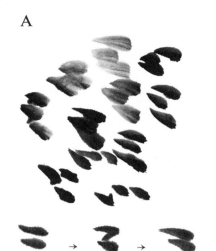

A

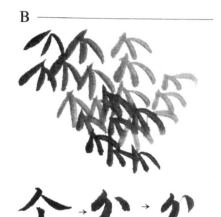

B

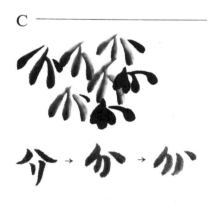

C

Painting Tree Leaves

Since trees are often used as the foreground or theme in ink-painting landscapes, the way in which the leaves are painted is very important. The method for depicting leaves described below is one that master painters worked out and established long ago. The mastery of this particular method will make it easy for the painter when he is working on trees or an actual landscapes, but there is some danger that he may give the method itself too much attention. Basically, modified Japanese characters, petal forms, and so on are used in the method.

[A] The *Santen* (ミ) Technique. In this technique the three short dashes comprising the character for three are used.

[B, C] The *Kai* (个, 介) Technique. Two versions of the character *kai* are used in this technique, which is applied in particular to the painting of leaves for deciduous trees, such as maples, or for leaves of bamboo when in groves.

 The brush is first charged with light ink and then the tip dipped in dark ink. By using a brush charged this way and painting the leaves in the foreground first, proceeding toward the background, you will be able to achieve the natural effect of perspective and of nuance gradation.

[D] The *Hitsu* (必) Technique. The basic shape of the strokes used in this technique are derived for the character for *hitsu*. The technique is used mostly for depicting hanging leaves, such as those found on willows or bamboo.

Illustration of the strokes used in A and B.

Illustration of
the stroke used in C.

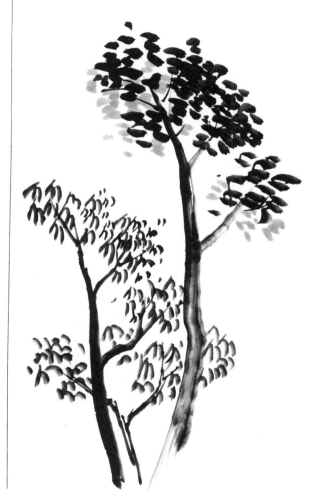

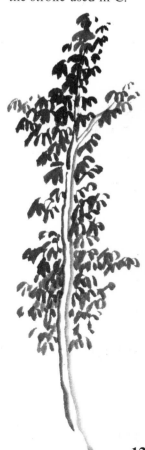

D

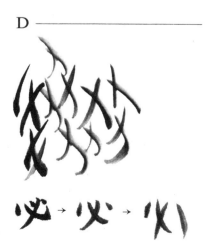

E

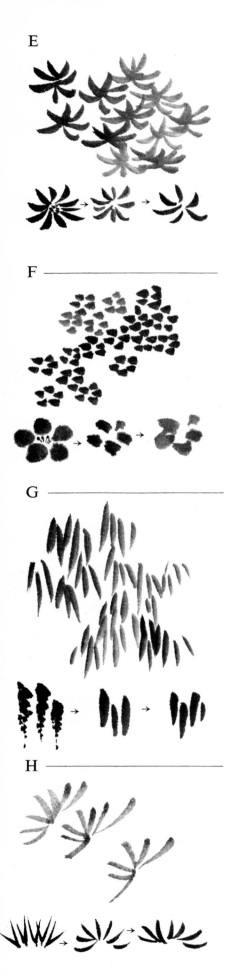

F ——————————

G ——————————

H ——————————

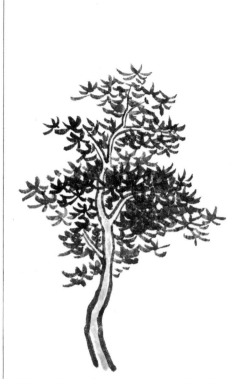

Illustration of the stroke used in E.

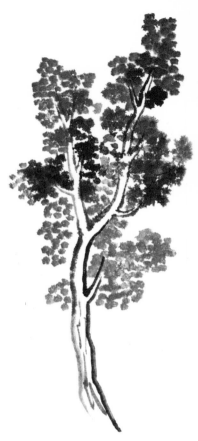

Illustration of the stroke used in F.

[E] The Chrysanthemum Technique. In this technique, used to paint grouped tree leaves, strokes are made to resemble the form of a chrysanthemum.

[F] The Plum-blossom Technique. This technique consists of making a group of five rounded dots resembling a plum blossom.

[G] The Hanging-wisteria Technique. Simple elongated dots made with downward strokes comprise this technique.

[H] The Fir-leaf Technique. This technique is one of the several used in depicting pine leaves.

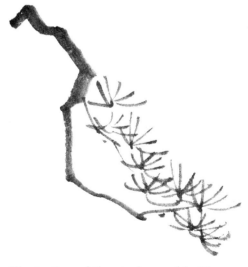

Illustration of the stroke used in H.

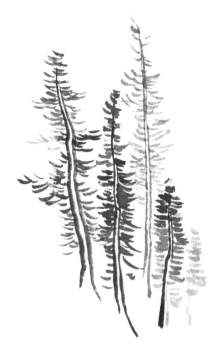

Illustration of the stroke used in J.

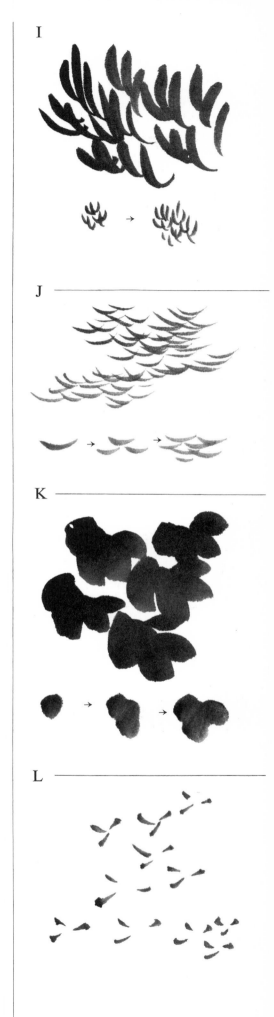

I

J

K

L

[I] The Seaweed Technique. This technique comprises strokes made to resemble seaweed.

[J] The Raised-head Technique. Horizontally elongated, slightly convey strokes are used in this technique.

[K] The Paulownia-leaf Technique. A form resembling that of a paulownia leaf is made in this technique.

[L] The Mouse-track Technique. The name for this technique derives from the resemblance between the strokes and the tracks of a mouse. The technique is used when painting young foliage and buds coming out in the spring.

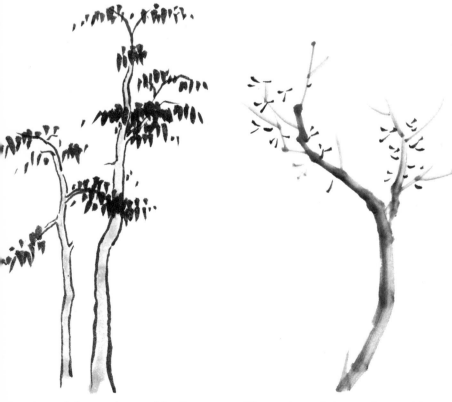

...ustration of the stroke used in G.　　Illustration of the stroke used in L.

M

[M] The Flat-head Technique. Horizontally elongated dots make up this technique.

[N] The method used when painting trees with broad leaves

[O] The Pointed-stroke Technique. Elongated dots made with a brush charged first with light ink and dipped in dark ink comprise this technique. The dots are made with downward strokes. The technique is used when painting distant trees, as on a far-off mountain.

[P] The Pepper Technique. This technique, in which a series of small dots resembling sprinkled pepper is made, is used for depicting thin tree leaves or moss on rocks. The dots are made starting on the lower side and working toward the upper. Sometimes the dots are made larger or elongated horizontally.

N ——————————

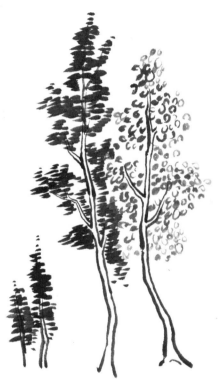

Illustration of the strokes used in M and N.

P

O

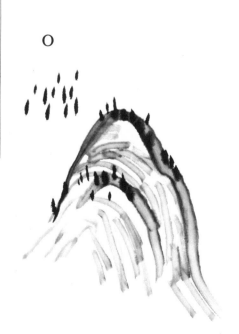

The method for painting weeds

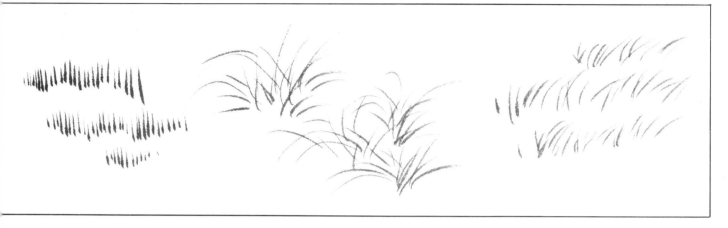

The method for painting trees with broad leaves and a pine-forest background.

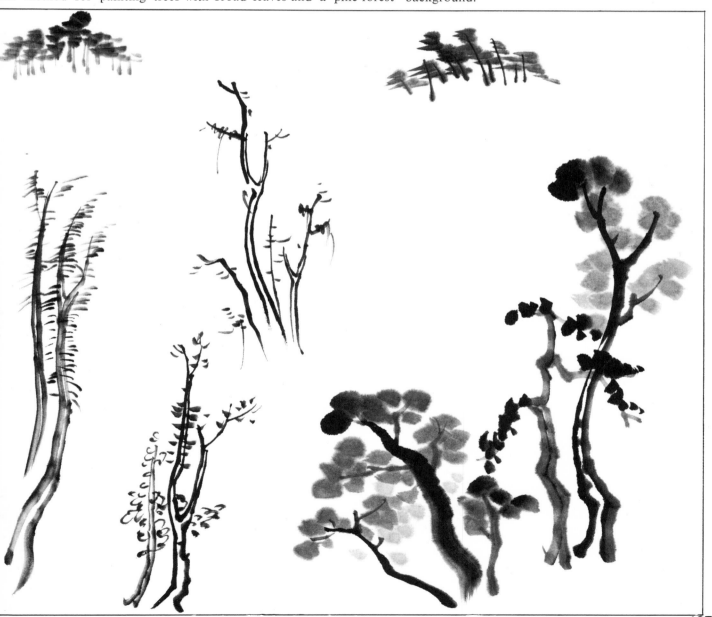

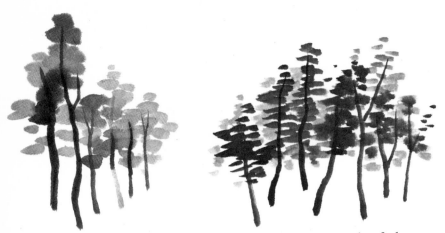

Depicting trees of various families by varying the strength of the strokes for the branches and leaves.

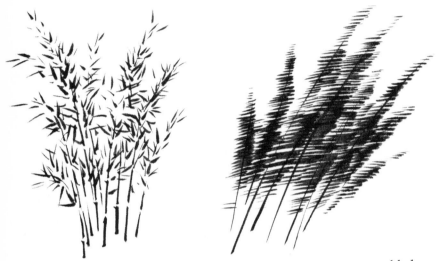

Two examples of how to paint a bamboo grove. The leaves are added after the boles are painted.

The method for painting forests in the foreground and in the background. To paint a forest in the foreground, paint the trees in front with dark ink and the trees behind with light ink.

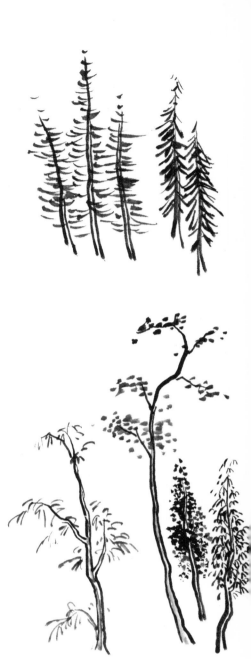

(*Above and bottom*) Depicting trees of various types by varying the techniques for painting the twigs and leaves.

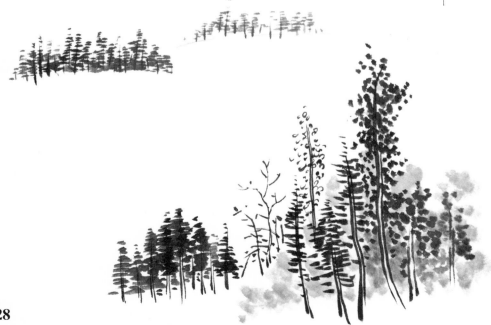

128

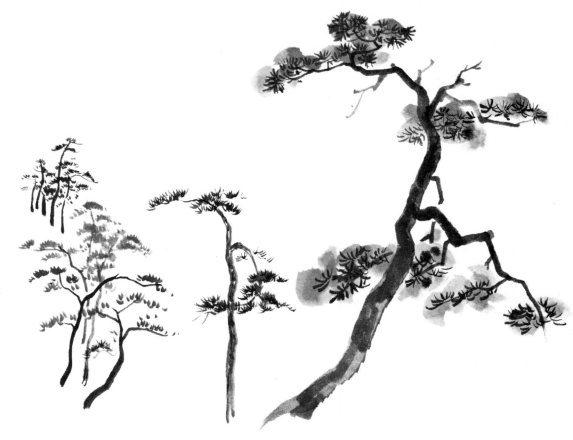

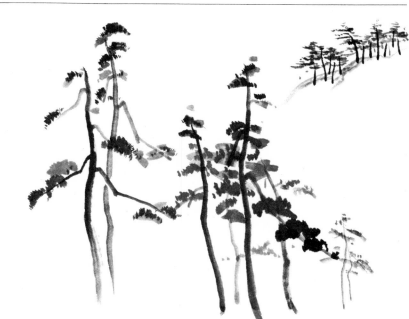

(*Above and bottom*) Depicting Pine Trees. The sequence for painting a pine tree is trunk first, then branches, and finally the leaves. The trunk should be made with slightly angled rather than straight brush movements. The leaves, made by holding the brush in an oblique position and using the three-ink method, are painted with downward strokes.

Depicting a Paulownia Tree. The trunk is outlined first, then the branches and leaves painted in. Outlining is the most appropriate method because the trunks of these trees have a whitish appearance. Short horizontal strokes added here and there help bring out a sense of volume for the trunk.

Depicting Mountain Ridges and Rocks

Chinese techniques for depicting mountain ridges.

[A] The Wind-blown Hemp-leaf Technique. In this technique an effect similar to that seen when hemp-leaf are being blown by the wind is produced.

[B] The Untwisted Rope Technique. A group of narrow strokes resembling an untwisted rope comprises this technique.

[C] The Rumpled Brushwood Technique. In this technique, the strokes have the appearance of tangled brushwood.

[D] The Lotus-leaf Technique. In this technique, used for painting ridges, strokes are made resembling inverted lotus leaves.

[E] The Cow-hair Technique. Lines resembling the wrinkles on a cow's back comprise this technique.

[F] The Crushed-alum Technique. In this technique strokes are made resembling lumps of crushed-alum. The effect suggests eroded granite.

[G] The Rain-drop Technique. In this technique strokes are made resembling a shower striking the ground. It is used to suggest a weathered slope. The strokes are generally larger near the bottom.

[H] The Folded-sash Technique. Horizontal strokes, broken sharply downward, suggesting folded sash comprise this technique. The effect is of horizontal stratification, with faulting across the strata.

[I] The Axe-split Technique. Wide, ragged strokes made with the side of the brush and resembling axe-splits comprise this technique. The effect suggests erosion.

[J] The Hemp-fiber Technique. Strokes resembling spread-out hemp fibers comprise this technique.

[K] The Axe-cut Technique. This technique is similar to the axe-split technique, but the strokes are smaller and resemble axe-cuts rather than splits. The brush is dipped in dark ink and V-shaped strokes are made with the brush held in a horizontal position. The effect is of faulted angular rocks.

B

E

H

I

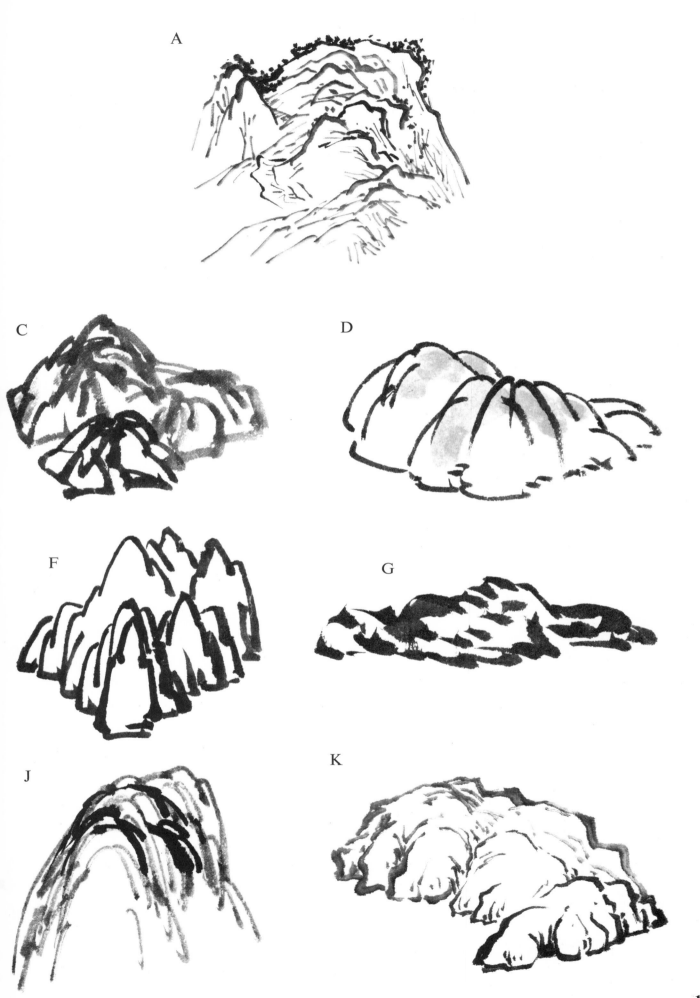

A

C

D

F

G

J

K

131

One rock.

Rock Composition

Two rocks.

Three rocks.

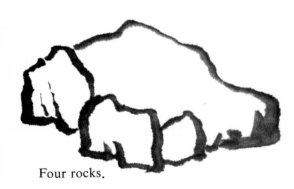

Four rocks.

Five rocks.

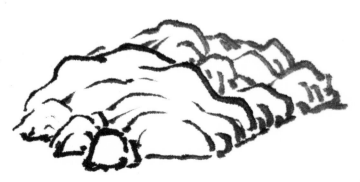

Group of rocks.

A

B

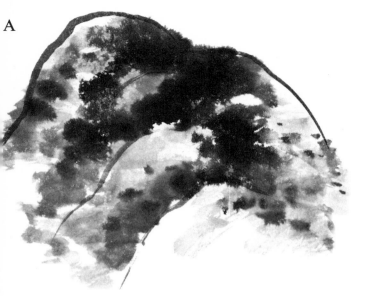

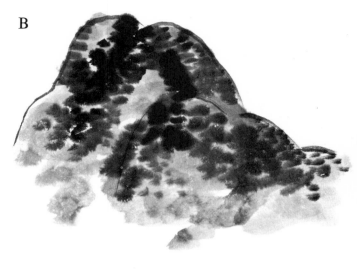

Painting Mountains

[A] Large Dotting. This technique is especially suitable for creating the effect of heavy summer foliage. The dotted strokes are characterized by an appearance of heavy dampness.

An example of this technique in which a heavily forested mountain is painted will make its use clear. Charge your brush with a little water and ink, then paint the outline of a mountain. Next, recharge the brush with a little water, dip the tip into dark ink, and combine the two in the brush by pressing the tip against the dish surface, then dip the tip into dark ink again. The strokes are made working from the top downward with large, overlapping strokes. The effect should be of a mountain covered with trees.

[B] Small Dotting. This technique is similar to the one above, but with some important differences. A double outline of a mountain, making the first stroke from left to right and the second from right to left, is first executed.

Next, the brush is charged with a little water, a little light ink, and a little dark ink, in that sequence. The dotted strokes are made from bottom to top, with the brush held in a horizontal position.

[C] Depicting a Mountain with the Hemp-fiber Technique. This technique has long been popular for depicting mountains. A combination of long and short strokes is used to form a mountain with an irregular, eroded appearance. The shoulders are shaded with light ink.

[D] The Axe-cut Technique. Charge your brush with dark ink and outline the rocks, using vertical and horizontal strokes. The folds are formed by allowing the vertical strokes to meet the horizontal strokes at right angles. The brush should be held in the oblique position. This technique is ideal for giving objects in landscape painting a rough, sharp appearance.

D

C

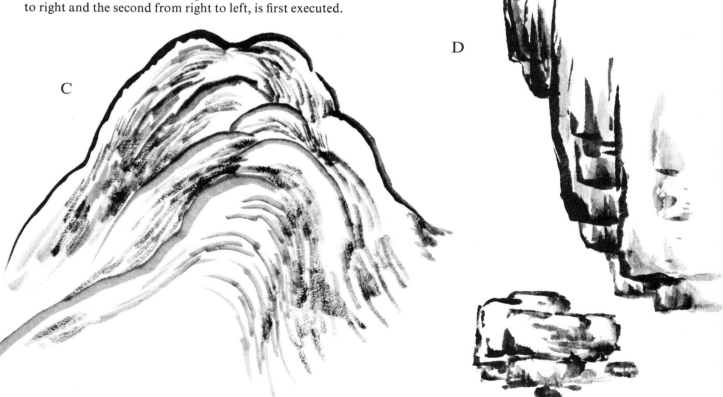

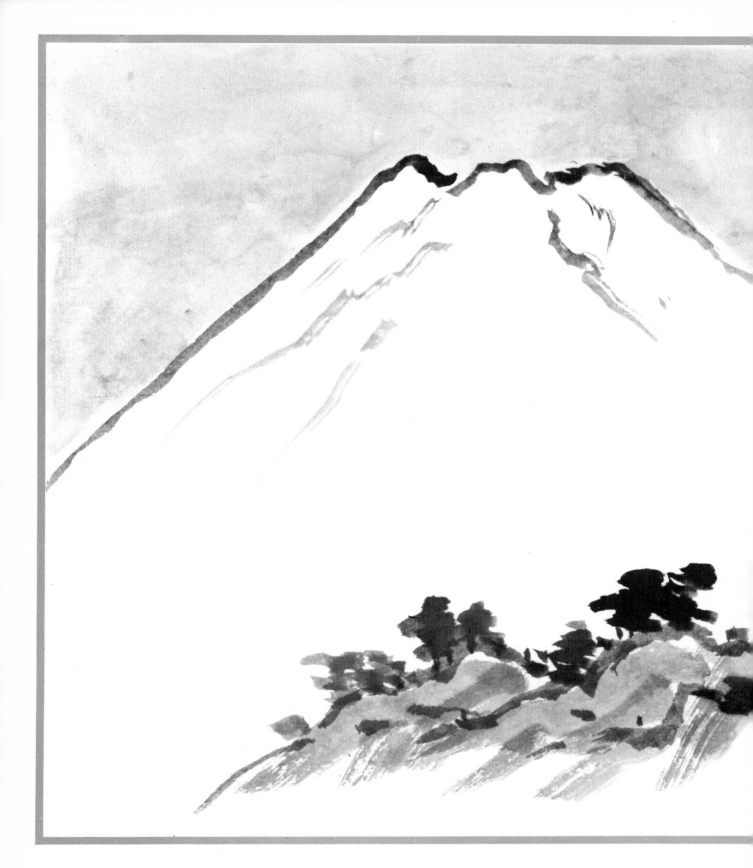

1. Mt. Fuji

Mt. Fuji in the winter is covered with a beautiful coat of snow. To paint this scene, the brush is washed and excess moisture squeezed out. Next, the brush is charged with medium ink and the left side of the mountain is painted in one slow stroke, made from top to bottom. The peak is then painted, and then the right slope. The ravines are touched in with "dry" strokes. To paint the rocks in the foreground the brush is charged with medium ink and the strokes made with left-right strokes, holding the brush in a horizontal position. Next, dip the tip in dark ink and paint the pine trunks. Then, holding the brush in a horizontal position paint in the foliage for the trees. The rocks in the foreground are shaded in with light ink. Finally, again with light ink, the sky is painted. The top of the mountain should appear a beautiful white, as though covered with snow.

Painting Practice

In landscape composition, the focal point of the scenery to be painted must first be firmly in mind. There are three basic perspectives, "high" distance, "deep" distance, and "level" distance. "High" distance is characterized by a clear, upward aspect, with height and distance combined without loss of height effect. "Deep" distance is characterized by a deep aspect, with a view from in front to mountains behind. "Level" distance is characterized by a wide, serene aspect, with a view toward distant mountains usual. Once the focal point for the intended landscape has been chosen, the rest of the scene assumes its own natural proportions.

2. Village on a Shore

This is a summer landscape of a village on a shore. The grove of trees in the foreground was used as the focal point, with the boats and houses painted next, and the distant mountain last.

First charge the brush with medium ink and paint the trunks of the large trees. Next, dip the tip in dark ink and touch in the leaves, allowing the heavy foliage to overlap and being careful to vary the shading. Next, holding the brush in a horizontal position, paint the earth and the bank along the shore. The house, boats, and forest are painted with medium ink. Finally, the distant mountains are painted with light ink, leaving "white space" above them.

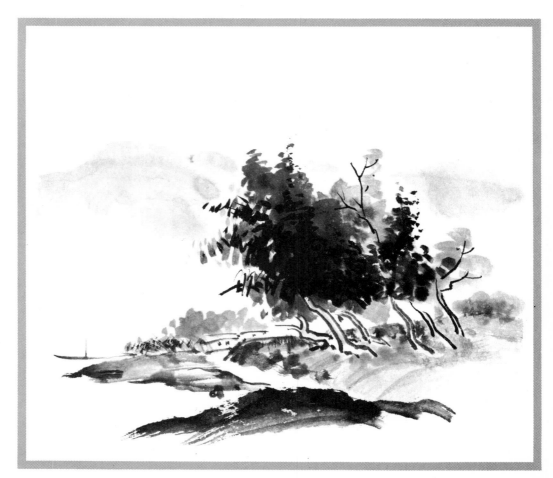

135

3. Stream

To paint this landscape, first, outline the rocks along the banks with dark and medium inks and then the tree trunks with medium ink. Next, paint the foliage with dark ink and shade with a brush charged with light ink and a touch of medium ink. The flow of the stream is depicted with linear strokes in light ink, with shading added in light ink for the still water.

4. Clear Mountains

This is a landscape of mountains seen after a rain. White, rain-laden clouds have parted to allow a view of rain-drenched mountains. First, the peak of the nearest mountain is painted with a brush charged using the "three-ink" method. Next, the brush is dipped in dark ink and the trees are painted in, using shading. To paint the mountains in the middle ground, use light ink first and then shade the peaks with medium ink. The distant mountains are painted with light ink. The mountains should be painted in such a way as to give the clouds in front of them a white appearance.

5. View of Naples

First, charge your brush with medium ink and outline Mt. Vesuvius, adding shading with light ink. Next, paint the shoreline with light ink. Then the foliage in the foreground is painted with dark and medium ink. Light ink is used to paint the houses in the town, with shading added in medium ink. Finally, the boats on the sea are painted.

3

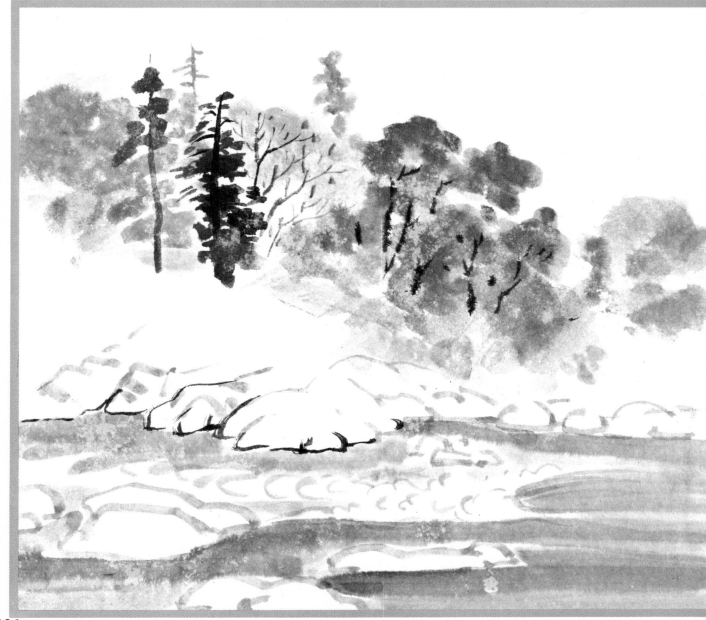

4

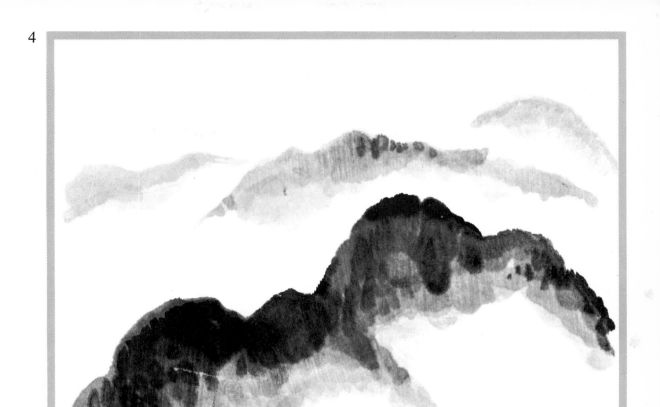

5

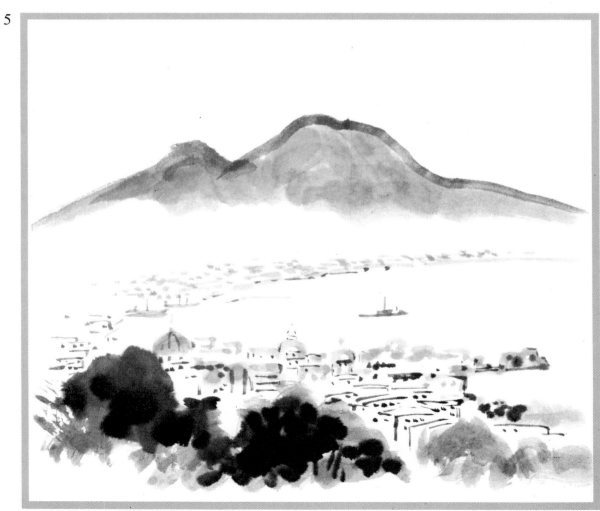

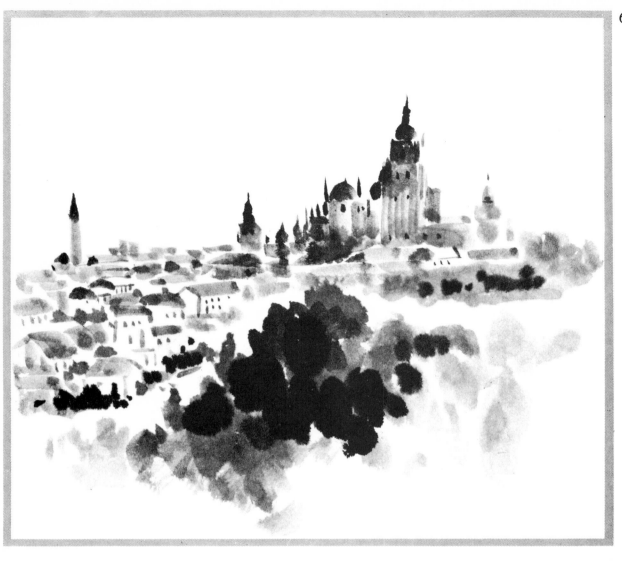

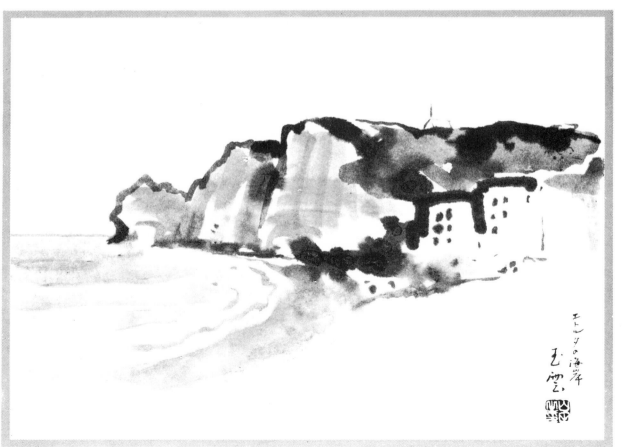

エトルタの海岸

玉雲

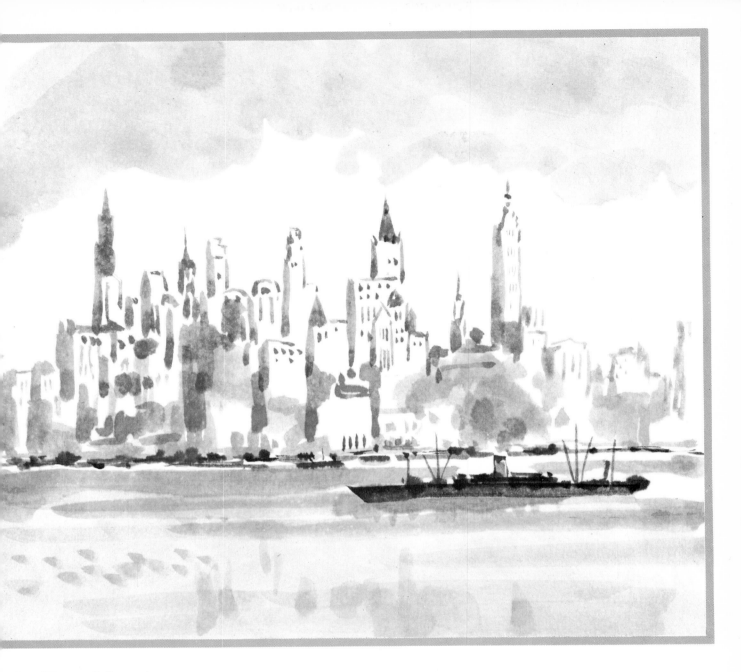

6. View of Segovia

First wash your brush thoroughly, charge it with light and medium inks, then dip the tip into dark ink. Start the painting with the spire above the center of the structure, continuing on to the dome and the main part of the structure. The sides of the structure are painted in the same brushwork sequence as the main part, that is, starting at the top and working downwards.

To paint the trees in the foreground, charge the brush with medium and dark inks and depict them in the appropriate technique. The houses in the middle are painted next. Finally, the background is painted, using light ink.

7. Shores of Etretat

First charge the brush with light ink and dip the tip in medium ink. Start the painting by delineating the lines of the central cliff, then proceed to paint the rock ridges on the cape and to outline the cliff on the hill. Next, paint the coastline, the horizon, and the buildings along the coast, in that sequence.

The cliffs and hill slopes are then shaded with light ink, and with these nuances of shading fixed firmly in mind, the painting completed by adding the waves and the seashore.

8. New York

First wash the brush thoroughly and form the bristles neatly into their natural shape, then charge it with light ink and dip the tip lightly in medium ink. Start by painting the central buildings, working from the top down, and next the buildings to the right and left. With light ink, shade the sides of the buildings to give the work a more three-dimensional effect.

In the next steps, use light ink to paint the river banks and medium ink to paint the ships and smoke, which helps soften the hard outlines of the buildings. Care should be taken to use varied lines rather than hard, wire-like lines in order to create the proper effect of a city. When the river and clouds are painted with light ink, it helps to emphasize the height of buildings and to give a feeling of breadth to the landscape.

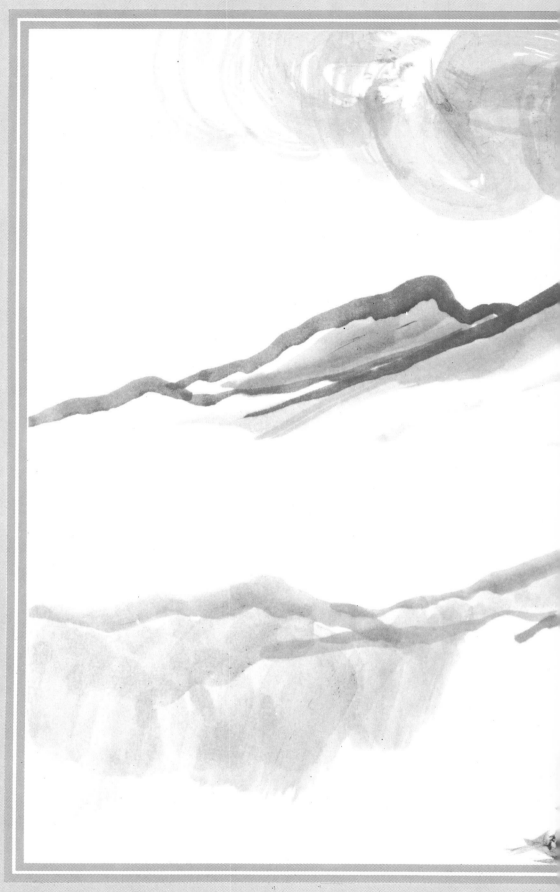

9. Mt. Asama To paint Mt. Asama, a live volcano, charge the brush tip with medium ink and start your brushwork from the peak, working down first toward the right foot of the mountain and then down toward the left. Next, paint the distant mountains on the left. To paint the larch trees, which are next in sequence, charge the brush with medium ink and paint the trunks, then paint the overlapping leaves with horizontal strokes. The closer mountains

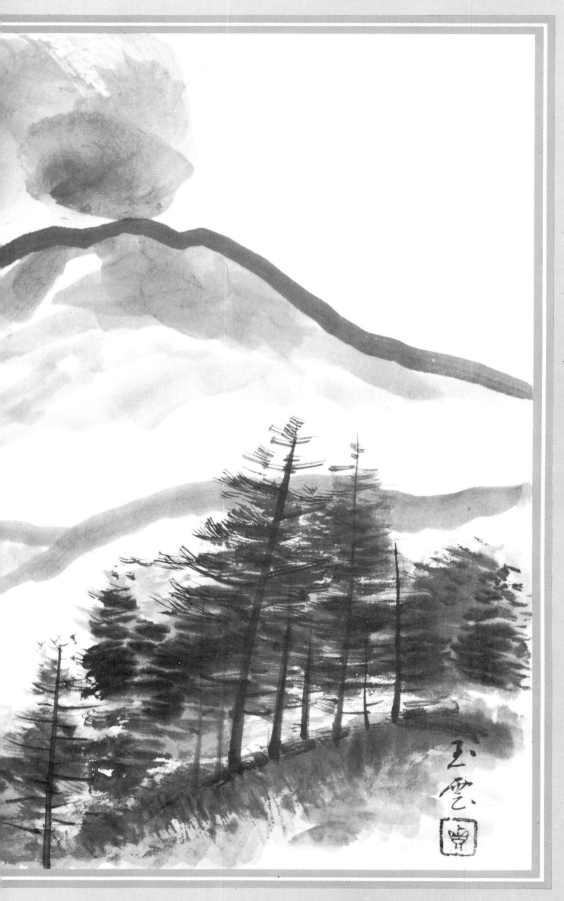

and the patches of grass are next painted using the "three-ink" method in order to give them variation.

To paint the mountains that should appear in the middle ground, use a brush charged with light ink, then shade in the sides of the mountains with light ink. Finally, paint in the gushing smoke. The grandeur of the mountain and the perspective of the scene are naturally emphasized by the unpainted areas.

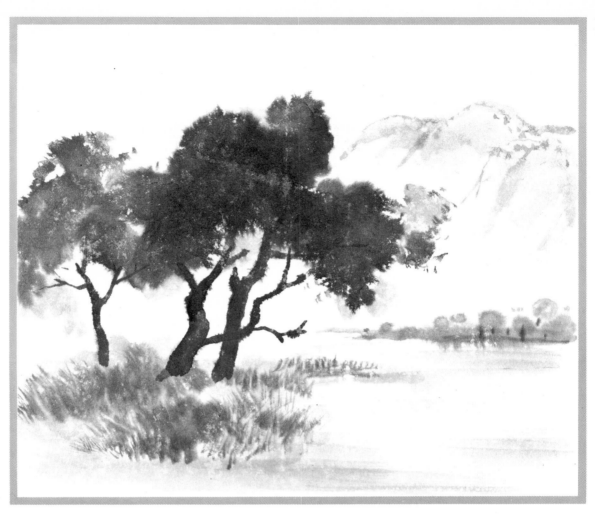

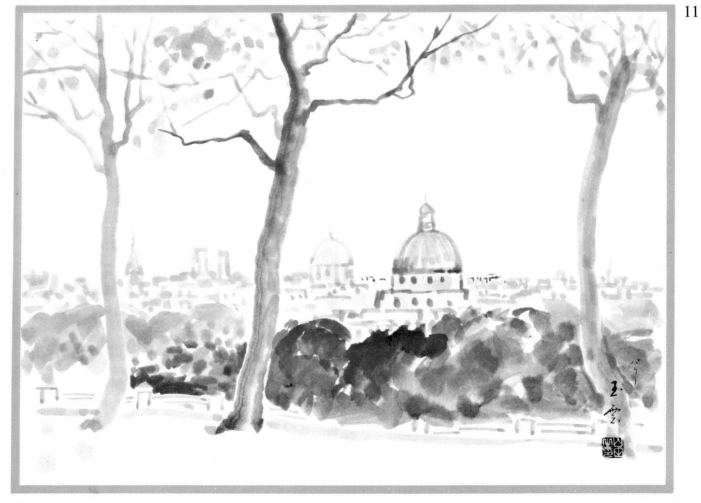

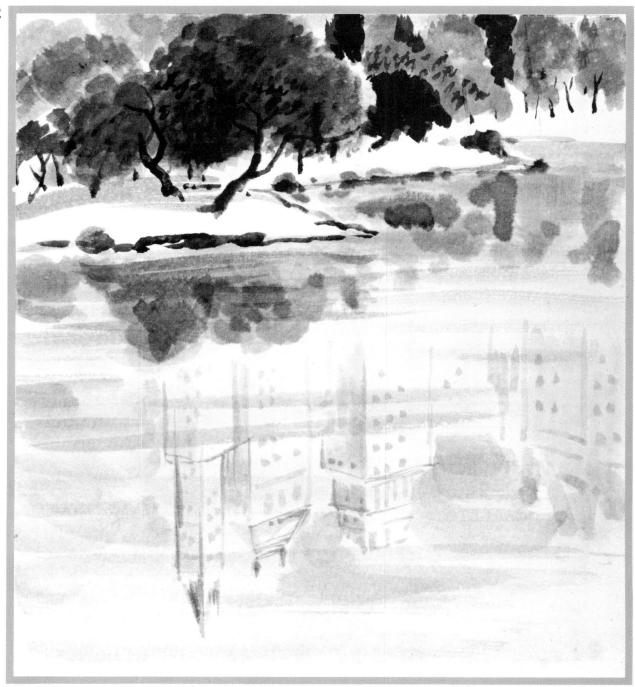

10. Lake

As can be seen in the illustration, the breadth and brightness of the surface of the lake are emphasized by painting the trees with dark ink. The trunks of the trees in the center are painted first, then the leaves added with medium and heavy ink. The grassy plain beside the lake is painted with light and medium ink, and the background mountains, forest, and so on, with light ink.

11. Paris

To paint this scene, the trees that stretch across the foreground are painted using a suitable ink. The trunks are made with downward strokes and the leaves painted in, starting with the larger ones and finishing with the smaller. Light ink is used to portray the ground and the leaves. Next, the grove of trees in the middle ground is depicted, and finally the buildings and town in the background are painted with light ink.

12. Central Park, New York

This is a pond-side scene in Central Park, New York. In it, an attempt has been made to depict the scenery, atmosphere, and feeling of the city through the reflection of the skyscrapers on the surface of the pond.

To start the painting, first paint the large trees at the top, the banks around the pond, and the groves of trees. Next, the brush is washed thoroughly and charged with clear water, then with a sideward stroke the brush is moved across the surface of the pond. While this area is still wet, paint in the tree reflections with light and medium ink.

Next, outline the buildings with light ink, then charge the brush with clear water and paint over the surface of the pond. Before this dries, paint the pond surface with light ink, holding the brush sideways. The pond will have a greater appearance of breadth if part of the surface is left white.

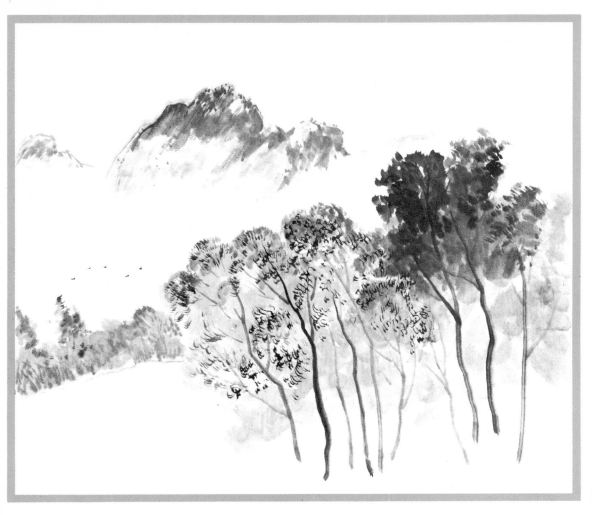

SPRING MOUNTAINS

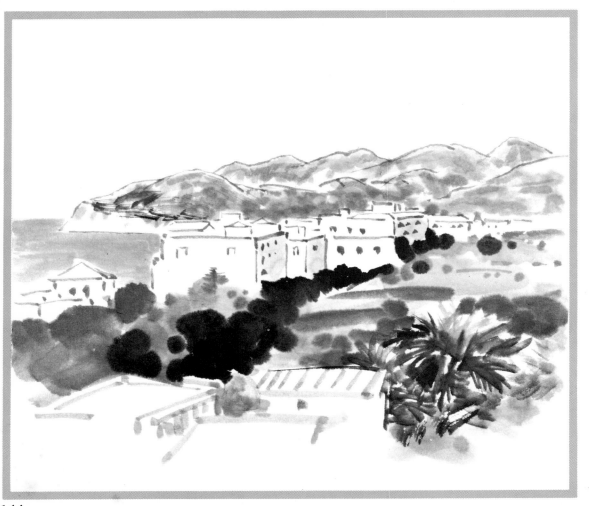

VIEW OF SORRENTO

ASSISI

Examples of *Sumi-e*

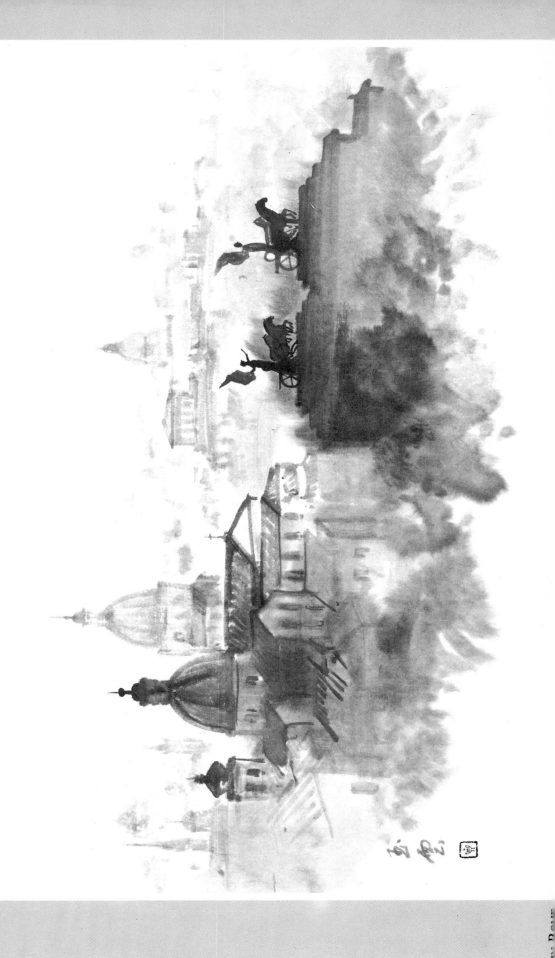

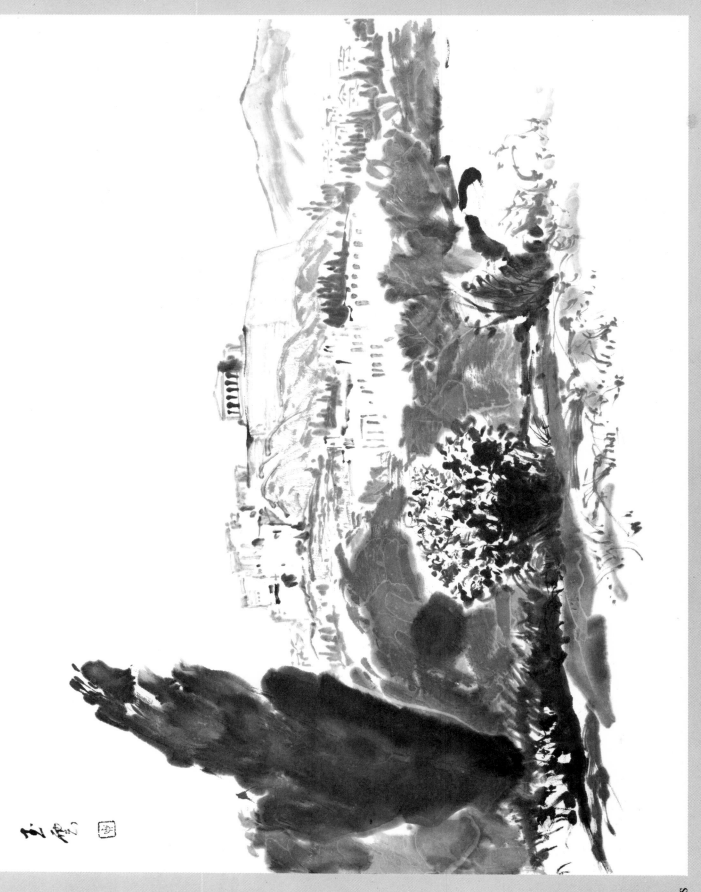

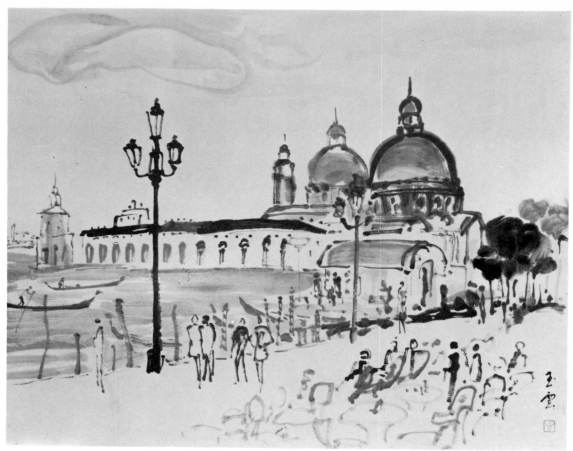

VENICE

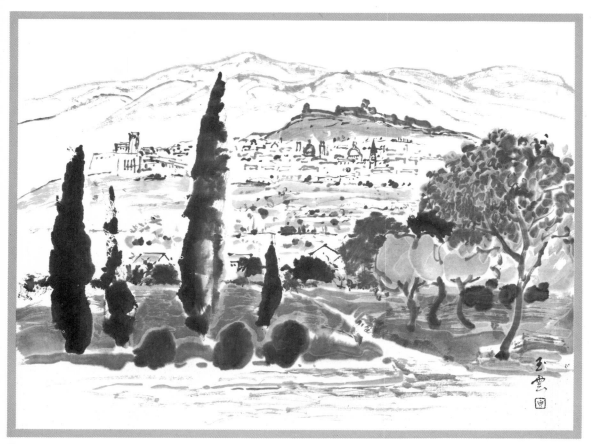

ASSISI

148